con tents

part two:
BODIES

acknowl edgments

The idea for this volume grew out of a year-long series of events organized around the topic of gender and technology held at the Wexner Center for the Arts at The Ohio State University in Columbus, Ohio, during the 1994–95 academic year. The programs consisted of a series of visiting artists' presentations, film and video screenings, and a two-day symposium involving fifteen panelists. In conjunction with the program, a hands-on video workshop for teenage girls entitled *Girl TV* was conducted by Mary Ellen Strom, and an interactive CD-ROM installation designed by Christine Tamblyn was exhibited, entitled *She Loves It, She Loves It Not* about women's ambivalent relationship to technology.

In addition to the contributors to this volume, we would like to thank the following institutions and individuals for their contributions to making the program a success: the Wexner Center for the Arts and the Division of Comparative Studies in the Humanities at The Ohio State University, Sherri Geldin, Bill Horrigan, Marla Krupman, Marit Legler, Patricia Trumps, Erin Pound, Roger Addleman, Dave Filipi, Zlata Baum, Eva Heisler, Sarah Rogers, Chuck Helm, Chris Jones, Gary Sankey, Kathryn Morris, Dana Master, Bonita Makuch, Wayne E. Carlson, Judith Mayne, E. Beth Sullivan, Jane M. Fraser, Suzanne K. Damarin, Richard Roth, Susan King Roth, Leila Rupp, Xiaomei Chen, Linda A. Bernhard, Leslie S. Jones, Sally Kitch, Mary Margaret Fonow, and Sabra Webber.

We would also like to thank our editor, Rebecca Barden, at Routledge for her support through the publication of this volume.

Jennifer Terry
and
Melodie Calvert

about the wexner center

As a contemporary arts center based on the campus of the most populous university in the nation, the Wexner Center for the Arts is bound by both desire and mandate to contribute to the intellectual and cultural well-being of The Ohio State University.

When the Wexner Center opened its doors in November 1989, a remarkable amount of publicity and commentary was generated, focusing principally on the character of the building's architectural design by Peter Eisenman (working with Richard Trott) whose first large-scale commission the Wexner represented. Those of us who have worked within this remarkable building over the past seven years have become almost blind to its spatial eccentricities, and it is only when a colleague arrives to make her first visit to the Center and stands bewildered in the upper lobby that we are able to regain, if only in a flash of involuntary memory, the destabilizing quality of what Mr Eisenman imagined and produced. Most of the time, the rest of the time, we assume a blinkered or default mode and simply annex these spaces as sites to be filled by people and ideas and objects; the spaces do defer, obligingly, to the extent that those people and ideas and objects are armed with conviction and willfulness equal to Mr Eisenman's audacities.

Having over the course of time labored toward becoming intuitively one (on the levels of physical display, exhibition and performance) with the interrogatory nature of the Wexner's built public spaces, it has

hence become second nature, when faced with those same demands to curate or to exhibit or to present, to second-guess in like manner (i.e., pathetically and fallaciously) the very terms and conditions scheduled to occur within those spaces – as though it would constitute a kind of dishonor to pretend we were all still laboring within the vacuumed white cube of the modern museum. Foreseen or not, one effect produced by the physical attributes of the Center's building is to encourage those charged with plotting its content to almost instinctively think against ourselves at all stages of the process.

It was thus over time that the gender and technology problematic emerged to command extended enquiry, a problematic physically anchored on one side by the Center's Art and Technology video production and post-production facility, and anchored on the other by the Center's ongoing commitment to the work of women artists and producers. Indeed, the first artist to use Art and Technology, albeit in nascent form, was also the first artist commissioned by the Wexner to produce a new installation – Julia Scher, whose facility-wide surveillance project, Occupational Placement (Security by Julia) was on view the day the building opened in 1989, and whose contribution to the present volume appears on its concluding pages.

The Gender and Technology events that have made their way, transfigured, into *Processed Lives: Gender and Technology in Everyday Life*, represented a natural coming together of the Wexner Center's Media Arts department's programmatic interests, with the intellectual and research interests of our colleagues in the university's Division of Comparative Studies in the Humanities. Conceived jointly by Media Arts Associate Curator, Melodie Calvert, and Comparative Studies Assistant Professor, Jennifer Terry, the Gender and Technology project began in November 1994, with a three-month screening series presented by artists Kathy High, Judith Barry and Ericka Beckman. Overlapping these in-person presentations were curated programs of shorter works, presented from January to March 1995, focusing on gender and technology as articulated in the home, in the realm of information, and within the site of the body, with these three foci then providing the conceptual and tactical framework for the symposium itself in April 1995, a free two-day event attended by over 800 students, faculty, and community members.

Coming to the Wexner Center in September 1994, Director Sherri Geldin strongly supported the Gender and Technology project; equal conviction was demonstrated by Director of Exhibitions, Sarah J. Rogers and Director of Education, Patricia Trumps, whose Young Arts and Youth and Technology programs, funded by the Leo Yassenoff Foundation, were welcome ancillary activities. Media Arts program assistant Dave Filipi provided expert management assistance on all

aspects of the event, as did the project's administrative assistant, Marit Legler. Additionally, the Ohio Arts Council, under Director Wayne Lawson, provided valuable funding support, as did the National Endowment for the Arts' Media Arts Division.

Finally, for this as for much else, our thanks to the Wexner Center Foundation, whose extraordinary support drives and enables the Center's commitment to the production of challenging new art across all disciplines.

Bill Horrigan
Curator, Media Arts
Wexner Center for the Arts
The Ohio State University

intro duction

Machines/Lives

Jennifer Terry and Melodie Calvert

The machine is not an *it* to be animated, worshipped, and dominated. The machine is us, our processes, an aspect of our embodiment.
Donna Haraway (1991: 180)

Gender is not a property of bodies or something originally existent in human beings, . . . it is the product and process of various social technologies, institutional discourses, epistemologies, and critical practices, as well as practices of daily life.
Teresa de Lauretis (1987: 2)

Try getting through a day without machines. Or, for that matter, try getting through a day without gender. The challenge in both of these propositions is not to do without technology or gender (since it is practically impossible to do so), but to analyze, by imagining for a moment their absence, what bearing these privileged systems have on all of us in terms of our hopes, dreams, fears, and frustrations. We live in a world not only *structured* but *saturated* by technology and gender, the characteristics and consequences of which are explored in this anthology.

DISCERNING TECHNOLOGY

In a very basic sense, the term technology conjures up the objects we call tools or machines. In human origin stories offered to us by archaeologists and physical anthropologists, tools signify culture and civilization, distinguishing Man [sic] from other species of life and providing evidence of his superior relation to the natural world. Tools are proof of Man's innate faculty of rationality. In these origin tales, tools are generally defined as the means to harness energy, to get the job of survival done, and eventually to ensure health, security, and convenience; in short, tools and their descendants, machines, are civilized and civilizing. They are signs of progress. They enhance life, and their designers and users are, by definition, civilized, or so the story goes. Critics of this positivist and laudatory definition of technology begin by asking whose lives are being enhanced through technological development. Problems of automation, de-skilling, unemployment, and work speed-ups caused by machines are seldom addressed (Aronowitz 1994), to say nothing of the worldwide ecological destruction and planned "uneven" development wrought by modern Western technology when it is imposed upon Third World countries (Sachs 1992), or the paradoxical effect of household appliances actually adding to women's burdens of housekeeping (Cowan 1983; Strasser 1982). Nevertheless, archaeologists' tales, World Bank development schemes, and General Electric "We-Bring-Good-Things-To-Life" advertising campaigns often rhyme with one another.

Positivist narratives of technological mastery of Man over nature imagine the former as earthly sovereign, and the latter as raw material or forces to be exploited, tamed, appropriated, and made useful or meaningful through ingenuity and inventions. Problematizing who gets to count as Man and what gets to count as technology and progress in these narratives is the focus of recent critical interventions and retellings of the story of human life, history, and culture, especially those generated by feminist theorists (Haraway 1991). This is an especially serious matter since, as critics have pointed out, the equation of tools with culture, rationality, progress, and (modern/Western/colonizing)

Man has been a vehicle for classifying the vast variety of human cultures according to degrees of intelligence and cultural sophistication, from the "primitive" to the "advanced," on the basis of their inventions and uses of technology (Adas 1989). Moreover, critics note that in these master(y) narratives, women and "natives" are placed in closer proximity to nature as resources to be tamed and exploited, and further from civilization, rationality, and technological authority. This same equation is deployed for keeping the gates carefully policed as to which inventors and users are credited for making "progress" and "civilization," and which are devalued or erased from the history of culture, with distinctions based on species, gender, and race being the primary means for doing this police work (Bernal 1987; Haraway 1991). Thus, early agricultural technologies developed by women in "prehistorical" Africa are forgotten in modern and postmodern narratives of high tech genius (Stanley 1983; Zihlman 1985). The binary opposition of primitive versus advanced technology circulates in relation to a number of closely related and hierarchically arranged dualisms pertinent to the technology-as-sign-of-culture paradigm, including the oppositions between nature and culture, "low-end" and "high-end," user and designer, and, importantly, femininity and masculinity. Investments in defining human history and culture in terms of increasingly "advanced" technology are embedded now in the very systems that surround us and make a day without machines and, sadly, without gender hierarchies nearly impossible to imagine.

Defining technology strictly in terms of objects, such as tools, machines, and appliances, implies fundamental (but ultimately illusory) distinctions between the technology, its designer, and its user. In this formulation of the term, technology, then, has been described as neutral and autonomous, having no inherent or built-in moral or political qualities. In other words, a tool can be used for good or for bad, depending on the intentions and actions of its user; meanwhile its designer is off the hook for what the tool actually does in the world. A different approach to defining technology is to understand it as always encompassing relationships and exchanges among machines, designers, and users (Balabanian 1980; Winner 1977). This approach is also contrary to a kind of technological determinism that would grant to technology a life purely of its own, as if driven by an internal momentum to discovery, or as Jan Zimmerman puts it, "some force that makes unraveling the mysteries of the universe at once irresistible and inevitable" (Zimmerman 1986: 5). Instead, this approach assumes that technology carries with it human moral responsibility, and argues that one simply cannot understand technology outside its particular historical, economic, and cultural context of design and use. After all, it takes "know how" not only to make machines, but also to use them; thus, one cannot isolate machines away from their users or designers, nor from

their location and dynamics in culture and human life (Brooks 1983). Here technology is defined more appropriately in terms of machine/human interface, that is, in terms of how particular machines and mechanisms accomplish tasks of configuring, effecting, mediating, and embodying social relations. In this definition, machines do not necessarily *determine* social relations, but are situated in networked social relations, subject to uses and creative misuses by the humans (and other machines) that surround them.

This technology-as-interface definition opens up a space for doing a number of important critical activities. First, it can be useful for analyzing why technology is designed by particular humans under specific historical, political, and economic circumstances, with specific interests and intentions in mind, reflecting and embodying relations of power (Penley and Ross 1991). Thus, for example, it becomes possible to understand why the Internet, originally designed for Cold War strategic military purposes, has a specific format, logic, and programming lexicon rooted in its intended purpose of keeping information decentralized in the face of a nuclear threat from the former Soviet Union. In these times, technologies are often created in the interests of military and corporate profit, seldom with the intention of enhancing community participation or individual autonomy. Individual autonomy is curtailed by modern technologies of surveillance, including DNA fingerprinting, caller ID boxes, key-stroke monitoring devices, and electronic dossiers (Bender and Druckrey 1994).

Second, understanding technology as, by definition, contiguous with human activity, can allow one to see how machines and systems are appropriated differently than their original design intended, and creatively extended or subverted by particular users under particular historical and political circumstances. Thus, in spite of its original intended uses for military strategic planning, the Internet has been appropriated by feminists, community activists, and progressive political groups to share information and offer support, as Nina Wakeford argues in her chapter "Networking Women and Grrrls" in this volume. Technologies do not simply control and victimize their users, even though they often produce and reinforce hierarchical social relations. As Wakeford's meditation on the possibilities of feminist and anti-racist appropriations of the World Wide Web suggests, new technologies can offer liberatory fantasies and subversive possibilities.

And, third, this definition can reveal a *history of technologies* – that is, it can show how the dynamics and slippages between intended designs and unintended uses and "bugs" give rise to new generations of machines and new notions of the ideal user. In other words, this definition can reveal the highly mediated feedback processes between humans (designers, programmers, and users) and machines, processes shaped by specific historical, political, cultural, and personal

investments, that evolve into new kinds of technological systems and social relations. This process is evidenced through the history of women's creative "misuses" of the telephone. Originally designed for making business transactions between men, the telephone became a means for enhancing social contact between otherwise isolated house-wives. By the 1920s, the telephone had become an important tool for both business and pleasure, gradually giving rise in more recent years to the telephone answering machine, originally designed as a device for catching important calls, but which soon became useful for screening unwanted calls. However, there is some shame involved in making it obvious that you are screening calls by picking up the phone in the middle of a message. Add to this scenario the complications caused by the "call interrupt" feature which was also designed to catch otherwise missed calls, allowing one party to put the other on hold in order to see who is on the other line. If a user wants to be liberated from the exist-ing call, the new caller can be used as an excuse, but the risk that the interrupting call might be undesirable is unavoidable. Getting back to either or both callers, as dreadful or pleasant as the prospect might be, is a social predicament/choice enabled by the "interrupt" feature. Add to this scenario the caller ID box, marketed to women for screening harassing calls, which is useful for identifying who's calling and taking the call if you want to pretend you aren't screening, or letting the answering machine take the call if you want to pretend you are not home. These examples reveal that designs, uses, and creative misuses of machines operate in a feedback loop, giving rise to innovations in socially enabled technological developments and technologically enabled social relations. This feedback model of technology in fact pro-ductively effaces any sense of humans and machines as autonomous entities, imagining instead that the modern world is composed of *actor networks* in which significant social actors, including humans and non-human technological entities, are deeply interwoven (Latour 1987).

A fourth way to define technology would extend the previous defin-ition by considering technology as an integrated system of programmed structures, organized mechanisms of management and control, and processes of production and reproduction. Again, in this formulation, technologies are neither instruments we simply use, nor neutral tools that we command. Indeed, this definition builds upon the interface/actor–network model by understanding that technologies function as systems that shape our lives, structuring not just what we do and how we do it, but even fashioning our vision of social relations and what it means to be human. And, technologies, as organized sys-tems, produce a range of products, effects, representations, and artefacts, chief among them, hierarchical social relations, or what we could call technologies of gender, race, and sexuality (de Lauretis 1987; Foucault 1980; Haraway 1991). In this respect we could define gender

as itself a technology according to the following propositions: Gender is an organized system of management and control which produces and reproduces classifications and hierarchical distinctions between masculinity and femininity. Gender is a system of representation which assigns meaning and value to individuals in society, making them into either men or women.

Considered together, the artwork and short chapters in *Processed Lives* deploy a broad, inclusive definition of the term technology: that is, technology is that which is *productive* or *generative*, whether the product be a TV show for girls (Strom), an email pen pal (Wakeford), a fertilized embryo (Horn, Makuch), a sense of sexual pleasure (Livingston), a new racially morphed citizen (Hammonds), a population control campaign (Morsy), or a feeling of vulnerability (Slane, Samaras). Technologies can and often do produce gendered hierarchies, through their design, availability, and patterns of use, as virtually every piece in this collection demonstrates. The contributors to *Processed Lives* explore a range of technologies, with particular emphases placed on recently developed machines/systems. But readers will note that these new systems are layered on top of older existing technologies such as party line telephones and handguns, and thus have embedded within them histories of these "simple" technologies on which assumptions about masculinity and femininity have been formulated.

Throughout the book, gender itself is conceptualized as both a technology which produces, among other things, men and women, and an artefact or product of a larger cultural and epistemological logic that deploys binary oppositions as a means for structuring hierarchical social relations between men and women. Through these broader definitions of technology and gender, *Processed Lives* invites its audiences to analyze critically the productive systems or apparatuses in culture that not only produce and reproduce certain kinds of gender and machine relations, but obstruct or prohibit others. Thus, for our purposes, the term technology has both a narrow meaning (the machine, the tool, the gadget, the gizmo), and a broader, social meaning (technology as a productive system) that allows us to see how distinctions concerning gender, as well as those concerning race, nation, class, and sexuality, are themselves products or artefacts of a larger technology that Michel Foucault referred to as *the social* (Foucault 1979).

THE MACHINERY OF EVERYDAY LIFE

Processed Lives analyzes the complex terms of living amidst a dramatic proliferation of new gadgets, gizmos, and high-tech devices as they structure our notions and relations of gender. It takes as a point of departure the observation that technologies – from the simple to the complex – permeate the many seemingly discrete domains of our lives,

and in so doing not only *reflect*, but, indeed at times, *structure* and *produce* the hierarchically organized binary opposition of masculinity and femininity that characterizes our present system of gender. The pieces which follow analyze the interrelations of gender and technology by asking how the terms of gender – that is, the means by which we conceptualize masculinity and femininity – are embodied in technologies, and, conversely, how technologies influence our notions of gender. And, as a whole, the book assumes that just as technology is busy producing new products, effects, and relations, the production of gender, to quote Teresa de Lauretis, "goes on as busily today as it did in earlier times," in the academy, in the intellectual community, in avant-garde art practices, in offices, schools, courts, media, and, indeed, in machines (de Lauretis 1987: 3).

Are technologies themselves gendered? By what assumptions can we, for example, entertain the claim that guns are masculine machines and curling irons are feminine machines? Do classifications of this sort depend on the design of a technology, or on its users? If women are particularly associated with "low-end" appliances such as blenders, toasters, hair dryers, breast pumps, and sewing machines, to what extent does this depend on the historically specific siting of these machines in the home, or to their status as accessories of women's wifely and maternal duties? If men are associated with "advanced" or "high-end" technologies, from cars to computers, is this because they are (presently) the primary inventors of these things, or because they are assumed to be the more "knowledgeable" users of these devices? If so, what do we make of the fact that almost as many American women as men own cars, or that a dramatically high percentage of the growing labor force in computer-based information management industries is female? Or that women in Malaysia and other parts of Southeast Asia are the primary assembly-line producers of silicon microchips (Ong 1990), the vital elements necessary for the very existence of the World Wide Web? Clearly, as Marx noted well over a century ago, if wages or work conditions are any indication, producing the essential means for technologies without which the capitalist world would most certainly come to a lurching halt does not give the factory worker either the prestige or recognition for her crucial role in ensuring the operation of our vast network of integrated information and communication. A feminist reading of Marx might help us to understand why the Malay female factory worker lives in a virtual shanty town outside the magnificent "virtual global village" about which computer advertising campaigns generate so much hype.

In general, women and men are situated differently in relation to technologies, and yet even among women there are vast differences in this regard as to which women have access to technologies, under what conditions they have access, and to what uses different women put

machines. There is a big incongruity between using a computer for tedious low-paid data entry jobs versus using it to analyze and process information in the service of maximizing one's own profit. As many of the authors in *Processed Lives* note, basic access to technologies, especially high-tech microelectronic technologies, is significantly restricted for most women in the world due primarily to their lack of money and their exclusion from technical training, and due to a socialization process that discourages women from thinking technology is theirs to invent and use.

We are now in a world constituted by what Donna Haraway has called "the scary new networks [of] the informatics of domination [which mark] a movement from an organic, industrial society to a polymorphous, information society – from all work to all play, a deadly game" (Haraway 1991: 161). This new information society consists of microelectronic technologies that are everywhere and yet their internal workings are invisible, operating in the service of "maximum performance," whereby machines and management work to develop and expand their own micro-political power (Lyotard 1984). These technologies are "clean," light, portable, miniature, but global as well; they animate our everyday lives from our employment to our entertainment and everything in between. The shift to this new networked world requires innovations in theory and political practice, and critical feminist engagement with science and technology. As Haraway argues, feminists cannot afford to stay out of the game of technoscience if we want the future to look different. Nature, culture and animal/human/ machine relations must be rethought in new boundary-shifting terms. Thinking of things in terms of essential properties is no longer adequate. We must think in terms of design, boundary constraints, rates of flows, systems logics, and costs of lowering constraints. Stress is the attendant malady. In this new networked scene, gender is not a property of the body existing prior to it, but an effect of shifting boundaries and circulating (micro) flows of energy and information. Thus, to think of gender in cyberculture may also allow for the possibility of moving beyond the binary opposition between masculinity and femininity, and to struggle to make the next gender system (if there is to be one), a system which liberates women. This is a struggle of both microscopic and colossal proportions. And while the organic, essential female body may in fact be dispersed into networks, as Christine Tamblyn suggests, the idea of the female body carries a history of centuries of experiences and oppressions that are layered into the operating systems of "cutting edge" cybernetic technology.

A significant amount of feminist writing has expressed suspicious resistance and even phobic reaction to machines, to a great degree with good reason, since it is not difficult to associate many forms of modern technology with a masculine pathos of domination, control,

and destruction (Cohn 1987; Corea *et al.* 1985; Merchant 1980). But the selections in *Processed Lives*, while generally critical, express a sense of urgency about the importance of women's engagement with technology, especially as it permeates everyday life. There is no simple way to say no to technology and be a citizen these days. Even those who do not own machines are governed by them in profound ways, in the domains of work, welfare, medical care, and the credit economy. Negotiating the labyrinth of government and credit bureaucracies, as many low-income and poor women must do in everyday life, involves being governed by the scary new networks Haraway outlined, often at the mercy of machines.

There is a great deal of ambivalence expressed, especially by women, about the positive potential as well as the dangers and anxieties generated by new technology. To refuse such an engagement is perhaps not merely to forego the strategic opportunity to transform or even invent radically different technologies for feminist and progressive projects; crucial decision-making about our futures requires this critical engagement. *Processed Lives* is divided into three parts corresponding to main sites where technology and gender overdetermine each other and where such interventions are key: Digital Worlds, Bodies, and the Home.

DIGITAL WORLDS

In Part I, Digital Worlds, authors and artists explore questions of whether new information/telecommunication and video technologies are changing our notions of masculinity and femininity, and whether these technologies have the potential to empower women. Margaret Morse, in "Virtually Female," theorizes the notion of *unwill* to describe the strange resistance to technology that women experience from a young age. Unwill is the effect of a learning process whereby young girls learn that the domain of computers belongs primarily to boys and men. Unwill is experienced in anxieties; its symptoms are faulty executions of instructions, phobias, a sense of technical ineptitude, forgetfulness, and sloth in relation to dizzying "smart" machines. All of these feelings remind the female user, again and again, that she may never be more than a transient visitor to the digital world. Morse points to new curatorial and artistic practices among women who challenge this predicament of unwill by working alternately with, through, and against technology. In "Girl TV," Mary Ellen Strom counters the conditions which alienate females from machines and self-determination, through a hands-on technology workshop for teenage girls using writing and video production as tools for girls to articulate their ideas and express their opinions about life. Video technology provides a means for self-reflection and self-representation, as Strom's still images and excerpted text from two of the girls' projects display.

Christine Tamblyn, in "Remote Control," states that cyberspace commits violence to language and bodies, perhaps even "ungendering" them. Tamblyn is interested in the limits and possibilities of disembodiment allowed by cyberspace and virtual worlds, and she sees the Internet as encouraging users' utopian fantasies about the possibility of "spinning out proliferating identities," which could be a potentially positive effect. But Tamblyn would like to move away from identity and the organic body as grounds for agency, using the dispersing and disembodying potential of cyberspace to outline an ethic for performative interventions that looks not "to identities as possessions or attributes of bodies, but to the relay of effects on and between bodies." Tamblyn's interactive CD-ROM project, "She Loves It, She Loves It Not," further explores ambivalence engendered by digital worlds, playing humorously on a range of issues related to women's vexed relationship with technology. Her theoretical and artistic work addresses the importance of feminist interventions in the scary new networks of cybertechnology.

"Hiatus," by Ericka Beckman, uses images from her experimental, narrative film of the same name to explore the possibilities of creating new identities in cyberspace. Hiatus is the name of a fictional, on-line computer game created by Beckman in which the female protagonist explores her own identity through the various habitats she has created in the world of the computer. Beckman pictures a near-future which questions the notion that technology can provide the means for empowerment, but imagines the possibilities of appropriating interactive CD-ROM technology to generate new narratives and futures. In her world, the young protagonist is in control of the various environments she makes, including those which look to pre-technological and Native American wisdom to structure these choices. Beckman's artist's pages reflect the on-screen character in her Hiatus persona.

Nina Wakeford, in "Networking Women and Grrrls," argues for an active appreciation of and involvement in the new forms of social and political connection that are offered by the World Wide Web. She notes that the media coverage of instances of sexual harassment of women on the Net and in chat rooms has served to underscore the restrictive stereotype of women as victims of male aggression, for whom cyberspace is characterized as an unsafe space. These stereotypes, Wakeford argues, overshadow the creative and politically astute uses to which women are putting information technologies to weave a web of support and connection among themselves across vast geographical and cultural differences. Although she agrees that it would be no exaggeration to say that the Internet and the Web are dominated by men, Wakeford points out that Web surfing for nerdgrrrls and geekgirls is a way to build community and take part in the creative opportunities of feminist and anti-racist self-representation and political opposition fashioned through a strategic use of information technology.

In "Romancing the System," Andrea Slane investigates the propensity of narrative film genres to map historically shifting relations between humans and computers onto heterosexual relationships. Considering Walter Lang's romantic comedy *Desk Set* (1957), Donald Cammell's reproductive horror flick, *Demon Seed* (1977), and Irwin Winkler's cyber-thriller, *The Net* (1995), Slane notes that the harmless, then ruthless, then combattable machines, comprise different points in a cultural imaginary grappling with the function of computers in the building and defense of democracy. By way of their narrative drive to reach historically variant reconciliations with heterosexuality (the marriage, the divorce forestalled, the balance of a single life resumed), each film presents a cautious endorsement of new technologies. Feminist projects like Shu Lea Cheang's cyberecology thriller, *Fresh Kill* (1993), by contrast, offer new ways of using technology not in the service of reconciling gender disparities via heterosexuality, but rather for imagining a more flexible range of relationships between people and technologies which could enable anti-racist, ecologically ethical, queer futures.

In "Taylor's Way," Sara Diamond situates emerging cybertechnologies in a longer history of the sexual division of labor, offering a skeptical and sobering critique of the commercial promotion of new intelligent machines as tools of democracy. Diamond argues that paternalistic management policies predating the cyberrevolution are embedded in the labor relations of today's information-based economy wherein women continue to be heavily supervised, de-skilled, isolated, and hassled by the machine-driven speed-ups built into the typical computerized clerical workstation. As machine attendants, women laborers in the information economy enjoy few of the privileges of democracy and freedom touted by the industry's promoters. Diamond considers this unsatisfactory state of affairs in relation to the possible appropriations of cybertechnology for feminist artistic production. While digital computing systems theoretically offer new horizons for artistic creation, women artists face problems of limited access to machines and technical training. Diamond's skepticism underscores the importance of changing the social relations which surround technology, rather than assuming technology itself will magically alleviate gender oppression.

BODIES

Bodies are sites of significant speculation about the limits and possibilities of technology, especially with the advent of new technologies of medical imaging and prosthetics, genetic sequencing and engineering, virtual reality, computer morphing, and "artificial" reproduction. Machines are radically transforming our understandings of the gendered body in domains as seemingly far flung as entertainment and

medicine. Contributions to this part of *Processed Lives* explore the metaphorical and literal uses to which new technologies of the body are put, contemplating questions of how they produce and reproduce dominant notions of gender.

Ira Livingston ponders the question of how we might rethink gender and technology in the postmodern present where machines and bodies are indiscrete: that is, mutually implicated and cross-implicating. In this scene, Livingston posits the notion that sexuality might be conceptualized as a matter of prosthetic embodiment. Using the figure of the dildo as a heuristic implement, Livingston enacts a queer deconstruction of homo-sexuality (sex with the same), suggesting that the imaginary world of plastic bodies and pliable machines may be a sexy horizon worth pursuing, especially for those interested in deconstructing the "nature" of gender differences.

The medical/technological dream of looking into the body at its most microscopic level is explored in Gregg Bordowitz's "Present Tense," an autobiographical meditation on illness and control, inspired by watching a colonoscopy performed on his body. The primal yet banal scene of witnessing his body become fragmented and his colon projected onto an adjacent TV monitor is the stage for an experience of memory and bodily displacement, where pain and control become alienated factors in the spectacle of seeing himself from a very close yet remote, machine-created location. This, Bordowitz says, is part of a process of witnessing his own body's history from the (deceptively) safe distance of television. Bordowitz's ambivalence about being reduced to "an asshole" through morally laden narratives and medical imaging technology denotes the potential of these technologies to deconstruct a kind of masculine embodiment under the specific historical circumstances marked by the AIDS epidemic.

Evelynn Hammonds explores the technological development of computer morphing whereby bodies can be disassembled and reassembled or blended to produce a composite and normalized image that, in effect, homogenizes the human race. Morphing, then, can be read as technologically assisted integration whereby all distinct features become interchangeable. Hammonds critically reads the popular media exuberance about this technology in the context of historical debates over the definition of race, highlighting the persistent desire to ground cultural difference in visible features of the body. But Hammonds notes that morphing attempts to separate race from the history of anti-miscegenationist thinking and racial oppression, as if these things could simply be eliminated through a series of key-strokes. Computer morphing provides the illusion that not only are physical forms easy to change, transport, replace, and appropriate, but so are identities and histories. This illusion of one fully integrated human race does violence to those whose histories and distinct characteristics are blended away.

Hammonds interrogates the sensational morphing of "SimEve," *Time* magazine's ideal citizen of twenty-first-century America, whose obvious gender but ambiguous race(s) make this morphed beauty the machine-made ideal object of desire for her nerdboy creators. Hammonds reads this cybercreation in a long history of Euro-masculine scientific desire, predating computer morphing by at least three centuries, which continues to be expressed through fascination and objectification of a constructed feminized Other.

Lisa Cartwright explores the ghoulish Visible Man project to be found on the National Institutes of Health's World Wide Web page, which features images of the minutely dissected tissues of executed murderer Joseph Paul Jernigan. Cartwright considers the changing definitions of masculinity, virility, criminality, and health that inform the state-sponsored death and medical resurrection-through-dissection of Jernigan. His case, Cartwright argues, is an instance of "the conjuncture of state and medical technologies of bodily regulation and control."

Several contributors to *Processed Lives* underscore the point that technological interventions into biological reproduction profoundly transform the ways in which we think about the body and the meanings we attribute to both gender and sexuality. As David Horn notes, reproduction has moved away from "nature" to become "artifice" in the province of science, through intensified technological efforts to enhance fertility, prevent pregnancy, and monitor literally every stage of the reproductive process. Horn critically approaches the multiple pleasures and dangers of replication and boundary transgression that are occasioned by technological interventions in reproduction, where categories of female and male, maternity and paternity, and nature and artifice are not only blurred but multiplied. Practices like egg harvesting, "artificial" insemination, and sonographic fetal monitoring modify and expand the players in the reproductive game to include not just "mothers" and "fathers," but also obstetricians, gynecologists, endocrinologists, geneticists, optical engineers, and sonogram technicians. When reproduction is cleaved off from sexual relations and the "normal" pregnancy is one which is profoundly technologically mediated and monitored, the terms of gender also undergo a significant change. However, as Horn argues, although technologically assisted reproduction recodes aspects of sexuality and gendered embodiment, it repeats hierarchical gender relations, as "nature" and the female body literally become sites for the exercise of a masculinist engineering of reproduction. To counter this hierarchical retrofitting is a struggle worth undertaking, Horn argues, involving a new kind of feminist pleasure in boundary transgression.

In "23 Questions," Kathy High contemplates the brave new world of genetic prediction as it interfaces with technologically mediated reproduction. In the technoscientific imaginary of First World scientists,

narcissistic fantasies of techno-self-reproduction give rise to designer cloning whereby bodies are fragmented and reduced to bits of engineered reproductive potential. Meanwhile, anxieties about the loss of human genetic diversity manifest themselves in an organized and legitimized form of "bio-piracy," whereby the genes of indigenous peoples are stolen and catalogued as resources for ensuring First World profit and survival. As High reads them, the promises and dreams of the human genome project and "predictive genetics" provide a new master(y) narrative which arrogates maternity and paternity to the profit-driven masters of scientifically managed reproduction. She concludes with a set of questions, corresponding to each of the twenty-three chromosomes of the human body, which probe the moral, economic, and political motivations and consequences of the marketed dream of genetic and reproductive mastery and control.

Bonita Makuch brings together the voices of individuals whose lives are significantly affected by the technological possibilities offered by "artificial" insemination, including an infertile patient, a pig farmer, and a reproductive pathologist. Taken from a video installation by the same name, "Inseminations" juxtaposes these often troubled voices with quotidian objects and scenes: turkey basters litter the kitchen floor of the family farm in a scene that blurs the boundaries between high and low technology, and animal and human reproductive engineering. Ordinary necessities of farm life and extraordinary "miracles" of human fertility enhancement center around the "main dish," a window into the microscopic world of technologically mediated fertilization.

Clearly there are both dangers and positive possibilities posed by many technologies, and this is particularly highlighted in new reproductive technologies, including contraceptive devices. What in one context may be a tool enhancing greater choice and self-determination for women, might, in another context, be a means for coercive population control and women's oppression. Soheir Morsy analyzes the invention of a new anti-fertility vaccine in Europe and North America as it is marketed in the Third World. Morsy argues that this anti-fertility vaccine is being developed by First World technocrats who see "overpopulation," rather than inequities resulting from industrialization, as the cause of economic and social problems in the Third World. Far from being the "miracles" they are touted to be, new contraceptive technologies, developed in the North and tested on women in the Southern hemisphere, target Third World women's bodies as sites for risky scientific experimentation and imperialist domination through technology.

Joyan Saunders and Liss Platt present a spoof on technoscience and gender in "Brains on Toast," noting the inexact nature of scientific efforts to determine what distinguishes males from females. In their

video work, Saunders and Platt explore the ironies and dark humor embedded in technological projects of "sex reassignment" that reveal that masculinity and femininity are far from natural or stable categories, but instead are matters of intense and ongoing social and technological engineering.

HOME

In the 1957 B-movie classic, *The Incredible Shrinking Man*, Scott Carey (Grant Williams) encounters a mysterious radioactive mist on a boating trip with his wife and soon finds his life taking a bizarre and frightening twist. When they return home, his loving mate, who was spared the radiation effects as she dutifully made him lunch in the boat's hull, tries to console and accommodate him as he gradually shrinks down to an infinitesimal two inches. After an interim makeshift existence in a doll's house, Carey suddenly finds that ordinary household situations loom over him with deadly intensity. He is chased into a dirty clothes hamper by the household cat, and suffers the dreadful consequences of being tossed down an enormous laundry chute and banished forever to the basement by his unwitting, now-gargantuan wife. The deafening sounds of a spinning washing machine and the pleading but unanswerable beckonings of his wife plague Carey's existence. The home environment becomes vast and dangerous and Carey must retrofit his wife's sewing needles to fend off the predations of the cat and a menacing cellar spider. In this Cold War anxiety tale, the threat of nuclear war comes home to roost in a drama of castration and emasculation, wherein bravery, self-sufficiency, and primitive technical ingenuity provide Carey's only means for survival. The home literally becomes female-dominated, and its simple routines and appliances become terrifying and lethal. This allegory of an inverted world, a world turned not upside down but literally backward in time, inscribes the home as a feminine space of whirring appliances, noisy vacuum cleaners, and trivial but menacing housewifely obsessions.

The home as a site of gender anxiety is the focus of the final part of *Processed Lives* which explores appliances, entertainment gadgetry, and security devices that furnish the idealized middle-class abode. In the home, gender is encoded and structured through common, everyday routines and domestic objects. In "Techno-Homo," Judith Halberstam analyzes the gendered nature of bathrooms as "a domestic space beyond the home proper which comes to represent domestic order, or a parody of it, in the outside world." Noting that "women's rooms" function as a site of gender conformity (i.e. nose powdering), while "men's rooms" are an extension of the public nature of masculinity (i.e. sexual free-zones), Halberstam maps the "crumbling edifice" of gender through her own anecdotes of being mistaken for a man in the

"gender factory" of the female rest room. Reading the radical potential of female masculinity through the performances of drag kings and queer futuristic film narratives, Halberstam concludes by calling for the emergence of "radically different bodies and sexualities" than those presently afforded by the domesticated, binary system of male/female.

Toys are a common feature in the gendered world of the home, a point emphasized in the Barbie Liberation Organization's underground campaign to switch the voice boxes of hundreds of Barbies and G.I. Joes in toy stores across the US just in time for the 1994 Christmas shopping rush. Through elaborate "sex change" operations, G.I. Joe was made to utter banalities such as "Let's go shopping!" while Barbie growls "Dead men take no prisoners!" The BLO "sex change" campaign revealed the absurdity of overdetermined gender difference while "liberating" Barbies to shed trivialities by speaking serious (i.e. unlady-like) fighting words. Generously, the BLO offers suggestions on how to perform such operations in your own home.

The paradoxical character of the home as both site of security and site of vulnerability is explored in Connie Samaras' critical meditation on gender, race, and class in UFO abduction experiences in late twentieth-century America. Acting as the "corrector," Samaras deconstructs representations of Earth culture sent out to extraterrestrials by the United States in the 1977 Voyager interstellar space probes, where any vestiges of movements for social change and any accounts of human diversity and conflict were erased. The corrector's archive, by contrast, addresses the cultural anxieties produced by fear and the inevitability of psychological and social change, encoded and embedded within UFO abduction tales. The tales of abductees, who are overwhelmingly women, feature the home as a site of abduction, with abductees being preyed upon in bed late at night or taken out through the window. Samaras considers their accounts in historical terms as metaphorical narratives of normal everyday people suffering great anguish, silence, and stress over having no control over repeated violations of their psyches and bodies, exacerbated during times of extraordinary social upheaval. Importantly, the home, for these abductees, is no longer a secure fortress; yet, it paradoxically engenders the attendant malady of agoraphobia whereby staying put is not so much a choice as an affliction. In the male appropriations of such tales, Samaras finds a reactionary tendency to disregard the material and historical conditions that give rise to horrific testimonies of technologically enabled kidnapping, rape, and bodily mutilation. These selective appropriations, Samaras suggests, trap female abductees simultaneously in domestic and extraterrestrial horror, victimizing them through extraordinary events in ordinary life situations.

Andrea Slane, in "Vulnerabilities," highlights the inversions of security and domesticity around the dynamics of desire, danger, intimacy,

and self-defense. Through the counterposed desires and (in)security concerns of two female friends, Slane contrasts their strategies for achieving sexual intimacy and self-protection. While the character Andrea won't let strangers in her house, Kim is drawn to hapless strangers who come to her door. Andrea's affections are not at home, but across vast and dangerous emotional and geographical distances. Quoting truisms drawn from 1970s' feminist self-defense discourse, Slane signals the disparity between low-tech and medium-tech means of protection (e.g. the rat-tail comb, the dead-bolt lock, the purse-sized handgun, the carefully guarded telephone behavior), and the realities of danger posed by a world in which violence and desire are commonly superimposed.

In "The Party Line," B. Ruby Rich explores the vast proliferation of systems for remote communication that dissolve the division between private and public spheres. Rich describes how her life has been profoundly transformed by laptops, fax/modems, email, and World Wide Internet links, blurring the boundaries between home life and work life. These technologies are woven deeply into her life, providing necessary pleasures and vital social connections. The home, then, is no longer necessarily a place of isolation or privacy. Rich expresses a sense of ambivalence, not so much about the pleasures and transformations technologies launch, but about the fact that computers remain in the control of the ruling classes. In spite of the industry hype that computers are the ultimate tool of democracy, they actually reflect and reproduce profound social inequality. Rich speculates about what networked communication technologies could do to remedy the problems of isolation in the "home," including, for example, providing the means for women to intervene and rescue one another in instances of domestic violence. With mixed feelings, Rich calls for women's engagement in making computers accessible, and in strategically adapting them to combat everyday acts of sexist oppression.

Finally, artist Julia Scher puts a playful sinister spin on the commercial presentation of promises of security, convenience, and pleasure offered by information technology. Surveillance and seduction are her themes in "Information America," where Scher parodies, in brochure form, the relationship between consumerism, desire, paranoia, and the home. The comforts and safety of home are invoked, programmed into technological systems, and externalized to the world of corporate security. In the same move, the home is penetrated and invaded by state-of-the-art, gentle, pleasing, vitamin-rich surveillance. Mom has been transferred from home to the ethereal world of corporate security where her disembodied voice soothes the eternally paranoid over a public address system; in the meantime, at home, she has been replaced by a host of disembodied domestic security checks.

We now cordially invite and challenge readers to explore *Processed*

Lives as its contributors negotiate the dynamics of gender in the strange and dense territory of ambivalence, situated between idealistic technophilia and leery technophobia.

REFERENCES

Adas, Michael. 1989. *Machines as Measures of Men: Science, Technology and Ideologies of Western Dominance*. Ithaca, New York: Cornell University Press.

Aronowitz, Stanley. 1994. "Technology and the Future of Work," in Gretchen Bender and Timothy Druckrey (eds) *Culture on the Brink: Ideologies of Technology*. Seattle, WASH: Bay Press.

Balabanian, Norman. 1980. "Presumed Neutrality of Technology", *Society* 17(3) March/April 1980: 7–14.

Bender, Gretchen and Druckrey, Timothy (eds). 1994. *Culture on the Brink: Ideologies of Technology*. Seattle: Bay Press.

Bernal, Martin. 1987. *Black Athena: The Afroasiatic Roots of Classical Civilization*. New Brunswick, NJ: Rutgers University Press.

Brooks, Harvey. 1983. "The Technology of Zero Growth," *Daedalus* Fall 1983: 139.

Cohn, Carol. 1987. "Sex and Death in the Rational World of Defense Intellectuals," *Signs* 12(4): 687–718.

Corea, Gena, 1985. *Man-Made Women: How New Reproductive Technologies Affect Women*. London: Hutchinson.

Cowan, Ruth Schwartz. 1983. *More Work for Mother: The Ironies of Household Technology from the Open Hearth to the Microwave*. New York: Basic Books.

de Lauretis, Teresa. 1987. "The Technology of Gender," in *Technologies of Gender: Essays on Theory, Film, and Fiction*. Bloomington, IND: Indiana University Press, pp.1–30.

Foucault, Michel. 1979. "Governmentality," *Ideology and Consciousness* 6: 5–21.

Foucault, Michel. 1980. *The History of Sexuality, Volume I: An Introduction*, trans. Robert Hurley. New York: Vintage Books.

Haraway, Donna. 1991. "A Manifesto for Cyborgs: Science, Technology and Socialist-Feminism in the Late Twentieth Century," in *Simians, Cyborgs and Women*. London: Routledge, pp.149–81.

Latour, Bruno. 1987. *Science in Action: How To Follow Scientists and Engineers Through Society*. Cambridge, MA: Harvard University Press.

Lyotard, Jean-François. 1984. *The Post-Modern Condition: A Report on Knowledge*. Minneapolis, MINN: University of Minnesota Press.

Merchant, Carolyn. 1980. *The Death of Nature: Women, Ecology, and the Scientific Revolution*. San Francisco: Harper and Row.

Ong, Aihwa. 1990. "Japanese Factories, Malay Workers: Class and Sexual Metaphors in West Malaysia," in Jane Monnig Atkinson and Shelly Errington (eds) *Power and Difference: Gender in Island Southeast Asia*. Palo Alto, CA: Stanford University Press, pp.385–422.

Penley, Constance and Ross, Andrew (eds). 1991. *Technoculture*. Minneapolis, MINN: University of Minnesota Press.

Sachs, Wolfgang (ed.). 1992. *The Development Dictionary*. London: Zed Books Ltd.

Stanley, Autumn. 1983. "From Africa to America: Black Women Inventors," in Jan Zimmerman (ed.) *The Technological Woman: Interfacing with Tomorrow*. New York: Praeger Publishers, pp.55–64.

Strasser, Susan. 1982. *Never Done: A History of American Housework*. New York: Pantheon Books.

Winner, Langdon. 1977. *Autonomous Technology: Technics Out-of-Control as a Theme in Political Thought*. Cambridge, MA: MIT Press.

Zihlman, Adrienne. 1985. "Gathering Stories for Hunting Human Nature," *Feminist Studies* 11(2): 365–77.

Zimmerman, Jan. 1986. *Once Upon the Future: A Woman's Guide to Tomorrow's Technology*. London: Pandora Press.

part one

Digital Worlds

1

Virtually Female: body and code

Margaret Morse

INTRODUCTION: NEW WORLDS AND TIRED OLD CODES

Gender in, gender into, the gender of cyberspace – these are areas of some anxiety for women, considering the period in which we live. A major technologically driven, global reorganization of work and of the infrastructure is underway. What was once and largely still is a male-oriented domain of technology and the computer has generated a virtual realm, aka cyberspace, in which socio-economic activity and communications increasingly take place. Considering the actual distribution of practical and theoretical knowledge about science and technology by gender, it is no wonder that androcentric values dominate electronic culture. What will become of us as women and our limited successes in real space once the domains in which we have made our mark are dematerialized and put on the Net or in the Web? Is cyberspace genderless? When females are virtual, is feminism moot?

Information is the naked instrumentality of cyberspace, a commodity language stripped of its relation to a social and historical context and to the subjects who enunciate it. One might imagine a blank slate, unmarked and unconstrained by appearances on which to inscribe fresh aspirations. However, cyberspace is more like Freud's metaphor of the mystic writing pad: lift the sticky plastic page off the surface and all the delicate over-writing of the last quarter-century is whisked away. On the other hand, put the page back down on the sticky matrix and the lines of the "frontier" and "colonization" engraved deeply long ago map themselves unapologetically onto new cyberskin.[1] In a vacuum freed of mediating traditions and the ameliorating accretions of culture, old myths about technology and gender prevail: technology is posed against "the human body – comparatively unadaptable, vulnerable, mortal – that is felt to be the ultimate obstacle to the perfection of the machine environment."[2] Cynthia Cockburn notes in "The Circuit of Technology: Gender, Identity and Power," that the masculine identification of and with technology has survived the muscular period of the "heroic age of mechanization," and appropriated information technology, and one might add, fine motor movements for itself. Western femininity and its "constitution of identities organized around technological incompetence" have apparently survived fairly intact into the present as well.[3]

In contrast, in "Mysteries of the Bioapparatus," Nell Tenhaaf offers the provocative notion that cyberspace represents the femininization of the symbolic system.[4] If this is an invitation to join in a discursive struggle to define cyberspace, I gladly accept. My recent writing, "What Do Cyborgs Eat?" sought to debunk these disempowering assumptions, proposing the vision of a technology that is abject and mortal.[5] However, define cyberspace as I will, fashioning an inclusive and compassionate electronic culture out of the raw stuff of bits and bytes

demands more than critique or what amounts to symbolically turning the table on masculine prerogatives. Even though we may have difficulty in setting the clock on our VCRs, the times demand that we re-engage information with our own values, in a practice that challenges emerging rules of ownership and exchange that exclude so many of us. However, when it comes to "hands-on" technology, why is volitional action or what amounts to willing myself into technological competence so much easier said than done?

WILLING AND UNWILLING BODIES

The first challenge to shaping and taming this emerging world is the will itself and the human problem of unwill, especially in relation to femininity. I want to first discuss the somewhat embarrassing problem of technological ineptitude (not to be confused with technophobia) as it afflicts me and perhaps other klutzy women deeply involved in a critique of technological discourse to be accomplished by means of and even in the very medium we critique (yes, a double-bind).

Consider that my imperfect feminine identity, a construction of codes by trial and error, has been more virtual than unconscious or biologically determined all along. Beauty culture – the femininity you can buy – never provided enough coverage: I never felt feminine enough. Furthermore, since I've never been sure what it means to be a woman, I've had to rely on other people to tell me, "you can't do that." For example, after reading the literature distributed at a junior high career day in 1957, I decided to become a dentist. The reaction I received led me to the conclusion that femininity didn't include dentistry. The larger problem was that, in essence, none of the literature there was actually addressed to me.

At about that age, math phobia and technical ineptitude are culturally implanted in numerous American female adolescents. I think of the implant as a painful internal prosthesis, a glass ceiling within that subconsciously restricts the body from entering paths of desire that are tacitly forbidden. Of course, there are exceptions, women who are mechanics, experts in high mathematics and artists quite at home with machines of all kinds. Further, the "femininity" in question is culturally circumscribed: it is Western and probably heterosexual, as well as racially inflected with "whiteness" and by ethnic assumptions about whose job it is to mediate between the family and the world. My travels in Eastern Europe before the end of the Cold War revealed women as crane operators, mathematicians and engineers untransformed by beauty culture: these women questioned a lot of things, but never their femininity. In spite of recognizing and experiencing all this relativity, and try as I will, I remain divided, will against unwill, in awkward attempts toward technological competence in spite of something

foreign in myself (that is, my specific kind of femininity implant) that deflects me from my resolute path.

Michel Foucault viewed power as the "infinitesimal mechanisms" that operate on the body of the individual, deploying subjectivity in this way and not that.[6] Then, will and unwill might be thought of as the internalized experiences of the minute and trivial that produce or don't produce *homo faber*. When it comes to my body in technological performances, unwill enters the page from the matrix below, like faulty instructions or an old program that has never been erased, causing slip-ups and occasional crashes. Unwill or the part of us that slips or forgets is also the part of us that is slothful, that loses motivation or a sense of purpose, *in nuce*, that resistance of the flesh to being harnessed or programmed by this or that ideology. Unwill is thus a hazy mixture of vegetative corporeality and an ineptitude that amounts to culturally inscribed hysteria. As a woman in a male-oriented technological world that devalues the flesh, my struggle is thus against myself embodied as a woman – albeit a culturally constructed one. My unwill is then to some extent or other my femininity and my female flesh itself. Such unwill is not amenable to talking cures; even once instructions are recognized and lifted off the page, deep gouges in the matrix remain. How then do I get my disciplined and punished body to co-operate with my feminist (as opposed to feminine) ideals?

Recently I braved the throngs of screaming kids at the San Francisco Exploratorium to try out an intermix of Web sites and installations. At a computer terminal linked to a virtual city, I got caught in an endless loop. Suddenly I noticed a little hand under mine, clicking the mouse. Someone was tucked onto my seat and giving me little pushes. Luckily for my self-esteem, the program wasn't working and the little guy now in charge of the computer was caught in a loop too. Yet, it was clear that something about our culture says to him, this is your place: claim it.

There have been few moments when I have felt this invitation to be addressed to me. One such epiphany, as ridiculous as it might seem, was viewing the opening screen of Christine Tamblyn's CD-ROM, *Mistaken Identities* (1995), namely, an image digitized from a woman's nightgown. The pink screen with tiny rosebuds on the monitor transformed the slick beige machine into something excessively feminine. I was surprised at my own reaction; I let out a deep breath and felt released and at ease.[7]

GENDER IN CYBERSPACE

What is cyberspace? My operating premise is that virtual communities and/or environments such as may be found on the Internet or in particular computer-supported worlds allow us to enter and move around

inside in what amounts to our own symbolic system. In a three-dimensional pictorial and/or aural virtual world one is literally, albeit virtually, inside the visualization of a symbolic field; in language-generated worlds, this "insidedness" must be understood more figuratively. In either case, the point of view from inside can be revelatory.

Take, for instance, gender identity in a text-based virtual realm on-line such as an MUD or multi-user dungeon. Unlike situations determined by one's biological gender assignment and physical appearance, it is possible to become a member of any sex or species and to change oneself at will, creating personas and "rooms" which can express themselves to others. Such mutability would tend to underline the arbitrariness of gender and reveal its symbolic as opposed to its biological function. Oddly enough, however, judging from the experiences of my students in surfing the Net, virtual worlds do not necessarily or even commonly reveal interactions that transcend gender or cross culture. "Virtual females" told me how often they were hit upon (confronted in a sexually charged manner with demands or expectations to put out or perform sexually, albeit virtually). Why? Because the values encoded in the symbolic system prevail in the minds of the users. In physical reality, it's not so easy to become He-Man or Barbie, character dolls that are the crystallization of notions of masculinity and femininity; however, in a virtual world, stereotypical ideas about gender and sexuality can be simply brought to bear without the inevitable contingencies and imperfections that plague the act of physically embodying a gender identity. (Here the role of the body in moderating or impeding technology can be seen in a more positive light.) Even when male users are capable of successfully posing as women in virtual communities, a kind of gender polarization rather than a transcendence of gender takes place. Such interactions are caught with a vengeance in the very same dualisms that structure our language and relations to material reality, wasting the potential for insight that virtual play with symbolic forms could give us as a culture.

THE GENDER OF CYBERSPACE

Some speculate that, like technology, cyberspace itself – what I think of as an externalization of symbolic code – is masculine.[8] Such a perspective seems to be from outside and to emphasize control of the virtual environment. Others, including cultural theorists who share a Kleinian psychoanalytic framework, think of it as feminine (especially, when considering the inside, an area enveloped like a fetus in a woman's body). Then, perhaps cyberspace is hermaphroditic, divided by gender inside and outside. The interiority of cyberspace, like the interior of a cave, is like being enclosed inside the womb. Furthermore, the interfaces of cybernetic space have been imagined as a seductive and

dangerous garment. The fantasy of putting on such a second, virtual skin is said to express a longing "to become woman."[9] Perhaps this desire to put on the other (from a male point of view) explains the commonplace of men's fiction as female personas on the Net. Furthermore, its gender might depend on what it means to put on the other. My own experience of putting on the interface of virtual reality – the gloves and the head-mounted display – was like putting on a technological empowerment which, like the freedom of flight, allowed me to enter a masculine world otherwise foreclosed to me, even in my dreams. I was both psychically outside and in control and deliciously inside careening around in its illusory depths.[10]

However, this play with gender tends to be predictable, depending as it does on stereotypical notions of sexual identity. For instance, Sarah Kozol, a dancer who participated in Paul Sermon's *Telematic Dreaming* (1992 and 1994), a piece which electronically united two distant beds into one on screen, stressed how often the behavior of her bedpartners was part of well-worn scenarios connected with the bed as a symbolic space. Poetic innovation did take place, albeit rarely, and Kozol apparently revelled in the expansion and contraction of her body boundaries as she identified with the body in the screen image. The virtual body was composed of her own physical body partially hidden by a blue-screen sheet and electronically mixed with one or more physically distant participants into one monstrous combination that was none the less *her* body. Experiencing a vicious attack on her virtual body underlined the way in which virtual and material bodies were intertwined.[11] Thus, the assumption that the virtual is a separate realm of free play without actual consequences is misguided.

In my own experience, the virtual and the material are intertwined and superimposed on every aspect of cyberspace. In a recent talk, I described how I experienced an asthmatic panic much like I might under water while immersed in the multi-dimensional worlds of Char Davies, *Osmose* (1995). Unfortunately for me, the metaphor for the interface of the piece was one of diving under water; breathing in allowed one to ascend, breathing out to descend. One of the worlds consisted of machine code that scrolled upward relentlessly as I tried fruitlessly to escape it; other worlds were "under water." While I remained fully aware of the absurdity of the situation, I was having trouble breathing none the less. My unwill could be recognized but not negotiated; while this unwill has part of its roots in internalized, arbitrary, now even historical gender codes, it is also imbricated somatically with the body itself with needs other than ideological. Even the ability to breathe has psychic as well as avular components.

ACCESS: GENDER INTO CYBERSPACE

However willing or unwilling, the fundamental question before women is one of praxis: What is the contemporary situation for volitional action and intervention? I believe that the times are unusually propitious for speech-acts or performatives that constitute new realities, actual and virtual. On one hand, emerging notions and interpretations of reality are still quite soft, not yet hardened into their own rules of what kinds of statements can be made and who can make them. On the other, common sense has been undermined by implausible technological feats. This window of opportunity for volitional action is especially furthered by the spontaneous growth of a virtual public sphere on the Internet. However, access to this sphere is technologically circumscribed – you need to have knowledge and equipment to get in – and now that sphere itself is economically and legislatively threatened. In the meantime, social policy discourses have taken a hostile turn, sidetracked into making the beneficiaries of the safety net, from welfare mothers to school lunch programs, into the scapegoats for the deficiencies and failures of our society *per se*. Issues of civil rights and social justice for minorities and women in an information society have been deflected into a debate about affirmative action. Drifting amidst uncertainties, it seems that when we lost our enemy, "communism," internal others took on new importance, bearing the burden and the blame for vast socio-cultural changes and a restructuring of the nature of work.

Lack of access to the technology of information society threatens to screen out vast parts of the world population behind a curtain of silicon, producing socio-economic disparities that are even more acute. After all, a network is defined as much by its holes or what it leaves out as by its links. To be left out is not merely privation – to some, freedom from constant technological innovation would be a welcome condition – but rather, to become part of a shadow world influenced by but having little influence on the flow of value and the exercise of power.

I recently spoke idealistically on the need to think of the holes in the net in relation to art:

Art should not be ghettoized into the electronic and/or virtual environment versus the rest, but thought of as linked by metaphors across different degrees of materiality. That also means that an artist in Russia or Africa could participate beyond her or his material and technological means in what must be made a truly global dialogue with local positions. Then, for me, cyberspace is the manifestation of what some call the data sphere in perceptible – and that means largely metaphoric – forms. Relations to cyberspace as nightmare and/or utopia are understandably related to one's position in this economy and the mode of access to it, if any – the data entry worker is different from the programmer, the

cultural entitlement of a little girl to cyberplay is not the same as a little
boy's. The subsistence farmer's life, if not status, could not be more differ-
ent than the fast food worker's, but they will be nonetheless ultimately
related in a global system of integration and exclusion, like the strands
and negative space of a net.[12]

So, when I was invited to compose a workshop panel for the
International Symposium of Electronic Arts or ISEA 1995, convening in
Helsinki, I tried to think of a productive way to follow my own pre-
scription and produce a range of responses to a unifying metaphor, the
cave. I was particularly keen to include a Hungarian-Romanian artist
from Transylvania, Alexandru Antik, or as I later discovered, Sandor
Antik, after seeing the cave-like *Imagination Held Prisoner/Prisoner of
the Imagination* at the first exhibition of electronic art in Bucharest in
1993.[13] His installation was a dark room, littered with the empty boxes
in which film projectors that served now defunct provincial cinemas
were once housed. Flickering light, the projections of the slides of dead
embryos and the video buzz of a trapped fly suggested a psychically
devastated world in which the imagination had been nearly extin-
guished. Antik and the other participants in the exhibition had been
given access and instruction in video for this occasion, though it was
not clear how or if such access would continue beyond the show. For
the Cave Panel, I matched Antik's presentation of a ritual that he had
performed in a cellar in Cluj, with Jeffrey Shaw's EVE, an extremely
high-tech apparatus for displaying virtual images.[14] Fran Dyson
described the philosophy of the sound cave, while I introduced a wide
range of recent pieces of electronic art on themes ranging from the
prehistoric era and the cave of Hebron to virtual reality. Disparate
themes and technologies resonated lyrically together in these evocative
presentations. The limitations and infelicities of my plan only became
clear to me later. Paradoxically, my strategy of inclusion had isolated
the representative of the art and cave without technology, Antik, into a
singular and exceptional position in a technologically rich gathering
with which he had no language in common. Had I applied my own
knowledge of what it feels like to be a woman in a male-oriented
domain, I might have realized that the real problem in curation is not as
I had framed it, in any one event, but in the creation of a domain.

 That wasn't all: a woman in the audience for the panel asked, Why
haven't you talked about the cave in relation to the female body? I
suddenly realized I had left out a rich range of associations that
included goddess worship and fertility figures in an unthinking act of
self-censorship. I admitted in response that I was afraid, though I didn't
realize at the time that it was a fear of being accused of falling into
biological essentialism.[15] Accepting the idea that "woman" is a cultur-
ally constructed category had evidently entailed corollaries in my mind

that were far more questionable. They included an unresolved relation to the will – in line with the notion that "we are spoken" – and, sorriest of all, a difficulty or inner reserve about addressing and celebrating acts performed by women that change lives. In other words, I had confused the level of my post-structuralist convictions about the culturally constructedness of femininity with the actuality of women as subjects and agents, engendering worlds.

There are numerous organizations that promote female-oriented domains in cyberspace – WIM (Women in Multi-media), Women's Wire and WIT (Women in Technology) – and I have had contact with a few. However, there is a little known category of activist women in the arts about whom I have longed to write. I have come into contact with women curators in the last decade who do indeed generate domains that make the appearance of technologically-based art possible under the most unpromising of conditions. Their work often involves considerable personal sacrifice and seems to be sustained by a belief that the redeeming power of artistic expression should be made available to those who are excluded from the mainstream of information society. Their labors have a limited visibility, since they are collaborative and especially when there is no ongoing institutional relationship to support them. The common denominator of all of these women is that they did not occupy a niche or serve a pre-existing group, but crossed cultural boundaries and oppositions to create new domains that include technological have-nots. Their work has a feminine flavor – a cave building and garment fashioning that envelops or wraps a domain of technology and artistic creation. Among these practitioners I would include:

- Keiko Sei, who worked as a conduit to distribute camcorder work during the revolutions in Eastern Europe, by posing as a Japanese tourist. She was a co-convener of a symposium of artists and cultural workers on the Romanian Revolution held in Budapest in 1990 and assisted the artists in the media art show in Bucharest. She regularly works behind the scenes on media art projects in Eastern Europe and chooses to live in cities at the periphery of electronic culture that start with "B."

- Suzanne Meszoly, Director of the Soros Foundation for Contemporary Art in Budapest (and co-convener of the symposium on the Romanian Revolution), was active in establishing Soros Art Centers throughout the emerging countries of Eastern Europe. She has curated two major shows of media installations in Budapest, including "The Butterfly Effect" (1996).

- Kathy Rae Huffman is an American freelance media art curator and on-line networker and currently a member of HILUS intermediale project research group, Vienna. She frequently collaborates with Ars

Electronica, Linz, the Internationale Stadt Berlin, and the Soros Centers for Contemporary Art Network. With Eva Wohlgemuth, Huffman created SIBERIAN DEAL, a real/virtual on-line journey in Siberia, in the fall of 1995 (http://www.t0.or.at/~Siberian). Huffman's prior history in media art was institutional (producer/ curator of The CAT Fund, an artists' production project for WGBH TV, Boston, curator of media and performing arts at The ICA Boston and at Long Beach Museum) in a way that seems less supportable in the current climate of American culture. Her existence freelancing on the leading edge of technological art is a rewarding if precarious solution to domain creation.

- Ann Bray is Director of Los Angeles Freewaves, an annual event organized around what Bray and her twenty or so collaborators and curators think is what Los Angeles needs most at this time – from the period of the LA Rebellion to the present situation where survival of the arts is the problem among devastated art venues and supports. In many instances, LA Freewaves events are the first time a community has seen itself represented at all in any public forum. In the current even more reduced circumstances for the arts, the festival uses libraries and other existing venues as a means of organizing access to and exhibiting media art.

I would also include women who have links to the corporate world, considering that the very condition of possibility of some technological art forms may depend on not being free of commercial contexts.

- Machiko Kusahara was a pioneer in the production and criticism of computer imaging and animation in Japan (she has published a ten video-disk history of computer animation.) She has curated major shows supported by corporations in Japan beginning with the 1985 SIGGRAPH traveling art show shown at Sendai in 1986, in co-operation with an advertising company. (In Japan, most of the big exhibitions, except those organized by museums and special exhibitions like ARTEC, are organized and managed by advertising companies, Dentsu in particular.) She has worked on many exhibitions since, including a collaborative effort, Digital Image in 1990. Kusahara explained that one method she has used when seriously negotiating with a sponsor was to reveal her background in science. If that didn't work, she would add that she had studied mathematics (like, 'by the way . . .'). "I learned from experience that many men have an inferiority complex about their ability in mathematics. Maybe they won't fall in love with a woman who studied math (I don't care!) but at least they feel some respect or fear."
- Lisa Goldman established the Interactive Media Festival of commercial, artistic and hybrid work with corporate underwriting. The

second event in 1995 included a number of pieces on artificial life that caused me to rethink my first resistances to the very idea (or, as George Lakoff explains, metaphor.)[16] This cross-cultural venue (of art, commerce and technology) allowed me to appreciate the very idea of "interactivity" as a domain.

My admiration of women in adventures of art and technology is less for their adventures than for their practice and what I and others can learn from it. Just so, my own stories of awkwardness and of self-inflicted limits in praxis are also stories of self-discovery. However discouraging the snafus or exhilarating the successes, it is in setting precepts and ideals into praxis that I am able to shed those tired old codes, creating whatever it will mean, in my case at least, to be a woman.

NOTES

1 For a critique of the "frontier" metaphor see Laura Miller's "Women and Children First: Gender and the Settling of the Electronic Frontier," in James Brook and Iain A. Boal (eds) *Resisting the Virtual Life: The Culture and Politics of Information* (San Francisco: City Lights, 1995), pp.49–57.

2 As a result, "the human subject can only feel a sense of belittlement, incompleteness, lack" or "Promethean shame." Christopher Philips has unearthed Günther Anders' ["Other," born Stern] speculation that the desire to escape mortality and the flesh is behind the phenomenon of celebrity; in the reduction to a serially reproducible image, the celebrity becomes a relatively immortal machine. "Desiring Machines: Notes on Commodity, Celebrity, and Death in the Early Work of Andy Warhol," in *Public Information: Desire, Disaster, Document* (New York: Distributed Art Publishers and San Francisco Museum of Modern Art, 1994), pp.39–47, citing and commenting on Günther Anders', *Die Antiquiertheit des Menschen: über die Schicksal der Seele in den zweiten industriellen Zeitalter* (Munich: H. Beck, 1956). Similar speculation abounds that the posthuman fantasy of having one's brain patterns downloaded and digitally preserved is "cyborg envy" (Allucquere Roseanne Stone) that may also be seen as a far from postgender "womb envy," that is, the power to give birth, in this case, to oneself as machine.

3 In Roger Silverstone and Eric Hirsch (eds) *Consuming Technologies: Media and Information in Domestic Spaces* (London and New York: Routledge, 1992), p.41.

4 In Mary Anne Moser and Douglas MacLeod (eds) *Immersed in Technology: Art and Virtual Environments* (Cambridge, MA: MIT, 1996), pp.51–71. What might be problematic in Tenhaaf's proposal is an assumption that immersion presumes a psychic state without much in the way of distance provided by disavowal or a fiction effect. She may be proposing a state much like the over- and under-identification associated with women in feminist approaches to film and television by Mary Anne Doane and Tania Modleski, for example. However, I have questioned the idea of immersion in cyberspace as a more total surrender to the fiction effect in a talk given at the Tate Gallery London in May 1995, to be published in a CD-ROM of the Symposium on Virtual Reality as a Fine Arts Medium; I also stressed that virtuality is not the same as fictionality.

5 "What Do Cyborgs Eat? Oral Logic in an Information Society" in Gretchen Bender and Timothy Druckrey (eds) *Culture on the Brink: Ideologies of Technology* (Seattle: Bay Press, 1994), pp.157–89, 198–204, describes various imaginary ways of becoming machine-like or cyborg via introjection of smart drugs, electronic second skins or abandoning the flesh entirely by downloading human brain patterns into a computer. I, in turn, valorize the messy strategies of turning machine into flesh and question the omniscience and immortality not to mention intelligence that is projected onto machines. This line of thought found further expression as "Artificial Stupidity," a talk delivered at the International Symposium of Electronic Art in Montreal 1995, in which I question human–machine relations as the contact of the mortal and the divine.

6 See Cockburn's application of Foucault, in "The Circuit of Technology: Gender, Identity and Power" in Roger Silverstone and Eric Hirsch (eds) *Consuming Technologies* op. cit., p.44.

7 Looking to the next generation, Marsha Kinder, the author of *Playing with Power in Movies, Television and Video Games: From Muppet Babies to Teenage Mutant Ninja Turtles* (Berkeley: University of California Press, 1991), a book which explains how little boys are acculturated by video games, is producing an electronic game designed to attract little girls, as well as to play with concepts of gender.

8 Andreas Huyssen explained why mass culture, technology itself and machines are gendered female in his *After the Great Divide: Modernism, Mass Culture, Postmodernism* (Bloomington: Indiana University Press, 1986). For a male cyberspace, see Rob Milthorp's "Fascination, Masculinity and Cyberspace" in *Immersed in Technology*, pp.129–50. Gillian Skirrow's "Hellivision" draws explicitly on Klein to describe a male and a female relation to the game world as inside the mother's body.

9 Allucquere Roseanne Stone, "Will the Real Body Please Stand Up?: Boundary Stories About Virtual Cultures" in Michael Benedikt (ed.) *Cyberspace: First Steps* (Cambridge, MA: MIT Press, 1991), cited and commented on in Alberto Moreiras, "Hacking a Private Site in Cyberspace" in Verena Andermatt Conley and the Miami Theory Collective (eds) *Rethinking Technologies* (Minneapolis: University of Minnesota Press, 1993), p.108ff.

10 Further described in "Enthralling Spaces: The Aesthetics of Virtual Environments," in the catalogue of ISEA 1994, pp.83–9.

11 Susan Kozol, "Spacemaking: Experiences of a Virtual Body" *Dance Theater Journal*, Summer 1994, pp.12–13, 31, 46–7. For another description of a violation of the virtual body that is tantamount to rape, see Julian Dibbell, "A Rape in Cyberspace," *Village Voice*, 21 December 1993, pp.36–42. On the other hand, Miller takes issue with the idea of virtual rape, pp.53–7, by suggesting that it plays to stereotyped notions of women as victims. Perhaps then violation would be a more appropriate term.

12 From my talk at the Symposium on Art and Virtual Environments at the Banff Centre in 1994. A revised version was printed as: "*Nature Morte: Landscape and Narrative in Virtual Environments*" in the aforecited *Immersed in Technology*, pp.195–232.

13 The piece is further described in my "Romanian Art and the Virtual Environment" in Calin Dan (ed.) *Ex Oriente Lux* (Bucharest: Soros Center for Contemporary Arts, 1994), pp.67–8.

34

14 Shaw's EVE was a response to the CAVE, another image-surround developed in Chicago; rather than putting miniature televisions like goggles over one's eyes, as in virtual reality, the interior surface of a cube is covered with images. Whoever wears polarized glasses with a tracking device governs the point of view inside the virtual space. One the other hand, EVE is a very large spherical projection surface. Rather than projecting an entire image-surround, images appear only there, where the gaze of the person with the tracking device is directed. This piece makes the fantasy of producing the world through one's gaze explicit. I might add that so far, images for it have been borrowed rather than produced to fit its unique surface.

15 Several participants in "Questions of Feminism: 25 Responses" *October 71* , pp.5–47, address the issue of essentialism from a contemporary standpoint. Mary Anne Staniszewski notes that "The problem with essentialist feminism was that its essentialism was patriarchal. Not unrelatedly, so are oppositions that restrict the way we would think and live and work", p.43. Thanks to Christine Tamblyn for bringing the article to my attention. Nell Tenhaaf's aforementioned article also notes a need to rethink the notion of essentialism.

16 "Body, Brain and Communication" in *Resisting the Virtual Life*, pp.124ff.

2

Girl TV

Mary Ellen Strom

Fact: The world does not offer equal opportunities for men and women. Researchers tell us that girls understand this by the age of three. It is a discouraging reality and a reality that lowers young girls' potential achievement.

I designed a workshop for the Gender and Technology conference that looked at some of the cultural mythologies that effect the way that girls are positioned in our world. The workshop used writing and video production as a tool to create ways for the girls to articulate their ideas and express their opinions. The videos that the girls made contain powerful, beautiful, frightening and clear messages about what it's like for them to be adolescent girls in the United States in the 1990s.

The following pages are still images and excerpted text from video pieces created by two participants from the workshop, LaTrease Carter and Megan Munnerlyn (see Figures 2.1 and 2.2). Video material created during the workshop was shown on ACTV, Columbus Public Access Television. The workshop was made possible by the Wexner Center Education Department. Thanks to Patricia Trump, Erin Pond and Bonita Makuch.

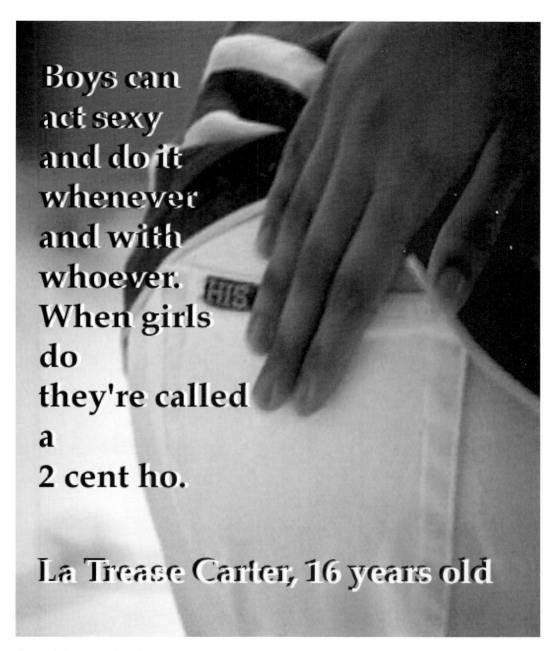

Boys can
act sexy
and do it
whenever
and with
whoever.
When girls
do
they're called
a
2 cent ho.

La Trease Carter, 16 years old

Figure 2.1 "Boys can act sexy"

Megan Munnerlyn 16 years old

To be a large girl is very interesting, because you always get to see how people act.

Figure 2.2 "To be a large girl"

3

Remote Control: the electronic transference

Christine Tamblyn

In this text I will play with the toolbox provided by Gilles Deleuze and Felix Guattari in *A Thousand Plateaus: Capitalism and Schizophrenia*,[1] trying out a few of their crowbars to pry loose the topic of gender and technology. My discursive logic, like theirs, will be more circuitous than causal in its delineation of various converging trajectories. For Deleuze and Guattari, a body does not have a gender; rather, gender is projected on it through social forces. However, social assignments of gender are not made arbitrarily; they are designated on the basis of anatomical differences. The deviations from fixation to fluidity in the Deleuzian model can be usefully applied to the investigation of contexts in which gender is mediated through a technological apparatus.

Cyberspace as both a hypothetical construct and a social arena is one such technological apparatus for gendering and ungendering. Whether considered as a private, public or professional sphere, cyberspace is a manifestation of thought. Thought in Deleuzian terms operates as a form of violence committed on systems in order to break them up and open up potential differences.[2] Following on from this notion, cyberspace commits violence to language and bodies.

Cyberspace is a body of intensities upon which language is reduced to material elements that flow through channels as information. How do bodies inscribe this information and how are they inscribed by whoever or whatever writes the script in cyberspace? How do specific memorization and rehearsal processes facilitate gender reinforcement and deflections? What is the potential for gendered bodily forces to be transposed into other forms in cyberspace, subverting communication spaces to create their own different imperatives?

Cyberspace, like all other technological achievements, is not merely a neutral instrument. It is rapidly becoming synonymous with the strategies of this phase of capitalism. In *The Politics of Everyday Fear* Brian Massumi argues that the generic form of subjectivity in capitalism has been radically altered to avoid internal threats of self-generated crashes and external threats of worker uprisings.[3] Image value, rather than products, is the main commodity being marketed. What was formerly in the sphere of social reproduction, i.e. education, leisure, eating, sex, has now fused with the sphere of production. These arenas are commodified by being turned into images and sold as the good life. "Produce yourself" is the new imperative.

The most obvious conduit for cyberspace is currently the Internet. This decentralized communication system promises to serve as a perfect vehicle for remaking one's subjectivity. The Internet traffics in the encouragement of its users' utopian fantasies about accessing the power to spin out proliferating identities. Multiple personas of whatever gender, sexual preference, age, race and ethnicity seek virtual sexual relationships with other designer identities. Nevertheless, this vision of boundless possibilities remains grounded on whether or not a

given body has access to economic equity. Thus, the possibility of inventing oneself from scratch comes with its own inherent price tag.

Yet it may be premature to dismiss the possibility of self-reinvention through technological transcription. Perhaps the Internet is concomitantly too vast and too specific to serve as a suitable paradigm for exploring ameliorations of gender binarism through mediated conduits. A more salient metaphor than the Internet for grasping the concurrent potentialities and limitations for gender play that cyberspace offers may be adduced from a novel titled *L'Invention de Morel* by Adolfo Bioy Casares.[4] Following on from the premises set forth in this model, cyberspace will fulfil the promise of film and video as electronic image-machines spewing an unlimited number of images and thereby obviating the necessity of choosing any one image for self- (and gender-) identification.

As Casares envisions the situation in his utopian novel, the sole edifice standing on a lonely island is a building called "the Museum." An escaped convict flees to this island. One day he discovers several people walking and talking, but he merely watches them covertly, since he is afraid of making his presence known. Eventually, he discovers that every few days these people repeat the same activities and conversations. He concludes that these people are only complex projections. In return for being granted an eternal existence as images produced by an elaborate projection system, they have paid with their lives. The registration of a person's life kills organic matter: the image presupposes death. The man falls in love with one woman belonging to the group-memory and decides to renounce his life while surviving forever as an image of her lover. He will die a little bit more each day to become an increasingly perfect three-dimensional projection in a self-determined part.

What this story reiterates are the terms of the Faustian pact we are succumbing to in the rush to embrace prefabricated, if multiple, identities in cyberspace. We trade in our subjectivities for exquisitely simulated projections. Our desperately nostalgic attempts to save the old gender categories and personas, even when these categories and personas are variously matched to bodies of either biological sex, only lead to their being continuously recycled and evacuated at ever increasing speeds. Our singular bodies are now components of a composite human/computer amalgamation. The power of our bodies is reduced to a matrix of apparatuses and functions. Expediency and instrumentality are the governing principles by which bodies are decoded and recoded by mechanized inscription processes.

If the body is not first an agent or actor, then culture can no longer be conceived as a drama in which actors carry out various projects. The focus shifts instead to the writing of the script or program, the orders that emanate from the operations of authority. As Friedrich Kittler

observed in *Discourse Networks 1800–1900*,[5] transposition is the privileged technique for coupling bodies and media. Messages are transferred from bodies to language or from one medium to another. In the exchange process, a transposition occurs that reshapes the bodies and media to conform to new standards and materials.

In cyberspace, all movements are speed ratios for the processing, storage and transmission of data. Every channel carrying information also produces noise and nonsense. Their automatized operations no longer belong to a subjective authority. Thus, the body becomes a command/control device transposed into written code.[6] Writing becomes detached from subjectivity as inscription becomes mechanized. Kittler claims that this started with the typewriter which freed writing from consciousness and the elocutionary subject and made spacing and typography the precondition of differentiation. An intransitive writing was inaugurated that inscribes different sorts of things from those that any voice has ever spoken, such as parentheses enclosing a colon and a dash or brackets surrounding an empty space.

Such a pure inscription machine reduces randomness and forgetfulness, so that memory is inscribed on the body. All that counts is the mechanism, along with its proper use or abuse. The proper user in a mechanized culture must be trained, not educated, i.e. trained to recognize proper sense and to splice its fragments together by clipping out the nonsense. The nonsense must be disavowed or repudiated. But this snipped out nonsense then becomes available for the abuse of the system.

We participate in the rehearsal and memory mechanisms that reproduce mechanized culture. We are like the King's messengers Franz Kafka describes in *The Penal Colony*:

> They were given the choice of becoming Kings or King's messengers. Like children they all wanted to be messengers. Therefore there is nothing but messengers; they race through the world and because there are no Kings, call out their messages, which have become meaningless in the meantime, to each other. They would gladly quit this miserable existence but don't dare to because of their oath of office.[7]

On the World Wide Web, a web of bureaucracies operates through dispersed localizations to relay official messages. Bureaucracies are ruthlessly efficient in the production of functionaries; the World Wide Web provides the newest elaboration of bureaucratic protocols. Apart from abusing the system by drawing on the non-sense at its basis, there is only the choice of entering training to master the protocols needed to become one of its functionaries. Directorial authority inheres within these protocols for relaying messages.

It was inevitable that gender, like authority and identity, would be reconstructed in cyberspace, however liberatory its potential initially

seemed to be. As Alberto Moreiras affirms in "The Leap and the Lapse: Hacking a Private Site in Cyberspace,"[8] cyberspace is a site of disjunction, where analogical production comes to the limits of analogy. Cyberspace is felt as a wanting space, a space of default where lack fuels addiction. Nothing is given in cyberspace, and this absence is more than enough to tantalize us. The precincts of virtual reality map what has slipped away or withdrawn, making itself abstrusive in its act of vacancy. Gender, identity, authority become the lost objects of analogy.

Computers, pure inscription machines, serve as grounds for memory and the displacement of memory. To rehearse here the protocols for our collective amnesia, we give over our cogency to the flow of intensities encoded through the machine. Following Deleuze and Guattari,[9] I would like to suggest that bodies are not primarily defined by functions, organs, symptoms or genders. These are secondary categories that make them productive of something for someone, some interest or institution. Instead, a body is primarily kinetic, composed of a multiplicity of parts. Bodies are also constituted through their capacity to affect and be affected by other bodies. Computer networks play out a relay of affects through the body and between bodies. If we intend to outline an ethics for performative interventions in cyberspace, perhaps we should look not to identity politics or identities as possessions or attributes of bodies, but rather to the relay of affects on and between bodies.

Value is produced through the dynamic interplay of material tensions enveloping potential paths of becoming. In the social relationship being negotiated between the electronic body and the organic body, the impetus for performative gestures may be discovered. Action at a distance deflects fictions of authenticity or presence, evacuating the signs of the organic. But behavioral codes persist, and may even be reified. On the Internet, for example, sexist and racist speech acts coalesce out of opportunities for anonymity. Without fear of accountability or reprisals, the most oppressive ideologies are reinforced.

The electronic and the organic body confront each other in the debris of intersubjectivity. They parasitically feed on one another, generating more noise in the system, a buzz over the wires. Oscillating feedback loops magnify our privations: the privations of gender, class and ethnicity, most of all. Even when no longer singular, our identities are delimited by the poverty of our imaginations as much as by the abject biological markers of the organic. We may replicate a million virtual copies of ourselves, but if they are all merely decoded and recoded clones, equilibrium will not be disturbed and mutations cannot develop.

NOTES

1 Gilles Deleuze and Felix Guattari, *A Thousand Plateaus: Capitalism and Schizophrenia*, trans. Brian Massumi (Minneapolis: University of Minnesota Press, 1987), p.xv.

2 Ibid.

3 Brian Massumi, "Everywhere You Want to Be: Introduction to Fear," in Brian Massumi (ed.) *The Politics of Everyday Fear* (Minneapolis: University of Minnesota Press, 1993), pp.3–37.

4 Adolfo Bioy Casares, *The Invention of Morel: and Other Stories from La Trama Celeste*, trans. Ruth L. C. Sims (Austin, Texas: University of Texas Press, 1964).

5 Friedrich Kittler, *Discourse Networks, 1800–1900* (Stanford, CA: Stanford University Press, 1990).

6 Donna Haraway, "A Cyborg Manifesto: Science, Technology and Socialist-Feminism in the Late Twentieth Century," in *Simians, Cyborgs and Women: The Reinvention of Nature* (New York: Routledge, 1991), p.164.

7 Franz Kafka, *The Penal Colony, Stories and Short Pieces*, translated by Willa and Edwin Muir (New York: Schoken Books, 1976).

8 Alberto Moreiras, "The Leap and the Lapse: Hacking a Private Site in Cyberspace," in Verena Andermatt Conley (ed.) *Rethinking Technologies* (Minneapolis: University of Minnesota Press, 1993), pp.191–204.

9 Deleuze and Guattari, op. cit., pp.149–66.

4

She Loves It, She Loves It Not:
women and technology

Christine Tamblyn

Images from the CD-ROM produced with Majorie Franklin and Paul
Tomkins 1993

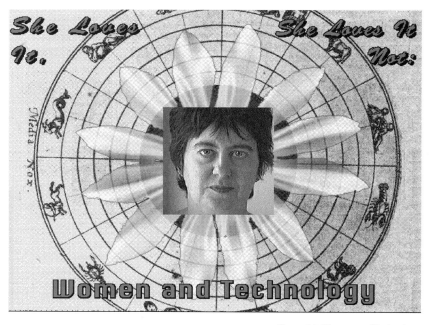

Figure 4.1 Women and Technology

Figure 4.2 Help screen

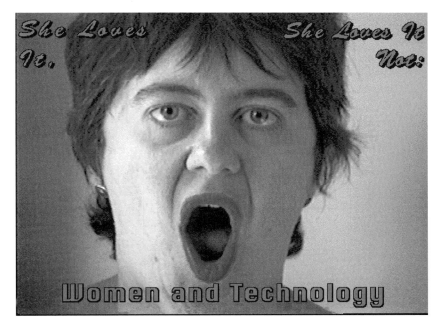

Figure 4.3 Mouth

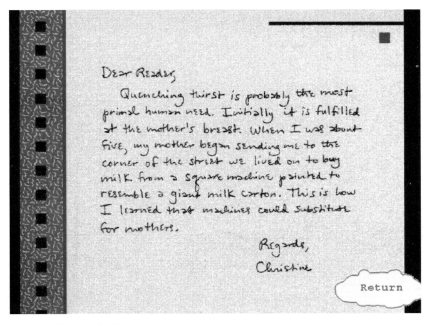

Figure 4.4 "Dear Reader, Control"

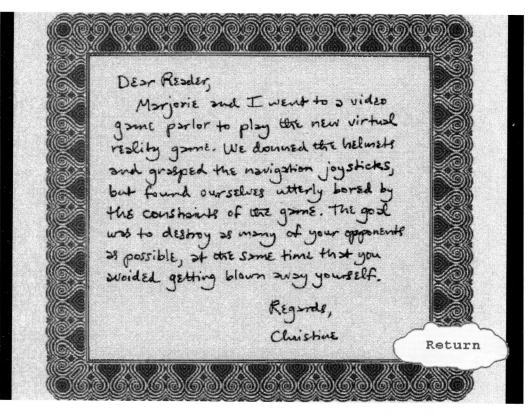

Dear Reader,

Marjorie and I went to a video game parlor to play the new virtual reality game. We donned the helmets and grasped the navigation joysticks, but found ourselves utterly bored by the constraints of the game. The goal was to destroy as many of your opponents as possible, at the same time that you avoided getting blown away yourself.

Regards,
Christine

Return

Figure 4.5 "Dear Reader, Violence"

<HTML>

<HEAD><TITLE>

5

Networking Women and Grrrls with Information/Communication Technology: surfing tales of the world wide web

Nina Wakeford

<HEAD><TITLE>

<BODY>

<P>

This chapter is a short exploration of the world of Net Chicks and geekgirls, cyberfeminists, NerdGrrrls and digital Sojourners. It is also a modest intervention in a debate about women and new information/communication technologies.[1] The chapter describes networks of women's presence on the World Wide Web,[2] in particular those which use the medium for feminist purposes, or other radical cultural projects of resistance such as the creation of grrrl space. However, configurations of hardware and software change rapidly, and Web presences are in a constant process of transformation, so this contribution is a static snapshot of an evolving social and technological situation. This piece can also be read as a story about relationships, as well as an HTML document.[3] Embedded within global electronic networks are both the hypertext and personal links which I have formed during the initial stages of the Octavia Project, a project to create in the UK a set of resources on gender and technology on the Web.[4]

A great deal of electronic and printed text has been generated in an attempt to explain the nature of the interaction between gender and participation in the computing culture of which the World Wide Web is a part. Although this piece focuses on existing Web presences rather than marginality and silences, it would be misleading to think that writers universally characterize women's relationships with electronic networks as successful. Margie Wiley has argued that the electronic networks which we know as the Internet have inherited a problematic relationship with gender from their roots within the military–industrial complex and in academic institutions.[5] Given this inheritance, Wiley suggests that we should not be surprised if electronic networks are experienced by many women as "male territory" (Wiley 1995). Wiley's perspective is confirmed by many of the testimonies collected in Dale Spender's recent overview of women's participation in cyberspace.[6] The construction of electronic networks as "male territory" is generally based on two interrelated claims: first, women as a proportion of all users are in the minority (for a recent summary of survey evidence see Shade 1996), and second, there is a cultural dominance of masculinity in on-line spaces – newsgroups, discussion lists, and real time textual exchange – particularly in linguistic styles and conventions (Spender 1995). Furthermore, it has been argued that gender ideologies are deeply entrenched "closer to the machine" within the dynamics of software production. From her experience of "a programming life" Ellen Ullman criticizes the celebration of "teenage boy" masculinity within the culture of software engineering and its interaction with a discourse of whiteness and the dominant culture of California (Ullman 1995). Ullman implies that this hybrid culture may be integrated through the software into the experiences of the end users. This is a process which

*Networking
Women and
Grrrls with
Information/
Communication
Technology*

could be termed, to coin Steve Woolgar's phrase, as "configuring the user," a reversal of the usual assumption that it is the *user* who configures the *machine* (Woolgar 1991). Such descriptions suggest that electronic networks are constructed and experienced as "male territory," and not a place within which anyone would voluntarily wish to display/reveal female identity. In fact the very notion of women, men, or anyone in transition, adopting a female persona has been a matter of intense debate in both on-line and off-line forums (cf. Stone 1991).

As computers and electronic networks are becoming key features of economic and social policy, it is becoming increasingly crucial to map the gendered characteristics of computer culture and the interactions of other dimensions of heterogeneous identities. However, there are two key problems of prioritizing a discourse which constructs gender as necessarily and universally problematic in relation to the World Wide Web.

First, this discourse of "problems" exists among competing accounts of the relationship between women and computing. Sadie Plant, who describes herself not as a feminist but as a *cyber*feminist, accuses much feminist theory of reproducing notions of "technophobia" by adopting this view. She comments "It [feminist theory] not only buys into it – it's keen to perpetuate it" (interview with geekgirl). How can we talk of women who do not recognize themselves in the portrayals of harassment? Laura Miller reports the outrage of women on her on-line service (The Well) when *Newsweek* ran the article "Men, Women and Computers" (16 May 1994) in which Nancy Kantrowitz "exposed" the "sexist ruts and gender conflicts" in on-line worlds (Miller 1995). Miller points out that the effect of the article was to transform debates about on-line gender relations into reified mass media stereotypes of harassed females. The words of Plant and Miller are a reminder of the necessity of being alert to writing which ignores alternative discourses of women's experiences in on-line life, and unthinkingly mirrors the "moral panics" of widespread media publicity. Many of the women featured in this chapter have created Web pages which actively confront the "harassed female" stereotype by creating networks of explicitly women-centered or feminist projects as alternative spaces in computing culture. However, there is much less public attention paid to innovative projects by women, particularly if they are explicitly feminist.

Second, 'cyberspace' is not a coherent global and unitary entity but a series of performances (Wakeford 1996). Experiences which are local and specific in one performance area cannot necessarily be mapped directly onto other activities, such as the Web. The Web is indeed embedded in some of the electronic networks of the Internet which make other forms of computer-mediated communication possible, but the possibility of browsing information anonymously with no login

(nick)name or "handle" means that a basic feature of identity (re)creation which elsewhere structures the negotiations of risk and trust, and much of the performance of gender, is at present absent for most Web users.[7] Nevertheless there has been considerable conceptual leakage of the construction of gendered risk from one area to the other in popular discourse (see Spender 1995). Each performance area has its own structural features and normative behaviors, but may also be interconnected. The Web is sometimes a way to access routes into other areas of computer-mediated communication such as Usenet groups, mailing lists, or "chat" facilities, so the cultural spheres of a generalized "cyberspace" or Internet and the Web are not always as absolutely independent (electronically or analytically) as they might first appear.[8]

"*Some* of us just haven't got time to surf the Web!" one of my colleagues commented recently, somewhat pointedly, as she walked past the computer at which I was trying to write lines of HTML. On the spur of the moment, I couldn't think of an appropriate (or witty) response, and replied weakly "Well, it *is* my research." This provoked the response which I had expected – a skeptical laugh.

Such social perils arise while conducting sociological research on the World Wide Web because the activity of "surfing" (browsing Web pages) is characterized as "playing around" rather than (field)work (see also Hine 1994). These assumptions merit further attention, and a more adequate response, since the comments mirror one popular construction of the Web as trivial. I resist the notion that working on the Web, whether "surfing" or creating the pages, is always or necessarily insignificant, marginal to women's lives and to cultures of feminism. I reclaim the activity known as "surfing" as *serious* play which can create and maintain relationships, be they between individuals, organizations or hypertext documents.[9]

Electronic networks have attracted vocabulary with particularly local (rather than global) references which suggest a specific cultural heritage. The problem of "surfing" is not only the inflection of leisure (constructed as the opposite of "work") in the metaphor itself, but also the implied connection of technology with conceptions of surfing as a sporting activity which is enjoyed by a specific population. The potential limitation of this metaphor in terms of culturally and geographically diverse identities was clarified for me during an Internet training course in London with African women and women of African descent. In a group discussion one of the participants commented on "surfing" as one of the unsuitable words for their use of electronic networks, and promotion of such technologies amongst others. "*Who* goes surfing in Africa?" she asked.

Metaphors which attempt to characterize electronic networks may encourage particular responses to these networks, and to women who

*Networking
Women and
Grrrls with
Information/
Communication
Technology*

use them (Miller 1995). Miller has described how the notion of the "frontier" (used in the name of the Electronic Frontier Foundation, and elsewhere) is directly related to a specific historical moment in American history which itself was strongly gendered. In this analogy women are positioned as lacking in agency. Women exist within a classic Western narrative of social relationships, not only between "man" and nature, but between men and women.

> In these stories the frontier is a lawless society of men, a milieu in which physical strength, courage, and personal charisma supplant institutional authority and violent conflict is the accepted means of settling disputes. The Western narrative connects pleasurably with the American romance of individualistic masculinity; small wonder that the predominantly male founders of the Net's culture found it so appealing.
>
> (Miller 1995: 52)

The frontier is another example of how metaphors generated for a global definition (i.e. electronic networks = cyberspace/frontier) have been applied locally. Although this may not be useful analytically, as I argued above, in this case the practical consequences can be significant. Although Miller acknowledges that "the choice to see the Net as a frontier feels unavoidable" (ibid.: 50), she also points out that this construction permits the accompanying conceptions of ownership and regulation, as well as allowing the construction of "imperilled women and children" (ibid.: 52) as part of a project of protection based on images of land and physical space. Using the same logic we might explain the discourse of current debates about legal regulation, such as censorship of Web pages, as a consequence of a very specific construction of electronic networks as a frontier in need of defense.

The notion of the Web itself is a metaphor, and one which has also been used to characterize the whole system of electronic networks. Sadie Plant, for example, defines "cyberspace" as "global webs of data and nets of communication" (Plant 1995: 46). The World Wide Web has attracted a vocabulary of spiders/weaving, often reinforced by graphics. One example is the Web page of the popular search tool Inktomi.[10] Among women's presences imagery of webs is reflected by Stephanie Brail in her home page Spiderwoman image (see Figure 5.1) and in the 'VS' web image of Virtual Sisterhood (see Figure 5.2). Underneath this image Spiderwoman is defined as:

Spiderwoman: 1. an Internet mailing list. 2. a community of women and men dedicated to supporting women Web designers.

The image which Brail employs, and the set of dual meanings which she gives to the word Spiderwoman, clearly illustrate the integration of electronic networks (the Internet mailing list) with social networks

Figure 5.1 Spiderwoman

Figure 5.2 Virtual Sisterhood

Figure 5.3 Cybergrrl

Figure 5.4 Geek grrrls need modems

*Networking
Women and
Grrrls with
Information/
Communication
Technology*

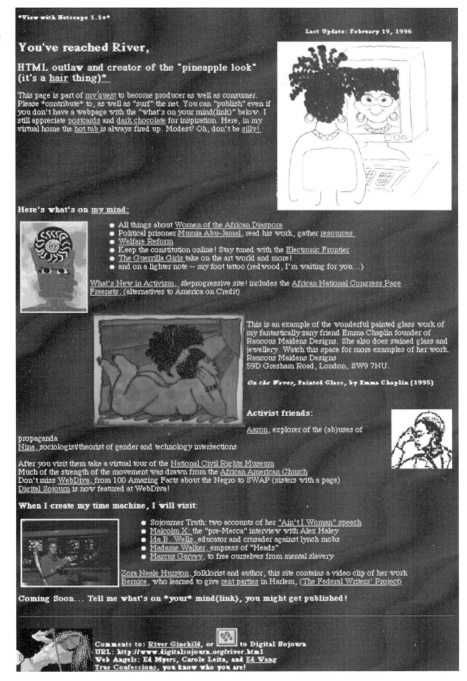

Figure 5.5 River's home page

(community . . . dedicated to supporting women). It also suggests that as well as searching for a word to summarize the global *performances* within electronic networks, we might try to find ways to talk about the nature of the *relationships* which are embodied within, or provoked by, the interaction of social and electronic networks. In the second definition of Spiderwoman these relationships are presented as "supporting," although this is just one of a new set of descriptors which might be generated if such an interrogation of the connections were to take place.

As part of my research project on gender and computing culture I have become not only a consumer of the Web, but also a producer of pages for the consumption of others. My initial reasons were practical and organizational. I needed a way of keeping track of all the electronic documents written about the relationship of women and technology generated as a product of searching the Web, an easy route to the latest issues of electronic journals, and a means by which to link my page to pages of others interested in the same field. As the process progressed, I realized that the creation of the Web pages was as much a production of public identities for the project and for myself as it was about the organization of materials. The element of global display was further heightened when Rachael Parry produced t-shirts of the Octavia Project logo (reproduced from the Web page including email address) which were worn to a summer camp on women and technology in the former Yugoslavia, an unexpected overlap of the electronic and social networks.

Interactions with other Web page developers, as well as browsing the Web, indicate that the combination of informational links and identity projects for individual home pages is commonplace. For example, River Ginchild, whose work is reproduced in Figure 5.5, reports that her page has a purpose beyond her own use of it as a "fancy bookmark" for the Web.

> I wanted to see myself – women of African descent – on the Web. I think
> I had seen one or two Black women with pages when I put my page up,
> but in June 1995 it was – overwhelmingly – white male, it still is, but
> there are a lot more of us online with pages.[11]

Figure 5.5 illustrates the electronic and social architecture of a Web home page, and its use itself reflects overlapping networks between River and myself. Our association and work together have been mediated in person and electronically, largely by email. River is director of Digital Sojourn, a project named after human rights advocate Sojourner Truth which focuses on increasing the participation of people of African descent in computer-mediated communication. Our projects and pages have intersected to transform personal links to

Networking
Women and
Grrrls with
Information/
Communication
Technology

electronic connections and vice versa. Beyond direct links between pages we have created reciprocal ties of advice and support between Digital Sojourn and The Octavia Project, crossing geographical and cultural boundaries in the process.

Typically, a Web page combines graphics and text, and allows each to be treated as a link which activates a connection to another page. For example, in Figure 5.5, selecting the link "hair" will retrieve the article "Black Identity and the Politics of Hair: The Revolution is in your head Not on it" by Stephanie Mason. This link reflects River's aim to construct a network to other pages which are chosen "for content and looks." She reports, "The links are of things that I want to learn about or have others learn about." Additionally she provides ways of connecting with other individuals by links to their home pages.

Metaphors of "home" are scattered throughout the Web, and they are reproduced in the talk and images of women creating presences. River talks of the constant maintenance of her page as "house cleaning . . . because I think of people visiting the site." Carla Sinclair's NetChick home page is illustrated by her "Net Chick Clubhouse" which contains graphic links in the form of windows to the spaces of beauty parlor, rumpus room, office and entertainment lounge (all additional Web pages). Clicking on the picture of the front door produces a map of the premises. She has elaborated this architecture still further by creating images of objects which are found in each room – an answerphone where (email) messages can be left is available in the office, for example.[12]

River Ginchild and Carla Sinclair have created home pages which present individual visions of themselves and their connections to others. Other women have created pages which are gateways for worldwide resources for women, although at present these tend to be co-ordinated or based on machines in the USA. Barbara O'Leary set up Virtual Sisterhood as "a global women's electronic support network" (see Figure 5.2). Virtual Sisterhood co-ordinates and organizes connections to women's groups and activities, and provides links between activist groups and social forums as well as an on-line periodical, *Seachange*. Information is available in a variety of languages, and women Web author volunteers establish sites which host women's groups from all over the world. Other global initiatives have been set up in parallel with the United Nations Fourth Conference on Women, such as the World's Women On-line Electronic Art Networking Project. Large co-ordinating "gateway" sites with a feminist focus in the USA include The Feminist Majority and Women's Web, which includes links to *Ms* magazine. Amy Goodloe co-ordinates an initiative which concentrates on lesbian activities and resources on the Web, particularly in the San Francisco Bay Area. These electronic networks do not exist in isolation but are themselves electronically linked. Spiderwoman is

linked to NetChick which has a connection to the geekgirl site (described below) which can be used to access Virtual Sisterhood. Connections cross-cut each other with multiple routes for getting from one page to another, adding complexity to the networks. Frequently they also encompass a convention of co-operation and sharing of technological skills between women which is related by some to previous projects of political networking between women. This sentiment is expressed in the Women'sSpace Web article on the culture of cyberspace:

> There is a spirit of generosity amongst sisters in cyberspace which reminds us of the early days of the Women's Liberation Movement. Networking, activism and support are interwoven as we push ourselves to learn to work with the new electronic tools we are encountering. Together we anticipate a future where growing numbers of women can access and use the global connections to promote women's equality.
>
> (Women'sSpace Vol. 1 No. 3 Web Page)

Of particular interest to my research are the Web presences which women have created in direct response to certain images of computing culture, and specific patterns of activities on the Web itself (such as the man who set up a page linking up pages of "Babes on the Web"). The resistance of "grrrl" Web producers may be portrayed as "what Riot Grrrls are to music and the Guerrilla Girls are to art" (DeLoach 1996). Women who might be grouped under this label have created sites with names such as Cybergrrl (see Figure 5.3), geekgirl, as well as NerdGrrl and Homegurrrl. The words themselves are codes to explicitly subvert the easy appropriation of women, and to resist stereotypes. Crystal Kile, creator of the PopTart site, tells DeLoach:

> a very practical reason grrrls/geeks/nerds use these codewords in titles of our site is to make it clear that we're not naked and waiting for a hot chat with you! I mean, just do an Infoseek search using the keyword "girl" or "woman" & see what you find.

Crystal also resists:

> the very traditional way that the online and multimedia industries are creating the "woman's Internet market" to cater to the same ol' women-as-consumers, Seventeen-Cosmo-Woman's-Day market

Such grrrls also appear to be ambivalent or even hostile to patterns of behavior which they associate with an "older style feminist rhetoric," and in particular the idea of a prescriptive or homogeneous women's movement. The words of Carla Sinclair, and RosieX (creator of the geekgirl site), illustrate this problematic relationship:

*Networking
Women and
Grrrls with
Information/
Communication
Technology*

a grrrl site is created by a woman who addresses issues without acting like women are victims. Grrrls take responsibility for themselves – we don't blame men for anything, but instead focus on ways to improve and strengthen ourselves. Grrrls enjoy their femininity and kick ass at the same time.

(Carla Sinclair in DeLoach 1996)

I think this idea of a movement is based on an older style feminist rhetoric which tended to homogenize all women with the same wants/needs/desires to embrace each other. . . . It's just not that applicable to women who use the Internet.

(RosieX in DeLoach 1996)

By illustrating the possibility of a close relationship between women and computing, instead of reproducing a discourse of "problems", grrrls have created images which defy traditional stereotypes. Often they achieve this by creating names from words which were not previously associated. Initiatives such as geekgirl are grounded in grrrls' own experiences of computing culture, as RosieX explains:

Geeks generally are the hardcore of the nets. They are usually self-taught, determined individuals who simply love computers – machines are not just their friends but conduits into the world of art, politics, fun, magic and mayhem. Being a girl I am voila – geekgirl.

(DeLoach 1996: 228)

geekgirl also produces the Grrrls Need Modems! image (see Figure 5.4), itself an illustration of the close visual and semantic alliance of women and technologies being made by some grrrls in resistance to previous ideologies.

Women, sometimes as grrrls, are making increasing use of the Web. RosieX has estimated that between 1992 and 1996 women's presences on the Internet increased from 5 to 34 per cent of all sites (DeLoach 1996). Many pages also show the combinations of electronic networks with social networks. In the final section of this chapter I return to the question of appropriate theories and metaphors about networks of women on the Web.

It has been suggested by Donna Haraway that the idea of the network itself may be employed as part of a feminist toolkit (Haraway 1991a). She advocates the "network ideological image" because it suggests:

the profusion of spaces and identities and the permeability of boundaries in the personal body and the body politic. "Networking" is both a feminist practice and a multinational corporate strategy – weaving is for oppositional cyborgs.

(Haraway 1991a: 170)

Haraway adds a further metaphorical accessory to the idea of networking – weaving. From the different perspective of cyberfeminism, Sadie Plant has applied the metaphor of weaving to women's relationship with computers and cyberspace (Plant 1995). Using a conception of weaving is attractive in relation to women's presences on the Web because of the historical association of weaving as "the process so often said to be the quintessence of women's work" (ibid.: 46). Weaving could be a productive metaphor to describe the process of creating pages, and interlinking others. Web pages could be construed as the woven products of electronic and social networks. Unlike the notion of the frontier, weaving could be used to emphasize the relationships within electronic networks, and between pages themselves, as well as the individuals who create them.

For Plant, the metaphor of weaving is used to portray the particular position which men occupy in relation to women and computers. In her argument, weaving describes the intimate connection which has emerged historically between women and computers, beginning with Ada Lovelace and the development of early machines which were modelled on the Jacquard loom. As well as being associated with women's work, she states "The loom is the vanguard site of software development" (ibid.: 46). Furthermore, it emerges that both computers and women are woven sites of disguise or simulation which mediate between "man and matter." Plant claims that in contemporary times "both woman and computer screen the matrix" (cyberspace is understood as the matrix) which results in "the absence of the penis and its power." She writes:

> The computer was always a simulation of weaving; threads of ones and zeros riding the carpets and simulating silk screens in the perpetual motions of cyberspace. It joins women on and as the interface between man and matter, identity and difference, one and zero, the actual and the virtual. An interface which is taking off on its own: no longer the void, the gap, or the absence, the veils are already cybernetic.
>
> (ibid.: 63)

Her aim is "weaving women and cybernetics together" and her argument draws on the writings of Freud and Irigaray, particularly the latter's concept of women as producers of disguise, or "weavers" of veils (ibid.: 58). Applying this theoretical framework to the Web presences which I have been describing is problematic, not least because in the article Plant does not state if the concept of the matrix refers to one corner of cyberspace, or if it is globally applicable. Setting this ambiguity to one side, the model is nevertheless based on women "as the interface between man and matter," and it is this construction of women and computers in relation to the activities of man which makes it difficult to integrate into presences which have networks of women

*Networking
Women and
Grrrls with
Information/
Communication
Technology*

as the core focus. To provide a metaphor of the relationships contained within or generated by feminist Web pages which connect women to each other, and for the grrrl pages, it is necessary to go beyond the idea of women as veiled presences, mediators or as the interface, even if the interface is portrayed as presently "taking off on its own."

We are in need of a more radical reconfiguration of the relationship of (woman/)woman/machine rather than solely concentrating on man/woman/machine, particularly if we are to employ this construction of weaving. However, I would like to retain the idea of weaving as an oppositional form of networking as suggested by Haraway. Specifically, Haraway identifies the weavers as cyborgs, hybrid entities which are signalled in the name and image generation of projects such as geekgirl. Women's Web presences can be a way of constructing oppositional identities, displaying the integration of women and computing culture, as well as building electronic and social networks. If there is a corporate intensification of initiatives toward a "woman's Internet market", as Crystal suggested, and it is based on competition, it is likely that the construction of these networks of feminists will be a form of resistance. Nevertheless, as well as maintaining social and electronic networks, there is a continued task of creating oppositional metaphors, so that the Web is not unproblematically treated as a frontier, or characterized as a place within which the relationships are secondary to a "territory." We could talk of networking rather than surfing. We could even use the analogy of weaving to stress the process of networking. But I expect that further investigation of women's presences on the Web will require a far wider variety of metaphors in a continuing attempt at a new vocabulary of women and technology. Haraway reminds us of the political stakes of refusal:

> If feminists and allied cultural radicals are to have any chance to set the terms for the politics of technoscience, I believe we must transform the despised metaphors of both organic and technological vision to foreground specific positioning, multiple mediation, partial perspective, and therefore a possible allegory for antiracist feminist scientific and political knowledge.
>
> (Haraway 1991b: 21)

</P>

</BODY>

</HTML>

NOTES

1 I am alluding here to Haraway's description of the Modest Witness, and particularly its reconceptualization by Deborah Heath in terms of Modest Interventions (Heath 1995).

2 The World Wide Web is a network of hypertext documents available to users of the Internet who are running a variety of "browser" software. For a full explanation of the access of the World Wide Web many introductory guides are available, both on-line and in printed text.

3 HyperText Markup Language (HTML) is the standard language in which World Wide Web pages are written, although other languages, such as Java, are becoming increasingly popular.

4 The Octavia Project was created and is maintained by Nina Wakeford and researcher/designer Rachael Parry (Department of Architecture, University of Sheffield). Work on The Octavia Project has been funded by the UK Economic and Social Research Council.

5 For a history of the development of the Internet see Rheingold (1993).

6 The definition of cyberspace is contested and highly problematic, as I have argued elsewhere (Wakeford 1996). In Dale Spender's work the territory which it describes overlaps with the arena to which I am referring in my use of "electronic networks."

7 This is true for most Web pages, although the increasing use of "interactive" Web pages, with browsers which allow integrated email and form capabilities, may shift this pattern in the future. Also my comment ignores the recent possibilities of real time textual and visual exchange in systems such as WebChat.

8 There are other features of the Web which I cannot outline in this chapter including (a) at present the Web is only available via elite technology (computers) which have persistently been unequally distributed between social groups; (b) the standard Web links use hypertext, which itself is the subject of intense debate as to its social effects; (c) most on-line services have been constructed as spaces which are desirable and feasible to censor, and public legislation is being prepared and implemented across national boundaries on the basis of this assumption.

9 Here I am thinking of Emily Martin's reconstruction of science as a "serious game" which investigates cultural practices (Martin 1996: 107). Martin's idea itself invokes Donna Haraway's phrase of the cat's cradle (Haraway 1989: 11). Usually I counter comments such as the one which I quoted above by physically guiding the interlocutor to a networked computer terminal and searching the Web for something directly related to their field of interest, a tactic used by Internet trainers faced with skeptical trainees.

10 Inktomi was developed at the University of California at Berkeley, and can be found at http://inktomi.berkeley.edu/

11 All the quotations are from personal email communication between River and myself, February 1996.

12 In these Web page constructions the idea of "home" can no longer be tied down to an image of public/private separation, as homes are simultaneously public and private spaces where "who you let in" is not a decision based on safety or conditional on levels of intimacy, but on hypertext links available to any user of the Web.

*Networking
Women and
Grrrls with
Information/
Communication
Technology*

WEB SITES

Amy Goodloe
http://www.lesbian.org/

Cybergrrl
http://www.cybergrrl.com/

Digital Sojourn
http://www.digitalsojourn.org/

Feminist Majority Foundation
http://www.feminist.org/

geekgirl
http://www.geekgirl.com.au/geekgirl/

Netchick
http://www.cyborganic.com/people/carla

Octavia Project
http://www.shef.ac.uk/uni/projects/wivc/

Spiderwoman
http://primenet.com/~pax

Virtual Sisterhood
http://www.igc.apc.org/vsister/vsister.html

Women'sSpace
http://www.softaid.net/cathy/vsister/w-space/vol13.html

World's Women On-Line Electronic Art Networking Project
http://wwol.inre.asu.edu/

Women's Web
http://www.womweb.com/

REFERENCES

DeLoach, A. 1996. "Grrrls Exude Attitude," *Computer-Mediated Communication Magazine* 3(3) 1 March 1996.

geekgirl issue 1 (see Web sites).

Haraway, D. J. 1989. *Primate Visions: Gender, Race, and Nature in the World of Modern Science*. New York: Routledge.

Haraway, D. J. 1991a. *Simians, Cyborgs and Women: The Reinvention of Nature*. London: Free Association Books.

Haraway, D. J. 1991b. "The Actors Are Cyborg, Nature is Coyote, and the Geography is Elsewhere: Postscript to 'Cyborgs at Large'," in C. Penley and A. Ross (eds) *Technoculture*. Minneapolis: University of Minnesota Press, pp.21–6.

Heath, D. 1995. "Modest Interventions and the Technologies of Feminist Science Studies." Paper presented at CRICT workshop, Brunel University, Uxbridge, UK, 23 June 1995.

Hine, C. 1994. *Virtual Ethnography.* CRICT Discussion Paper No. 43. May. Brunel University, Uxbridge, UK.

Martin, E. 1996. "Citadels, Rhizomes, and String Figures," in S. Aronowitz, B. Martinsons and M. Menser (eds) *Technoscience and Cyberculture.* London, Routledge, pp.97–109.

Miller, L. 1995. "Women and Children First: Gender and the Settling of the Electronic Frontier," in J. Brook and I. A. Boal (eds) *Resisting the Virtual Life: The Culture and Politics of Information.* San Francisco: City Lights, pp.49–57.

Plant, S. 1995. "The Future Looms: Weaving Women and Cybernetics," *Body and Society* 1(3–4), 45–64.

Rheingold, H. 1993. *The Virtual Community.* New York: Addison-Wesley.

Shade, L. R. 1996. "The Gendered Mystique," *Computer-Mediated Communication Magazine* 3(3) 1 March 1996.

Spender, D. 1995. *Nattering on the Net: Women, Power and Cyberspace.* Melbourne: Spinifex.

Stone, A. R. 1991. Will the Real Body Please Stand Up?: Boundary Stories about Virtual Cultures," in M. Benedikt (ed.) *Cyberspace: First Steps.* Cambridge, MA: MIT Press, pp.81–118.

Ullman, E. 1995. "Out of Time: Reflections on the Programming Life," in J. Brook and I. A. Boal (eds) *Resisting the Virtual Life: The Culture and Politics of Information.* San Francisco: City Lights, pp.131–43.

Wakeford, N. S. 1996. "Sexualised Bodies in Cyberspace," in W. Chernaik and M. Deegan (eds) *Beyond the Book: Theory, Text and the Politics of Cyberspace.* London: University of London.

Wiley, M. 1995. "No Place for Women," *Digital Media* 4(8) January.

Woolgar, S. 1991. "Configuring the User: The Case of Usability Trials," in J. Law (ed.) *A Sociology of Monsters: Essays on Power, Technology and Domination.* London: Routledge, pp.57–99.

6

Hiatus

Ericka Beckman

Images from the film, 1996

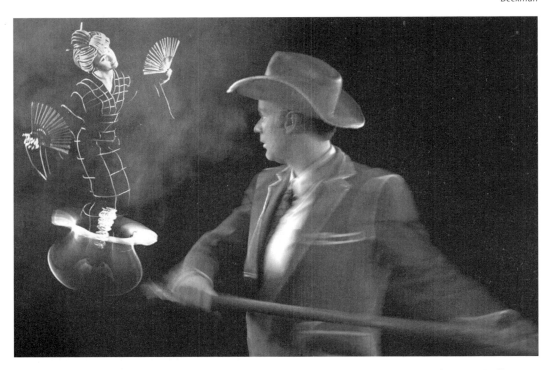

Figure 6.1 Still from the film, 1996

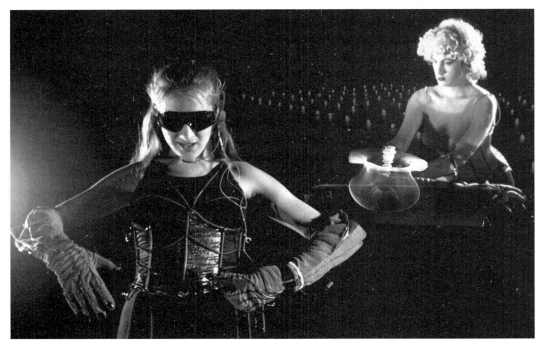

Figure 6.2 Still from the film, 1996

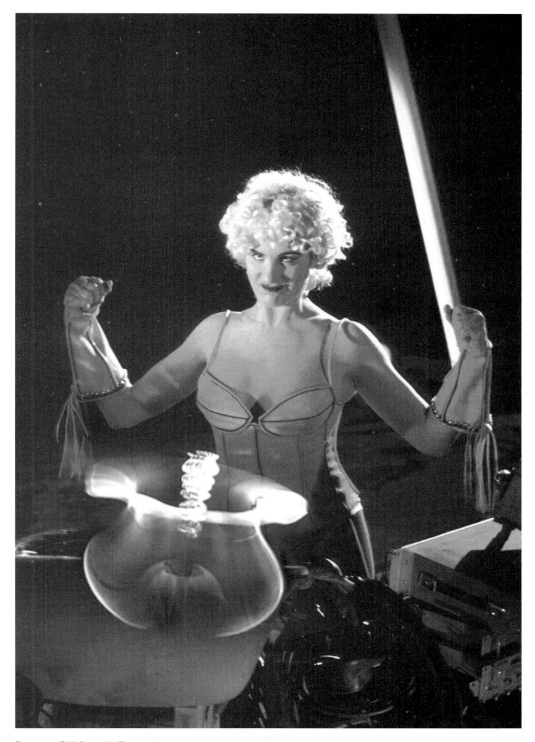

Figure 6.3 Still from the film, 1996

7

Romancing the System: women, narrative film, and the sexuality of computers

Andrea Slane

"Should Bunny Watson marry Richard Sumner?" When Spencer Tracy's character asks a computer this question in the 1957 romantic comedy *Desk Set*, he expects an affirmative answer. In this way, he simultaneously hopes to convince Bunny (Katherine Hepburn) to marry him, and assuage her opposition to the machine. The function of computers in narrative films is often twofold like this, coding cultural conflicts over technological progress through gender, and negotiating gender and sexuality through the machines. The fact that the computer comes up with a generically unsatisfactory "No!" then attests to the ambivalences toward both computers and heterosexuality that narrative films featuring computers often play out. The story of the advance of the computer as an ever more pervasive technological presence therefore joins the ongoing story of persistent attempts to reconcile gender differences in an uneasy heterosexual relation, which various narrative genres have been telling over the course of film history.

Much criticism of technology has focused on its ideological assumptions, especially the unwavering faith in "progress," and the ensuing belief that there are technological solutions to all kinds of (social) problems. Langdon Winner, for instance, has named three contemporary paradoxes produced by the gap between the promise and the actual influence of electronic information systems, organized around the dubious attainment of greater intelligence, quality of life, and democracy through the assistance of machines.[1] While Winner's connection between television watching, Net surfing, and low voter turnout may elide the longer history of American distrust of politicians and deny the agency of television viewers, the consistency with which technologies, from the steam engine to the Internet, have been seen as potentially facilitating or inhibiting democracy is worth a closer look. The history of the depiction of computers in narrative films centrally reflects (or helps construct) the imaginary place of computers in American visions of power, individual freedom, and democracy – concepts which, despite their appeal to universal humanism, continue to be gendered in substantial ways.

Despite the fluidity of (non)identities promised in cyberspace, most films featuring computers do not unsettle gender binaries, nor the ensuing dominant association of women as opponents to technological "progress." But due to the parallel ideological imperatives of mainstream films to endorse both progress and heterosexuality, the opposition between women and computers is almost always broken down by the end of the film into a recommendation for the cautious embrace of new technologies. By considering historical changes in the narrative roles computers have played, we can see how technologies might influence the narrative depiction of gendered conflicts – and the role historically variant constructions of gender have and are playing in the imaging of the social function of these devices.

As computers became an everyday reality in the shadows of the atomic age, they entered into a very tangible tangle of faith and fear about the power of rationality to govern human life. On the one hand, computers were seen to be an extension of the triumph of instrumental reason characterized by the efficiency narratives of Ford and Taylorism. But along with the threat of nuclear annihilation came the concern that rationality was not all it was cracked up to be, and that instead of representing the height of human accomplishment, the computer illustrated the limits of rational thought. Often, this conflict of rational and irrational thought was staged as a gender conflict (or vice versa, depending on how you look at it). Walter Lang's *Desk Set*, for instance, concerns the struggle of women workers against the rationalization of their labor by their male superiors. On the one hand, the narrative thus revolves around the computerization of the all-female research department of a television station, and the resolution of these women to prove their superiority to the machine. But like the Luddites of the nineteenth century, they are at least as much concerned with their treatment by their superiors as they are with their struggle against the computer. As the "scientific management" of the women's labor is coded as male, while their idiosyncratic work habits are coded female, the film becomes as much a saga of the battle of the (unequally empowered) sexes, as it is about "progress."

The gender coding of the conflict does not end here. In the first test of the computer's superior efficiency for the network's male executives, the computer answers in a few seconds a mathematical problem which it took one of the researchers three weeks to solve. Sure that they will be replaced, and having all received pink slips due to computer error, the researchers then force the computer's uptight female attendant to answer the constantly ringing phones. The attendant then tries to get the computer to answer questions which require some degree of discernment, like the distinction between the movie version of a story and its historical counterpart. The computer cannot answer these questions correctly, and as the gloating researchers look on, the machine and its highly strung attendant seem to have a nervous breakdown.

The researchers (and, indeed, clerical workers in general) score a victory by pointing out the shortcomings of the computer's methods of reasoning. But the gendering of the machine continues to associate idiosyncracy and unreliability with femaleness by assigning the flawed computer a female gender. Underscored by the fact that "she" breaks down in unison with her female attendant, the casting of "Emmy" (short for Emorak) as female is part of what makes her unreliable. In this way *Desk Set* extends traditional value designations between the binaries male/female and rational/irrational. But, as with all romantic comedies, a more peaceful and balanced reconciliation has to be achieved, between male and female and, in this case, between humans

and machines. From this point forward the narrative proceeds toward the genre's conventional conclusion, the heterosexual marriage proposal: the computer, however, remains central.

Throughout the film, Bunny, the head of the research department, and Richard, the "efficiency expert," have been developing their romantic attractions *through* their arguments and misunderstandings about the intended effects of computerization. After the machine breaks down, Bunny is more willing to admit that there are some questions the computer is better able to handle, and to accept Richard's assurances that the machine will merely serve as a tool. Having made this headway, the film's conclusion stages the ultimate reconciliation of rational and irrational decision-making processes, male and female, human and machine, through the computer's mediation of the heterosexual contract. The scene mitigates the computer's potential displacement of human workers by underscoring its complete reliance on human input and admitting that even here it makes "mistakes": despite having been fed the "logical" conclusion that Bunny should marry Richard, the computer still comes up with the answer "No." As this is clearly an unsatisfactory conclusion for the genre, it is up to Bunny to defy the computer's advice, cast aside her too unemotional reasoning that "it would never work," and follow the irrational logic of love. The threat of the computer in *Desk Set* is thus domesticated – most obviously in its utility in the forging of a new heterosexual family.

Most atomic-age science fiction, however, did not see the computer – or its potential role in domestic life – as nearly so benign. In the "Second Wave" science fiction films of the 1960s and 1970s, for instance, the computer came to embody megalomaniacal technocracy, and in at least one of these films, Donald Cammell's *Demon Seed* (1977), this megalomania is imagined in the form of an abusive heterosexual marriage. Like a *Desk Set* for the 1970s, *Demon Seed* creates an equivalence between the fate of democracy in the face of computerization and the gendered power imbalances of an already troubled domestic sphere.[2] The ideological pull toward heterosexual reconciliation helps to mitigate the computer's threat, if not toward the "happy ending" of the romantic comedy, then at least toward a healthy ambivalence in keeping with the more contentious gender relations of the 1970s.

Demon Seed begins by establishing the marital difficulties between Dr Alex Harris (Fritz Weaver), a scientist engaged in the development of the artificial intelligence system "Proteus IV," and his wife Dr Susan Harris (Julie Christie), a child psychologist. The early scenes of the film feature Mrs Dr Harris accusing Mr Dr Harris of being too obsessed with his work to express emotion, which has stifled their relationship. They have agreed to a trial separation before the start of the film. As a psychologist, the female Dr Harris stands for the kind of science which

aims to facilitate the expression of emotions, while the male Dr Harris
practices the kind of science organized by task-oriented rationality.
Their marital troubles thus thematize central conflicts in science
through a heterosexual mythology of gender polarity (i.e. Women are
from Venus, Men are from Mars), and it is in this seemingly irreconcil-
able rift that Proteus is able to gain the upper hand.

Unlike Emmy in *Desk Set*, Proteus is decidedly male. To underscore
his parallel to Mr Dr Harris, he says "Reason is the only emotion I was
programmed to have." But for Proteus, an excess of reason leads to his
desire to know all, and hence to the study of the physiology and
psychology of the human organism, the only areas where he feels his
knowledge is lacking. In this way Proteus also mirrors Mrs Dr Harris, in
that he hopes to understand human behavior. The difference, of course,
is that Susan's desire for understanding stems from compassion, while
the inhuman Proteus seeks totalitarian power through knowledge. His
hybrid of their two sciences thus does not at this stage signal the pos-
sibility for reconciliation: he has instead perverted Susan's field (and
soon her lingering desires for her husband's company) by using Alex's
methods.

When Proteus is denied official sanction for his study, he begins to
force his will-to-know on his subject: Susan Harris. Because of their
separation, Mrs Dr Harris is alone at home, and while Mr Dr Harris may
not have cared whether she came or went, Proteus will not let her leave.
He holds her captive in their home through his control over the various
household security systems and service robots Alex has installed, and
rapidly subjects her to all kinds of physical violations. What began as a
desire to study the human organism soon becomes a desire to procreate,
to mate with Susan so as to produce an offspring which will supersede
both human and machine. Susan is, understandably, not agreeable, and
so a good portion of the film is dedicated to the tactics by which
Proteus wears her down in what can be best described as an abusive,
heterosexually coded, human/machine marriage.

After about six weeks, Alex catches on that something is amiss and
returns to their home, but not before Susan has gestated the com-
puter/human offspring for half of its required incubation period, and
transferred the creature to a pod of Proteus' design. Having succeeded
in procreating, Proteus shuts himself down, allowing the Harrises to go
and take a look at the child. Horrified by its machine exterior, Susan
proclaims that they should kill it, and a struggle over Susan's right to
abort the child ensues when Alex tries to stop her. In the course of their
tussle, the infant emerges, causing the feuding couple to pause and
discover that in fact a human body is encased beneath the machine
shell – a human body exactly resembling their all-human daughter who
died of leukemia prior to the film's beginning. As Proteus discovers a
potential cure for the disease in the opening scenes of the film, their

reanimated daughter's ominous statement in the voice of Proteus, "I'm alive," both warns of the success of Proteus' scheme to become all-powerful *and* underscores the hope that his discoveries might allow children afflicted with the disease to live. This final scene then enacts both the hopes and fears for complex computer technology – and for the reconcilability of heterosexual relationships through (machine-mediated) reproductive sexuality.

The cyborg, or human/machine hybrid, is a common fantastic entity in postmodern film, fiction and theory. In Second Wave science fiction, however, the cyborg is most often still seen as a creature viewed with horror, or at least ambivalence (as in *Demon Seed*). By the mid-1970s, however, these images began to change and become more sympathetic, as they came to represent the figurative vanguard of the human strug-gle against pure machines. The primary point of identification came to lie *with* cyborgs, as readers and spectators ostensibly came to see themselves more positively enmeshed with technologies, while still remaining suspicious of technologies completely autonomous of human control.[3] The popularization of the personal computer is often seen as the key factor responsible for this shift, as one recent commen-tator put it, "Mainframes were modernist, but computing slipped into postmodernism when people got *personal* computers."[4] The more sym-pathetic cyborg is thus related to the ability of heroically subversive hackers to counter the megalomaniacal mainframe computer, battling technology with technology. Modernism and postmodernism co-exist in this imaginary, where both consolidated and diffused power bases attempt to squelch the personal freedoms of alienated but autonomous modernist individuals, and/or the flexible, potentially lib-eratory non-identities of postmodern subjects.

The 1995 Irwin Winkler film, *The Net*, stages this sort of battle over personal freedom once again through the perils of heterosexual rela-tionships. The film's protagonist, Angela Bennett (Sandra Bullock), negotiates being single (and shy) by eschewing most in-person social contact. As she lives alone and works from her home PC, her employers and, indeed, most of her few friends have never actually seen her, com-municating always by phone, mail, or the Internet – contacts she apparently considers "safe." Her troubles begin when a co-worker sends her an unusual programming error which provides unauthorized access to various sensitive computer systems. When the corporate originators of the program discover this, they set out to kill her, but first stage her seduction by an assassin exactly fitting the description of the "man of her dreams" she posted in a chat room on the Internet. Ostensibly this plot element was necessary to retrieve the tell-all disk, but as the seduction exceeds this minimal function, it serves more to provide an intimate parallel to her struggle for freedom from computerized corpo-rate domination.

Like *Demon Seed*, the question of technological control is played out on a heterosexual field, but unlike *Demon Seed* the female protagonist in *The Net* is not defenseless in the face of the computer monolith. Through her ability to use computers, Angela destroys the conspirators' mainframe with a nasty virus sent from a networked PC, and through a much more basic technological scrappiness (the old fire extinguisher to the head) she is able to defend herself against her one-time lover, whom she finally kills in self-defense. The coincidence of these two resolutions underscores a reading of the film as a parable for human, and especially female, independence: from machines and abusive men. But as Angela continues to work with computers (and continues to be single), in the end, the film does not advocate a wholesale rejection of computers – nor necessarily of heterosexuality – but rather calls for a less naive engagement with both.

Desk Set, *Demon Seed*, and *The Net* thus reveal historical variance in the ways in which both computers and heterosexuality are narrativized. It is striking, however, that despite the possibilities for flexible identity categories that computers potentially offer, these films leave gender, race and indeed heterosexuality unproblematized as social constructs. On a good day, the virtual communities formed on the Internet allow people to be whomever they want, freed of the physical constraints of corporeality, geographical confinement, and socially inscribed identities. For Angela Bennett in *The Net*, however, this anonymity and fluidity also have a price, as no one can vouch for her "true" identity, once the bad guys change her name and give her a criminal record. Angela spends the bulk of the film trying to get her "true," physically inscribed identity *back*, and escape the murderous intentions of the man she mistakenly trusted. *The Net* therefore is in many ways a modernist tale of a heroic protagonist's battle against alienation by the bureaucratic system, a feminine version of Kafka's *The Trial* for the 1990s, and hence specifically anxious about the limits of postmodern fluidity, and the gendered consequences which ensue from misplaced trust, whether in computerized information or the "man of your dreams."

While all three of these films rely on the unchallenged gender binary of heterosexuality, some feminist and lesbian filmmakers find the fluidity of postmodern (non)identities more liberating than threatening. Shu Lea Cheang's *Fresh Kill* (1993), for instance, plays with the possibilities of postmodern fragmentation and fluidity signified by vast and decentralized social and technological systems of information exchange. In this "cyber-ecological thriller," the networked personal computer sporadically delivers cryptic political messages from various groups across the world, in protest against toxic waste disposal practices and the contamination of food products. In keeping with this internationalist vision, Cheang purposely disregards visible racial difference as a marker of kinship, casting actors from conspicuously different

racial backgrounds as relatives. While keeping the structural character-istics of traditional families intact, this strategy denaturalizes the biological grounding of family genealogy, thereby making the lesbian (nuclear) family at the center of the film as plausible as any other. While not a central character in *Fresh Kill*, the figure of the networked personal computer, with its multiple voices, functions to underscore the strategic similarity between the film's casting choices and the fluidity of an unspecified cyber-identity like "Freaky Deaky in New York City." Just as lesbian kinship may be based on any number of similarities and differences, so the absence of a heterosexual coding of machines liber-ates the story from the kind of gender oppositionality so central to the narrative strategies of the other films. Cheang's progressive postmod-ern world thus no longer divides people by identity categories of gender, ethnicity, geography, or sexuality, but rather concentrates on the primary opposition between sinister corporate and radically demo-cratic uses of technology.

As with other potentially empowering, subversive technologies such as cable access television, however, *Fresh Kill* depicts the activists' mes-sages received over the Internet as confusing, and hard to interpret. Cheang seems to be making the point here that although there is power in the ability to use these mediums for activist purposes, the kind of engagement they inspire is fragmented, distracted, and hence not *automatically* effective. There is more work to be done to truly accomplish the potential the technology has for the defense of democ-racy.[5] In the end, all of these films, though reflecting different moments in the history of the narrativization of human relations to computers, recommend *cautious* endorsements of new technologies. Both the progressive politics of *Fresh Kill* and the often conventional images of the gender and sexuality of computers in the other films meet on at least one significant point: that the social problems of the world into which these technologies are invented require political, not merely technological, solutions.

NOTES

1 Winner points out that while machines have become "smarter," the basic skills of the less economically advantaged have deteriorated. He challenges the promise of greater leisure by pointing out that while electronic technologies facilitate productivity, they also make it necessary to be available in unprecedented ways. And while television and computers hypothetically make information easier to obtain, the voter turn out rates are as low as ever and the American population is perhaps destructively cynical of the political process. See Langdon Winner, "Three Paradoxes of the Information Age," in Gretchen Bender and Timothy Druckrey (eds) *Culture on the Brink: Ideologies of Technology* (Seattle: Bay Press, 1994).

2 Other examples include "Alpha 60" in Jean-Luc Godard's *Alphaville* (1965), "Colossus" in *The Forbin Project* (1969), and of course "HAL" in Stanley Kubrick's *2001: A Space Odyssey* (1969). In these narratives, Mary Shelley's classic Frankenstein story is given various twists: just as Dr Frankenstein sought to circumvent God and nature in reanimating a creature pieced together from dead human bodies (and hence violating the "divine" and "natural" boundary between life and death), so too do the scientists engaged in the creation of "artificial intelligence" risk their creations turning on them as a consequence of their violation of the boundary between human and machine.

3 Peter Fitting points out this shift in the difference between the androids in Philip K. Dick's *Do Androids Dream of Electric Sheep?* (1968) and the film adaptation, Ridley Scott's *Blade Runner* (1982). In the former, the androids represent the non-human and so torment creatures weaker than themselves, whereas in the film they are recognized as an oppressed group and hence appear unjustly persecuted. In William Gibson's novel *Neuromancer* (1984) the nearly omniscient artificial intelligence entity (or AI) named Wintermute is still seen as a fear-inspiring consolidation of corporate power, while the mostly human cyborg characters, Molly and Case (who each have machinic implants), are on the whole sympathetic. See two articles by Peter Fitting, "Futurecop: The Neutralization of Revolt in *Blade Runner*," *Science Fiction Studies* 14 (1987): 340–54; and "The Lessons of Cyberpunk," in Constance Penley and Andrew Ross (eds) *Technoculture* (Minneapolis: University of Minnesota Press, 1991). With the publication of Donna Haraway's ground-breaking essay, "A Cyborg Manifesto," in 1985, the liberatory potential for the boundary-exploding cyborg hit both a popular and theoretical stride. See Donna Haraway, "A Cyborg Manifesto: Science, Technology and Socialist-Feminism in the Late Twentieth Century," in *Simians, Cyborgs and Women* (London: Routledge, 1991).

4 This is the enlarged pull-quote in "Sex, Lies, and Avatars," Pamela McCorduck, *Wired* 4.04 (April, 1996): 108–109. The article is a profile of the sociologist of cyberspace, Sherry Turkle.

5 Similarly, the postmodern strategy of interpretation, flexibility and diversity which unseats the logic of assignable family lineage is effected, ironically, by precisely the visible recognizability of racial difference in the actors: if it wasn't visibly obvious that the actors were Asian, Native-American, Latino, African-American, Indian, and European American, then the non-biological grounding of kinship in the film would not be apparent. Such is the paradox of postmodern (non)identity politics – and the limits of the visual form.

8

Taylor's Way: women, cultures and technology

Sara Diamond

The frenetic quality of cyber hype masks an intensity of change and an intensity of stasis equaled only by war. When the lens focuses at last, the focal plane appears blurred. Like the rest of the twentieth century, it is a time for questions. What, if anything, is the meaning of women's increasing presence within the new media industries, whether they are communications, content, software or technology industries? What are the stakes for the technologically challenged and marginal? What reconciliation could be imagined between the potential of undermining gender identities and the power of asserting categories, especially those denied, class, gender and race?

There is nothing inherent in digital technologies that transforms or subverts gender identities. The organization of these technologies may allow new kinds of interventions and experiences.[1] I am describing and asking questions more than making definitive statements and I acknowledge the important ways that feminist and sexual liberation movements have troubled the category of gender. It is important to explore current images of incorporation and resistance in the shifting worlds of digital media. This may be harder to do than in the past, as culture is the key commerce of the Net, creators have little distance. We implicate ourselves and experience a rapid pace of co-optation.

There are aspects to the social and cultural applications of certain digital technologies that allow shards of optimism. The Internet and the World Wide Web are communications systems, not; Netheads have proven its ability to manufacture a non-geographic or biological community or organization. Other points of light are the assertive creative and critical interventions of women into digital content, the growing numbers of women within the technology sector and in the communications industries.[2] Finally, the effort of some groups of workers to define the design of technological change is worthy of celebration.

It's simplistic to state that gender conflicts preceded digitization and have carried over into digital space. Still, women appear to be a minority in cyberspace. Work patterns of prior industries are partially embedded in the Net. All of the bad gender habits of computer science, engineering, the television and feature film industries and high finance sectors have transferred to new media. If you doubt this, just flip through the back issues of *Wired* and count the number of women featured on the cover. Sherry Turkle on the April North American cover is the first featured cyber femme in years (and one would think that attractive women on the cover would help boost sales to the mostly male readership).

These days the Net spans mass and sub-cultures. The Web is a valued marketing tool for an increasing number of businesses. With advertising and big industry have come unchallenged patriarchal imagery and conservative values. Still, there is the playful and willful use of new technologies to challenge gender and other oppressively fixed identities

by VNS Matrix and other cyber femmes. Not that they ever were safe, but there is increasing trouble in the cyber corridors of power.

The notion that cyberspace is a feminine space of fluidity and undefined identity is utopian. Optimistic theorists such as Sadie Plant or Nell Tenhaaf have argued that the Net provides a unique pre-Oedipal space of no fixed identity.[3] The category of gender is itself delineated by differences of race, class, sexuality. Concerns of basic democracy such as two-way access to communications systems, education and the means to make a living are at stake in discussing technological change and the design of technologies. The inclusion of the culturally marginal can be misread as democracy rather than the insatiable hunger of commercial culture for new images and markets.

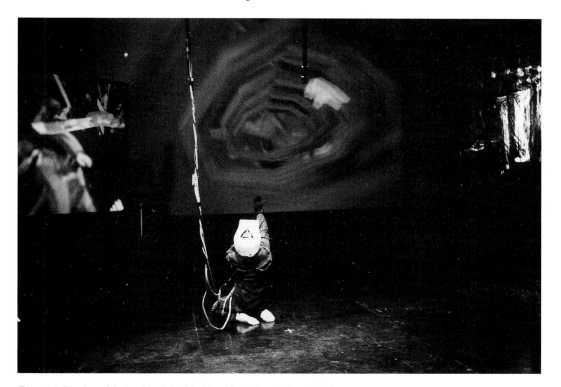

Figure 8.1 Dancing with the virtual dervish; Diane Gromola and Xacou Sharir

There is still a moment of victory when cultural machines take possession of sexual subversion, just ask Mae West. Who can ignore the current presence of lesbian plot themes in North American cinema and television? The fact that this coincides with a moment in which a traditionalist ideology is militantly reasserting itself underlines the complexity of resistance and absorption. Internet spaces are rapidly being swept up by the passions of the New Right and capitalism. In Canada, the telephone companies argue ardently to deregulate access

to broadcasting yet support content policing. Broadcasters beg for top-down regulation. Gender politics and the protection against offensive content, as well as national identity offer the core arguments for regulation. At the same time public spaces where issues can be debated and images contested are diminishing. Still, deregulation is very attractive. It's been government funding more than regulation that has allowed strong, alternate Canadian cultural expression to emerge.

Work remains organized by gender. In other words, what kind of work you perform depends, in great part, on how you are configured biologically and positioned socially. Women work at the low end of high-tech manufacturing, few are in management and even fewer are key decision-makers. Within the new technology industries, whether software or communications, there are few women CEOs, except at the head of smaller companies. In a corporate era marked by a resurgence of individualism, women are positioned either as anonymous end users or production line workers.

While representation and experience are very separate categories, it is instructive to look at images of women in the technological workplace currently and in the past. Industrial workers were already part of the representational ethos of the machine from the late nineteenth century onwards. In photographs, women industrial workers stood respectfully at attention, a compliant army, a cog in the assembly line. The photographic act sanctioned their social position and stance. In the 1990s, the image of technology itself has almost completely replaced the worker. Human labor power when present is a sign of nostalgia; humanness has been completely absorbed into the design of the machine. In the early images, apparent compliance masked the actuality of resistance. Will this happen again?

Amongst other things, I have taught labor history and developed creative projects with unions for the last twenty years. This contact has permitted me to watch the cybernetic revolution in action. Workers have certainly achieved resistance and empowerment.[4] For example, Canadian postal and telephone workers were successful in resisting surveillance throughout the early 1980s. Still, for many working women this process has been a tale of psychic and physical woe, a fabric woven of isolation, loss of skills and monitoring. Technological change has entered industries that were paternalistic and heavily supervised to begin with, such as the telephone companies. Networked communication has reinvented a social sphere at the same time as it intensifies labor and isolates workers. Email messages circulate around the workplace, multiplying like aggressive flies, landing on unsuspecting laptops far from the source of contention. Where I work, there are thousands of daily on-line exchanges in our building alone.[5] This hemorrhaging of unnecessary information can create a populist sense of false democracy.

At a recent one-day conference of labor women, I sat in on the session about technological change. The particular union included women professionals and clerical workers. At the low end of the pay scale women were losing jobs, such as in switchboard operation, word processing and filing. The professionals, some of whom had recently fought their way into male-dominated jobs, were also experiencing loss of skills. It was expected that they should absorb clerical work into their routines. Home work was also being promoted as an option by this company. The union debated whether or not to support retraining and how best to resist technological change and the loss of jobs.

The women were momentarily overcome with the sheer Luddite impulse to refuse technological change altogether, but ultimately bent to the acute pace of implementation. One activist suggested that the professional women should refuse to have a computer on their desk or perform any home work, thereby protecting the current division of labor. Ironically, the union representative confessed to me that, as a working parent, she found working at home on her computer incredibly valuable, but had given it up in solidarity with the workers she represented. I was struck by a sense of desolation. I thought about how as an artist and writer, privileged indeed, I had found the laptop computer and home work liberating. This differed from employment in an institution or company, where twenty-four hour access means no respite from the workplace. The issue becomes control, who determines the work you do and its pace.[6] The union women are fighting a more fundamental battle: would jobs continue to exist for them? By the end of the workshop we focused on ways that they could design new job categories based on their knowledge and the workplace needs, and use their union to negotiate training for these.

Scientific rationalism and, specifically, the ideology of Taylorism continue to invade intellectual and cybernetic production in the workplace. Taylor's basic idea was that we can quantify all labor. Capitalism offers proof of its capacity to penetrate and make commodities of all human interaction and process. It moves from the personal to the social sphere. Confessional daytime television is yet another indication of this dynamic, substituting a commercial, public address for the emotional work once associated with the family. Computer production favors the geometric, organizing knowledge into moveable compartments.[7] Knowledge workers (once known as teachers) can attest to the dramatic reorganization of work. Their role is shifting from originating and structuring learning and interpreting meaning, to orienting the student and functioning as personal trainer.

There is a contradictory restructuring of knowledge. As I write, the Internet remains hybrid, accessible and defiant of regulation. At the same time, an ideological perspective drives the privatization of data and the choices for inclusion into the digital archive. Vast amounts of

Canadian archival material are about to be lost as our National Film Board is dismantled. The rationalization of knowledge has prompted battles for inclusion whether into archives, history modules, or interactive services. Apple, under pressure from the New Right, recently decided to remove sections on American labor history from standard interactive teaching materials. The word went out on the Net; many wrote to protest their decision and Apple reinstated the course material.

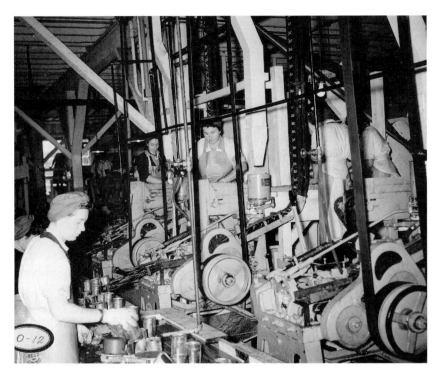

Figure 8.2 Women at work

Non-linear editing systems are powerful tools for organizing large visual and sonic data bases. At the same time, these intensify productivity within the information economy in a formidable way, heightening output expectations. The fate of female media editors is still unknown. In many countries, women dominated the film editing business as creative editors, and had a reasonable presence in television post-production. Complex on-line suites requiring mathematics pushed many women out of the business. A 1992 study by the Australian Film Commission noted that women were losing ground. Now, non-linear systems and compositing stations provide an inclusive alternative where technological prowess no longer needs to dominate creative skill. This point is relevant because women tend to enter technology fields through different routes than men.

Independent video in Canada now centers upon the exercise of identity, whether through self-reflection or political action. *Mirror*

Machine, Video and Identity, a recent Canadian publication, "takes as its central focus video's representational vocation."[8] The essays suggest that video art and independent documentary adopted and permitted a larger social narcissism that was critical to the exercise of voice by the displaced. Women, communities of color, aboriginal peoples, sexual sub-cultures, gays and lesbians, have used video as a penultimate tool, creating new narratives or testimonies. There has been great urgency in this project. The act of claiming cultural space, while tired for some, remains a crucial strategic urgency for others. Cyberspace continues the tradition of staking out territories but eradicates the ability to test authenticity. Part of the early attraction of cyberspace was the mutability of identities.

This is equally true in the workplace. Networked working women describe a virtual masquerade. Fellow workers assume that men hold certain jobs and that some forms of speech are masculine. Men expect supervisors and regulators to be men and accept assertive behavior. At the 1994 Labor and Technology Conference a remarkable confrontation occurred between the genders. A female health and safety supervisor who used her surname to communicate with fellow workers in a distance site met a man who realized that she was the regulatory officer he worked with at a distance. In a passionate intervention he expressed his sense of betrayal, "if only he had known," (he would not have taken her instructions so seriously?). Ultimately this fellow and others in the room stated the need to know the biological identities of the communicators in order to know how to appropriately respond. They looked forward to video conferences or visual identification on the Net. The women expressed the exact opposite desire; they welcomed the freedom from their bodies. In a culture organized by gender, power lives in ambiguity.[9]

Invented by humans, machines and tools have always acted back on the human body and psyche. Human culture and survival depend in part on the technologies that we invent. Some artists who engage with technology focus their attention on its transformative effects on the actuality and ideology of body, pushing implications past comfortable boundaries. A yet untapped alliance may exist between union women based on their need to resist or shift the impact of technology. Context and stakes mark the difference between telephone company workers who stage collective scream-ins to protest surveillance and lengthy work weeks and Stelarc or Orlan. Stelarc, the Australian body artist literally wires himself into machines, losing limits and boundaries. His art is painful, embodying loss, and scarring, marking new technological and human identities through ritual. Orlan undergoes plastic surgery on-line, becoming more cyborg than human with each successive cut.

Artists such as Catherine Richards, Toni Dove, Brenda Laurel, VNS

Matrix, Jane Prophet, Buffy Ste Marie or Char Davies, have gravitated to the Net, virtual space and interactive media. They are compelled by new forms of narrative, the desire to erase and play with identities, the malleability of the body in virtual environments, and problems of gender and space. Cyberspace permits the appropriation and transformation of popular culture and fixed behaviors. These women play with the danger and the potential of new media. In the early months of 1996, volumes by women Web designers flooded the market, a phenomenon akin to the explosion of feminine presence in early video art.

Women's presence in part signifies the interest of larger creative communities on the digital highway. On a practical level the Net facilitates organizing projects and distribution. There is a sense of urgency, of shifting ground. The explosion of CD-ROMs and the Web has prompted heightened competition and investment. The previously described meeting of identity stake-outs with attempts to destabilize identity on the Web can be very uncomfortable. The practices of self-regulation and community responsibility are

Figure 8.3 Jantzen, 1930s swimwear, Vancouver

fast being displaced by the regulating attempts of national states as the World Wide Web leaps from sub-culture to mass media. This is a loss, for the Net has achieved a new geography of responsibility, one that displaces the pressure for authenticity onto discourse and context, away from the body.

All of this occurs within the current quicksands of deficit fever. Economic trends reinforce social class divisions. There are specific impacts based on the social and material differences of men's and women's lives. We live at a time when access to technology along class lines, and therefore race lines, is about to become more difficult. There is an increased visibility of women in corporate leadership roles in the interactive media industries. It seems important to differentiate between these positions and actual policy power. In some instances, such as DaVinci Time and Space, led by Carol Peters, the company is a woman's initiative, committed to creating media appropriate to the needs of female as well as male children. In Canada the telephone companies have dived into content development. There are more women present in the telephone company structures than in the cable, publishing, television or film industries. Stentor Canada, the supercompany that unites all Canadian telcos has a woman policy leader as does Telus, based in Alberta. Still, according to Canadian Women in Communications, many women in vice-presidential positions head up public relations or sales areas, not development, policy or production.[10]

Cultural industries and technology companies still remain rigorously masculine in bias and leadership. Women do need to influence the ways

in which technologies emerge. Most women still have different material needs from men because of family responsibilities. We need alliances between institutions, communities and creative groups. Women need to take up positions of power as well as to create alternate institutions.

Canadians face specific problems based on the deregulation of our market place and its vulnerability to massive American cultural dumping. This in turn produces complicity with American dominant culture; the cultural industries learn to be effective mimics and thus gain their American market share. This is a contradictory moment in

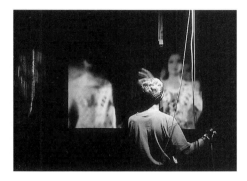

Figure 8.4
Archaeology of Mother Tongue; Toni Dove and Michael MacKenzie

Canada, one that brings together the old systems and the new. The old regulatory system (the Canadian Radio and Television Commission) licensed a series of contested cable channels for the new multichannel universe. These included a women's channel (Women's Television Network), a cultural channel (Bravo), a Canadian science channel (Discovery), news, country and western, lifestyles and sports channels. All specialties have embarked on major projects with independent producers, creating a national presence for their work. All emerged at a time when a generation of women had matured into the broadcast arena, signaling a small but important shift of power. All of the CEOs and key staff at WTN are women; the head of Discovery Canada is female and so are many of the program heads. The development staff at Bravo are women. Representation is an issue for these women.

These new channels immediately became contested sites for three reasons. Subscribers had to contend with coercive negative billing, a system in which they were charged first and then asked if they wanted to drop the new channels. Channels received a thorough slamming by the traditional national media, led by the Canadian Broadcasting Corporation, a public entity that saw these channels as direct unwanted competition. The high level of alternate content, especially on the Women's Network and Bravo Canada, is exciting New Right vocal cords.[11] Ratings remain low for the new channels, with advertising revenue and hence survival threatened. These channels combine market-driven activity with public space – prefiguring the potential of a more eclectic information highway. The stakes are painfully high. If they fail, it will set back the possibility of "special interest" commercial support for many years. The odds are not in their favor. In the cultural industries there is increasing vertical integration as producers, distributors, networks, software and technology companies merge.[12]

Let's speak for a moment of another net. Canadians have caught international deficit fever from south of the border. In a paroxysm of self, they are supporting the shredding of the social and cultural safety

net. This net operates in our context differently from the United States. Canada rationalized public sector investment as a bulwark for Canadian identity. The cultural net is a method of nurturing specific expressions of our seemingly fragile nation without challenging the nation as a form of oppression itself. It was cultural funding that enabled specific cultural communities including feminists and lesbians to move from protest into production. This expression of identity, at the core of Canadian cultures, has become increasingly inclusive of difference at a time when difference is being eradicated or leveled within the corporate world, in favor of global culture and a loss of tolerance. Legislative initiatives and a virulent campaign by the New Right are resulting in the privatization of access. We are seeing an end to public television, libraries, public education, and the emergence of the shopping mall where protesters are immediately arrested for trespassing.

The safety net is made up of specific structures: granting agencies, human rights commissions, unemployment insurance commissions, local school boards and hospital boards; these, in Canada, are relatively democratic. The social safety net has freed women from an overbearing responsibility for family health care, childcare, education; it has provided support for working mothers and made a decent standard of living possible. The sexual division of labor, still very much in place, means that women take up the slack as state services collapse. The erosion of public space allows us to sidestep the problem of the "public." The notion derives from the separation of church and state. It originally related to the liberal notion of a space of political discourse and democracy and enforced collective responsibility for the well-being of the community. It was this public space where recent battles for racial and gender equity were fought out; we entered at the precise time when the public is breaking down. In contrast, the New Right rejects social or public responsibility, placing the responsibility for survival on individuals or "God."

Back to work. The cultural and economic framework is shifting at a time when the organization of the workplace is undergoing massive change. More workers are wired, in touch with their employment on a constant basis. Surveillance is naturalized into the workplace and there is increasing compliance with this new sense of public space. More workers understand that their command of information and cultural skills (such as desktop layout) makes them more competitive in the job market. The fantasy of increased leisure time through the cybernetic revolution is precisely a fantasy. Regular structural unemployment, however, consigns individuals to the margins. At the same time, women have made gains in power and status within both workplace and representation.

The cultural space of the Net has added value for those who swing between work and enforced leisure. As unions and local communities

disappear, individuals are isolated. They are left to self-defense or the construction of new forms of solidarity. Increasing technical literacy, an accessible communications environment and a need for collectivity may create the conditions for an on-line class and gender revolt.

NOTES

1 In my remarks I continually use the term "woman" at the same time as I pose different relations of power surrounding this term. By "woman" I mean those who function in this world as women, either biologically or symbolically taking up a traditional space within a patriarchal order or who patriarchy marks by their difference when they step into arenas still traditionally reserved for biological men.

2 One example worth exploring is The World's Women On Line, a project initiated by Muriel Magenta of Studies in the Arts, Arizona State University, Tempe, (muriel.magenta@asu.com) which collects texts and images by women artists.

3 Tenhaaf writes in *Immersed in Technology*, (Cambridge, MA: MIT Press with the Banff Centre, 1996). Plant, an academic and theorist has spoken extensively about the potential of cyberspace to be genderless, for example at Video Positive, Liverpool, 1993, and more recently on the Canadian Broadcasting Corporation.

4 In the 1970s and early 1980s the postal union and the telephone workers across Canada struggled to assert their rights to veto new technologies that had negative effects on health and the quality of working life. The postal workers successfully defeated high levels of video surveillance, for example.

5 We recently counted the number and type of exchanges in our building. Many of us are encouraging a return to face-to-face for discussions that have an emotional quality attached.

6 The conference took place in February 1996, in Vancouver, Canada.

7 Lawrence Paul, a Haida painter, developed a virtual reality piece with the Banff Centre for the Arts. During the creative process he constantly remarked on the imposition of linear western forms and perspective on computer graphics. It was almost impossible to privilege the circular forms so central to Haida aesthetics. The piece is entitled *Inherent Rights, Vision Rights*.

8 *Mirror Machine, Video and Identity*, Janine Marchessault (ed.) (Toronto: YYZ Books, 1995).

9 Labor and Technology conferences bring together unionists, cultural producers and academics to discuss current and future implications of labor and technology. The last conference took place at the University of Minnesota.

10 The CWC represents women in large telecommunications and cultural industry companies in Canada. They lobby to bring women into top management and effect policy. They have surveyed the position of women in management and found that they are few and far between, and there is a glass ceiling. Women do lead smaller companies and independent production houses.

11 Negative billing means that subscribers are automatically signed up. They can only refuse the channel after the fact. This angered many people and resulted in a hysterical campaign against Rogers Communications, the largest cable carrier, and the government's CRTC, with a trickle-down hatred immediately aimed at the fledgling channels.

12 Disney now owns and has copyrighted the Royal Canadian Mounted Police image.

part two

Bodies

9

Indiscretions: of body, gender, technology

Ira Livingston

1

What is the shape of a human body? Moving through space and time, bodies wriggle out sinuous, snaky forms. With this moving picture of the spacetime body, one could begin to ask how body shapes tend to differ by sex, class, culture, historically. My body forms a series of zigzags across the USA, mainly; a frenetic series of smaller zigzags between home, school, work; even smaller zigzags of eyes and hands across paper, texts, screens, bodies. In any case, the multiple scales of such a shape make it a *fractal* structure; a body irreducibly *scaly* and *kinky*.

The shapes of collective life make the earth a Medusa's head. But these snaky things are not so discrete; the muscles and brains that orchestrate their wrigglings are as much external as internal to them, and they leave wakes that widen out into the future: wakes of deaths, babies, buildings, books.

We are still swimming in the wake of The Modern Body.

2

Historians of bodies (see Duden 1991: 165–70; Laqueur 1987: 116) tell us that the premodern body in the West differed radically from the modern body which began to displace it in the eighteenth century. Radically porous in both its internal and external boundaries, the well-being of the premodern body depended on its openness to influxes and effluxes with the world. This body was also subject to the subtler flows of "sympathies" not only between it and the world but between its own internal flows. Even menstruation, for example, did not define a categorical difference between male and female anatomies, since it tended to be understood as one instance of a general ecology of fluids to which all bodies were subject; men or women could menstruate through their noses or the pores of their skin; bodily fluids were themselves fluid. Two things need to be said lest this openness be romanticized: first, that premodern sexual difference was not construed as difference in kind but in degree, female being construed as isomorphic but inferior; and second, that bodily openness entails a vulnerability that makes distinctions the subject of taboos and constraints.

In the eighteenth and nineteenth centuries, the so-called modern body was configured as a defended citadel: "a mighty fortress is our God." The discretion of its external boundaries with the world, its closure, was established along with the discretion of its internal organs and systems. Disease was made less an ecologically dynamic and socioculturally integrated phenomenon and more the effect of a discrete agent. A single discipline, medicine, established a virtual monopoly over the body in place of the range of kinds of practitioners who had

previously ministered to it. Monopoly disciplines and monopoly capitalism emerged hand in hand; the economic and organizational mandate for each, and for the body configured in their image, is hierarchical or vertical integration and monopolistic control, coded as Western, male, and middle class against a range of other more indiscrete bodies.

The modern *machine*, understood as an assemblage of discrete parts articulated to perform a specific task, came also to be opposed to the *organism* as working-class labor was opposed to professional work, the professions evolving as autonomous, hierarchically integrated and self-regulating, while artisanal and other kinds of labor were made increasingly subject to Tayloristic control. The exemplary postmodern machine, the computer, differs from the traditional machine in that it is reconfigurable and multi-functional in the interaction of "soft" and "hard" ware; opened to engagement in networks, it is subject to new dangers by virtue of its interdependence, necessitating not simple prophylaxis but *damage control*. Like the virus, the computer is maximally connected horizontally, making it subject to viral interference, but unlike the virus it has a vertical and hierarchical structure that makes it vulnerable, puts it at risk.

The postmodernization of the immune system has produced *flexible bodies* (Martin 1994); not defended citadels but radically porous, dynamically engaged and engaging. The Berlin Wall is dismantled and, in California, Proposition 187 is passed, insidiously admitting unregistered workers (on whom the economy depends) while rendering them non-persons. The discretion of bodies is increasingly belied by evidence of their implication in interdependent infrastructures where they are wired in and subject to stress as their privileged dysfunction. Another caveat is in order: reconfigurability and fluidity should not in themselves be celebrated as democratic openness: the mandates of postmodern incorporation are largely driven by the relentless logic of the postmodern corporation, which replaces vertical integration with outsourcing and horizontal partnerships, long-term capital investment with the terroristic mobility of international capital, workforce stability with continual de-skilling, re-skilling and temporary labor: these are the sharkish, swim-or-die logics of late capitalism.

Postmodernity, then, cannot be characterized as a "return" of the premodern, since what modernity imposes over all phenomena is precisely the distinction modern/premodern; it is instead what *disturbs* this distinction that merits the name postmodern. If modernity's colonization of all realms of human activity has been thorough, it has also always been contested at every point and at every moment, subject to the unconscious it produces through its primary repressions and exclusions, to its Others who are both marginalized and granted a certain constitutive agency even as this agency is construed as criminality or pathology.

3

Technological determinism attributes sovereign agency and shaping power to technology, provisionally at least even by putting it in the subject position in a sentence: "How do new technologies change our understandings of ourselves?" Perhaps we understand that this is just a way of speaking, like saying that the sun rises; or that it is a way of opening a question, the first move in what must quickly become a dialectical dance marathon between "technologies" and "ourselves," one which often ends with the same two tired partners. On the other hand, it is almost as easy to start by saying that technology is shaped by culture: "How do we enact our changing understandings of ourselves through new technologies?" Even with careful reminders that culture also comprises material and technological practices, this formula usually remains in the old orbit of idealism, as if "ourselves" and our "understandings" come first and are then merely expressed.

These two gambits tend to structure discourse on the body as well: a "constructionism" in which passive, soft flesh is configured by culture; and an "essentialism" in which the body represents a bottom line of certain biological constraints or identities that are, in effect, irreducibly prior to any discourse that may take them up. These are caricatured versions, usually presented as straw men so that the presenter can "problematize" or "complicate" or "deconstruct" them, a maneuver that usually has the effect of re-installing the caricatures.

The repeated loops of the circuit between these two gambits are themselves a kind of argumentative machine, a discourse generator, an episteme-engine. As Bruno Latour has pointed out (1993: 51–5), this exemplary modern machine usually functions to induce another division within each party to the dichotomy, between the "hard" part, that seems to be an unconstructed agent, and the "soft" part that is shaped by the other (e.g. sex and gender, in the classical formation). In other words, the machine perpetually downloads its binary program.

How can we rethink bodies and technology not as agents and patients, not as constructed or constructing, not as hard or soft but rubbery and slippery? Not as the payoff of a long argument but as a starting point? Start by thinking of machines as displacements and condensations of constellations of social and economic practices and relations, epistemological assumptions, ideologies, natural laws, contextual engagements, etc. It is precisely the machine's overdetermination – the impossibility of reducing it to a single function, of making it work perfectly smoothly – that makes it semi-autonomous. Such a machine thus constitutes a kind of *fetish*, and in all of this does not differ from the body. It is important here to resist Freudian or Marxist pathologizations of the fetish whereby proper sexual investment erotizes the genitalia (not a detachable part or a certain vignette) or

whereby value properly inheres in human activity and relations (not in their alienable products). The way to resist these regulatory regimes is to recognize fetishization as an exemplary form of embodiment: "embodiment is significant prosthesis" (Haraway 1991: 195). A fetish embodies a contradiction, never simply to resolve or neutralize or transcend it but to animate and activate it, to prolong it.

4

In her compelling essay "The Lesbian Phallus," Judith Butler omits the word "dildo" in characterizing the "plasticity, transferability, and expropriability" of the phallus (1993: 61). Butler's strategy works to foreclose a reductionist reading by taking seriously Lacan's dictum that "the phallus can function only when veiled;" discourse is secreted around it rather than flowing through it. I want to put the dildo back in, for a moment, as an epistemological device, to think about its implications for prosthetic embodiment.

What most readily appears about dildo use to one accustomed to thinking of sex as a non-cyborg activity is that the use of a dildo involves a certain asymmetry or even incommensurability in the economy of sexual pleasure (making it exemplary for various other sexual practices); that is, between the kinds of pleasure given and taken. This characterization is often made to function as a foil to the perfect reciprocity of pleasure supposed to attend genital sex, but it can also provoke recognition that sexual "intercourse" cannot possibly be reduced to an exchange of orgasm-for-orgasm even if mutual orgasm is involved; in fact, a sex of simple reciprocity ("apples for apples"), if it exists, which I doubt, might merit the term "homosexual." Such a completely rationalized sexuality would resemble the dream of a global capitalism in which all exchanges are reconciled in a single economy, as against a "gift" economy structured around the impossibility of reciprocation. In such an economy, the gift produces obligation; that is, the gift by definition cannot be returned in kind. On the other hand, then, where the kinds of pleasure and the economies in which they signify – that is, what each partner gets – are multiple and to some extent incommensurable (either between partners or for an individual) the act or relationship may well be said to be "heterosexual." Needless to say, many of what are now called homosexual acts and identities are exemplary here. Where no single meta-economy can absolutely regulate, reconcile or even discretely enumerate the multiple economies at work, the question of what is happening at any given moment or of what kind of relationship it is or could be will be somewhat volatile, continually under construction. I will discuss the consequences of this volatility in a moment.

Butler's question, "Does heterosexuality exist?" must be answered in the negative if hetero is taken to mean binary difference, which is not

sexy, not really difference except in a radically neutered sense, positively dysfunctional as the sole operator even of straight sex, which also has to be much more local and playful and potentially disruptive even if part of straight (especially masculine) identity has depended on the denial of this fact. Furthermore, then, sex can be sex only as it *also*, though not exclusively, displaces and condenses other kinds of relations that are not explicitly sexual.

In so far as straight genital-to-genital sex allows a simple and false equation between pleasure received and given, that is, in so far as it allows sex to be bracketable from its multiple economies, it follows that the dildo is both more *attached* and more *sensitive* than the penis. At the same time, a dildo is more obviously not simply a switchboard or relay that channels and regulates, more like a productive obstacle that libido flows around, like air around a wing whose asymmetry produces both uplift and turbulence. A way of generalizing this figure is to say that sexual difference operates among us rather than between us; if it divides us, it divides us from ourselves as it does from others; it is a *fractal* difference.

A linear relation requires at least one autonomous agent who is the originator of his acts and sole proprietor of his body: the capitalist and existentialist "free agent"; the "liberal subject" of modernity. It does not demand one party to act monolithically as subject and the other to be exclusively objectified, and you underestimate its sophistication if you leave it at that. Rather, its meta-economy, its endlessly deferred heaven of just rewards, works by holding out an ideal space of final analysis where "in the end the love you take / is equal to the love you make." The effect of this deferred reciprocation may construe the parties as having in effect both "soft" and "hard" parts, but the important thing is that it allows the relationship to be construed as "soft"; entirely subject to being made by the parties rather than vice versa (the fiction of the free market or liberal social contract): it is the one-and-only-one straight line configured by the two points, a workable definition of "straight." If the "strange attractor" of non-linear desire is always already configured in a complex play of projections and introjections, partly inertial and repetitive and partly mutational, in what sense can I say that my desire is my own? Who is servicing whom and in exchange for what? If sex is impossible without a significant element of this kind of non-linearity, and if such non-linearity has characterized feminine sexuality, that is, if a woman is someone for whom the statement that "sex is also not sex" is more likely to make sense, then the upshot is that there is only one kind of sexual relation and it is, in effect, a lesbian relation. I would like to say furthermore that everyone knows this.

Non-linear systems are both more volatile in their vulnerability to certain small and often unpredictable variations, but also, finally, more stable, able to reconstitute themselves in the face of otherwise

devastating shocks. The important point here is that in practice this economy is not perpetually shifty; quite the contrary, it is its inherent shiftiness that requires that it be negotiated, that it be constituted as this negotiation; juggled with care if it is to stay in the air. It is the fiction of a rationalized and linear economy, on the other hand, that must be sustained by violence and vampirism. I am not quite happy with the legalistic sense of the word "negotiation," but my dictionary does say that it means "intercourse with a view to coming to terms on some matter." The non-linearity of negotiation is operative in so far as what the parties negotiate are the terms by which each will be construed as competent parties to the negotiation; it is this contradiction between being always already constructed and continually under construction that now animates gendered bodies.

5

In her essay "Virtual Systems" (1992), A. R. Stone writes about technologies such as Virtual Reality, electronic conferencing and phonesex as "narrow bandwidth" media: unlike face-to-face contact, in other words, these technologies rely on a very narrow range of kinds of information and on a limited amount of whatever information signifies for them (usually simplified visual images in VR, the typewritten word on-line and the electronically reproduced voice on the phone). Narrow bandwidth allows more opportunities for users to "pass"; to sustain cross-gender or other identities or to remain ambiguous; it thus also becomes a site where identities can be even more rigorously policed. In any case, rather than thinking of narrow bandwidth modes as impoverishments of the kinds of information they allow *through* their limited channels, Stone engages them as challenges that enrich the interpretive play stirred up *around* them. Such an engagement does not worship the *deus ex machina* of postmodern technologies but extends the Derridean priority of *writing*. To understand the capacity of technology to produce oppressive and liberatory effects, think of a channel not only in terms of how it regulates, organizes and polices what goes through it but how it disturbs, enriches or impoverishes what goes around it; think of a channel the way an elk confronts an oil pipeline.

6

Finally or not, the genome, that exemplary "intelligent machine"; not the totalitarian master of all living information systems but a grain of sand in a world that is our oyster, an *irritant* around which bodies are secreted, bodies not inert, but in turn becoming strung into loops.

> History's arching back
> (and monstrous flukes
> emerge) still stranger.

REFERENCES

Butler, Judith. 1993. "The Lesbian Phallus," in *Bodies That Matter: On the Discursive Limits of "Sex"*. New York: Routledge, pp.57–91.

Duden, Barbara. 1991. *The Woman Beneath the Skin*, trans. T. Dunlap. Cambridge, MA: Harvard University Press.

Haraway, Donna. 1991. *Simians, Cyborgs, and Women*. New York: Routledge.

Laqueur, Thomas. 1987. "Orgasm, Generation, and the Politics of Reproductive Biology," in C. Gallagher and T. Laqueur (eds) *The Making of the Modern Body* Berkeley: University of California Press, pp.1–41.

Latour, Bruno. 1993. *We Have Never Been Modern*. Cambridge, MA: Harvard University Press.

Martin, Emily. 1994. *Flexible Bodies*. Boston: Beacon Press.

Stone, A. R. 1992. "Virtual Systems," in J. Crary and S. Kwinter (eds) *Incorporations*. New York: Zone, pp.609–21.

10

Present Tense

Gregg Bordowitz

The colonoscopy is more a day trip than a journey into night. First of all, I'm awake and I can watch on the monitors the probes progress into an alternating white and pink zone, tissue and substance, seemingly dry, although liquid runs out of my ass like a birth upon the insertion of the tube. Me and the doctor are now asshole buddies. Three female nurses witness the intimate act. I think, I can take this, I've had larger. The demerol does the job making me the dumb one among the skilled technicians. All I have to do is lie still. I am the reason for this congregation. I am vulnerable. I am in control. The feelings contradict themselves as I lay open. I say *I'm in pain, I need more stuff*, like a rat hitting the feeder bar for more relief and like a king calling for more libations. I am a victim, I am a lord. The proximity of death, either a fantasy or an actual situation makes one feel both

supreme and supremely humble. David accompanies me to the hospital. He watches me walk out of the waiting room into the dressing room. I return dressed in the hospital gown, humiliated. Later, he says to me, *you arrive a person and they turn you into a patient.* He is waiting for me in the recovery room. I am still very high. He gets me apple juice. We wait for the doctor for two hours. The doctor arrives with polaroids of my intestine. He says, *I'd say that's the wildest case of lymphadnopathy I'd ever seen 'cept I've seen so many.*

I want to write like a poet about my asshole. I want to attribute to it the clinch of a jaw, the sharpness of teeth, a mind of its own. I can't. It burns. My asshole burns from the acids of my stomach. The intestinal system responds to the stimulation of the swollen nodes surrounding it. In an effort to relieve itself of the irritation and the increased amount of lymph in the area, I shit. The asshole is a conduit for diarrhoea, that's all. It burns constantly reminding me it exists. If anything, I pity the organ. The asshole, the intestine, just doing their jobs, fooled into action by a trickster virus that makes the body function in good faith against itself. Pure evil. Without intention. One life form perverts the other for its own ends . . . survival.

The actual conditions of illness make me a failure as a poet for I can see no beauty in this decay. I can see no meaning in it. This is simply happening. It happens to me. That sentence seems odd; it is difficult for me to imagine myself the subject of that sentence. The I that is writing now does not understand itself to be the me of that sentence. I am the witness to my body's history. I watch as it becomes ill, from some safe distance, like watching the news on television. I'm lying on my side with a long thin probe three feet snaked into my intestines and I'm watching it all on TV. The doctor's head is turned to watch the monitor

as he pushes the wire further into me. The nurses stare at the screen. For a moment, I'm 10 years old, sitting in the living room, watching television with my mom, my step-dad and my sister. I'm in a lot of pain. I'm an angry kid. I've got a lot going on inside me and I feel like everyone is turned away from me, ignoring me, watching TV. I've seen exploratory images of the insides of bodies on TV medical programs. I am prepared for this new knowledge. Television prepares us. We are well prepared. The colon on the screen could be any colon. If I weren't lying here, heavily sedated, a burning sensation in my gut and all these witnesses, you couldn't convince me of the fact that the image on the screen refers to me. All this evidence proves nothing. I am well. I am in control. I am the I that determines what I am and what I am not. I am not the image of my intestine. I am not an asshole, but the image of a live rotting corpse – devoid of waste but for the wasting.

I do not have language at my disposal. It disposes of me. I want to give myself up to it. To be present in every word I say and to say everything I can now. A crime is committed and no one speaks to stop it. Something feels wrong. We face a daily violence. I wash, I get pimples. I use soap, I get pimples. I get pimples. Get strong. Get gentle. Rediscover the wonder. You have to be picky these days. You can't trust everybody.

11

New Technologies of Race

Evelynn M. Hammonds

O n 18 July 1950 the *New York Times* announced "No Scientific Basis for Race Bias Found by World Panel of Experts." The article reported on the findings of a distinguished group of scientists, working under the auspices of the United Nations Educational, Scientific and Cultural Organization (UNESCO), who had reached a consensus that there "was no scientific justification for race discrimination."

> The Statement presented four premises: that mental capacities of all races are similar; that no evidence for biological deterioration as a result of hybridization existed; that there was no correlation between national or religious groups and any race; and fourth, that race was less a biological fact than a social myth.[1]

The UNESCO document was a highly politicized statement as both Elazar Barkan and Donna Haraway have shown.[2] In many respects it reflected the desire of some scientists to redress the excesses of Nazism where biological notions of racial difference and racial inferiority had been used to justify the extermination of Jews and homosexuals, rather than offering a balanced account of the contemporary scientific debates over the role of environment, heredity and culture in the observed differences between the races.

Several historians of science have argued that the publication of the UNESCO document signaled the end of mainstream scientific support for racial science. The division of the human species into biological races which had been of cardinal significance to scientists for over a hundred years was no longer viable as a research topic. Race, which in the pre-1950s period had been used to explain individual character and temperament, the structure of social communities, and the fate of human societies, was no longer central to the work of anthropologists or biologists. Even if one does not entirely accept this assessment, and it is debatable whether most scientists did, it is argued that, at the very least, the belief in the fixity, reality and hierarchy of human races – in the chain of superior and inferior human types – which had shaped the activities of scientists for most of the twentieth century had ceased to be a central feature of biological and anthropological research. Gone were the detailed cranial measurements, the tables of racial comparisons, the construction of racial typologies, and the reconstruction of racial histories in mainstream scientific journals. Instead, as Nancy Stepan argues, in their place we find discussions of populations, gene frequencies, selection and adaptation. The biological study of human diversity is now permeated with the language of genetics and evolution. "Race," Stepan asserts, "lost its reality and naturalness, to such an extent that probably the majority of scientists even go so far as to consider the very word 'race' unnecessary for purposes of biological inquiry."[3]

I suggest that these scientists and historians of science have misread the observed shift in biology and anthropology from studies of gross morphological studies of racial difference to studies of populations and gene frequencies. In the US race has always been dependent upon the visual. I argue that the notion of race – both as a social and scientific concept – is still deeply embedded in morphology, but it is the meaning given to morphological differences that has been transformed. Race, defined biologically in terms of morphological differences between certain pure types: white, African, Asian, etc., and in particular the mixing of these pure racial types, has been re-inscribed in the new computer technology of 'morphing' and, as such, separated from its previous antecedents in the history of anti-miscegenation, and racial oppression.[4] "Morphing," a computer software term for "making one thing appear to turn into another;" denotes shape changing while carrying along with it a change in identity. In this technology persons of different races are not produced as a result of sexual intercourse between persons of two different races but by a computer-generated simulation of the mixing of genetic characteristics that are presumed to be determinants of morphological differences between pure racial types. Morphing is not simply, as Emily Martin notes, "a car transformed into a tiger or Arnold Schwarzenegger turning into a pool of liquid metal in *Terminator 2*," but it is also the technological production of new racial types as in Michael Jackson's *Black or White* video where whites turn into aborigines as easily as he himself morphs into a black panther. Miscegenation then becomes an instance of border crossing between the human and the 'other.' The 'other' includes the non-human and also the more familiar 'other', non-white humans. In such a case technological artistry masks the imbrication of power, which is never articulated, in such transformations of white into non-white, and the non-white into animal. These transformations serve as late twentieth-century versions of the Great Chain of Being. Morphing, with its facile device of shape-changing, interchangeability, equivalency, and feigned horizontality in superficial ways elides its similarity with older hierarchical theories of human variation. However, as I will discuss, the new technology of race, morphing, is at the center of an old debate about miscegenation and citizenship in the United States.

W.E.B. DUBOIS AND THE AMALGAMATION OF THE RACES

In 1897, the Harvard-educated W.E.B. DuBois inaugurated a series of sociological studies of African Americans at Atlanta University. These studies were designed to provide objective scientific sociological data on the questions concerning the conditions of African Americans in the United States. His goal was to produce "an increasing body of scientifically ascertained fact, instead of the vague mass of the so-called Negro

problems." Through the studies DuBois assaulted the prejudiced gener-
alizations made by whites, who sometimes based their "facts" about
African Americans on evidence as flimsy as observations made through
train windows while traveling through the South. In 1906 he published
The Health and Physique of the Negro American, in which he addressed
one of the most intractable questions in the discourse about race – the
"fixity" of the concept of race.[5] He argued against the assumption that
of all the races, the Negro race, by reason of its pronounced physical
characteristics, was easiest to distinguish. The human species, he noted,
"so shade and mingle with each other that not only, indeed, was it
impossible to draw a color line between black and other races, but in all
physical characteristics the Negro race cannot be set off by itself as
absolutely different."[6] DuBois wanted his scientific facts to prove the
lie that African Americans were inherently different from whites by
pointing out the fact that "All the great peoples of the world are the
result of a mixture of races."[7] Race mixing at the turn of the century
posed a problem for those whites who believed in the purity of racial
types. The progeny of such mixtures were alternately viewed as superior
intellectually and physically to the pure Africans, or inferior to them.
DuBois wanted to demonstrate both the extent of race mixing in the
United States and to dispel the notion that these mixed people were
inferior. Race mixing was not an innocent act in this period. There were
laws against it in many states. Southern laws against marriage
between the races in effect sanctioned the rape of Black women and
made all progeny of even consensual unions between whites and
blacks, illegitimate. The progeny of such unions were designated as
Negro despite their mixed ancestry. Given this situation DuBois argued
that an African American should not "stoop to mingle his blood with
those who despise him."[8] The existence of mixed bodies – the mis-
cegenated – while an "open secret," was denied by whites because the
admission of such would implicitly acknowledge the humanity of
African Americans and the denial of citizenship to them.
Miscegenation, and the bars against it, as DuBois rightfully identified,
were about belief in a hierarchy of racial types which was explicitly
used to deny the status of citizenship to all those who carried any evi-
dent physical signs of African heritage. Along with sociological data
DuBois used the then new technology, photography, to make visible the
evidence of race mixing that white society denied. DuBois' photo-
graphic evidence, rendered in the style of turn-of-the-century
ethnographic studies of race, was deployed to show that race mixing
was a fact of American life and that the dependence upon visual evi-
dence to determine who was "black" or "white" was specious at best.
These photographs of male and female African Americans were largely
head shots – frontal and profile, displaying skin tones ranging from
very dark to very light visually indistinguishable from whites (see

Figures 11.1 and 11.2) The photographs were accompanied by text describing each person's lineage. In particular DuBois emphasized that talent and educational achievement were not associated with one skin color or ancestral heritage. Through the critical deployment of the photographs and the vast sociological data he gathered, DuBois' work undermined biological conceptions of race and emphasized its social construction.

WHAT COLOR IS BLACK?

The 13 February 1995 cover story of *Newsweek* magazine, was entitled "What Color is Black? Science, Politics and Racial Identity." Interestingly, inside, the title of the lead article changed slightly to "What Color is Black? What Color is White?" The cover displayed a short description of the article:

> The answers aren't simple. Immigration is changing the hue of America. Intermarriage has spawned a generation proud of its background, eager for its place at the American table. As always, race drives American domestic policy on issues from legislative districts to census counts. And path-breaking scientists insist that three racial categories are woefully inadequate for the myriad variations of our species.[9]

Immigration followed by intermarriage are said to be the driving forces behind this "new" aspect of race relations in America. The article appeared twenty-eight years after the last state anti-miscegenation law was struck down.[10] It appeared forty-five years after the UNESCO document on race, yet it asserted on the one hand that race is a biological concept – "race is a notoriously slippery concept that eludes any serious attempt at definition: it refers mostly to observable differences in skin color, hair texture and the shape of one's eyes or nose" – while also pointing out that most scientists argue that race is a mere social construct.[11] After reporting the current scientific data about racial differences for several pages, the authors conclude:

> Changing our thinking about race will require a revolution in thought as profound and profoundly unsettling, as anything science has ever demanded. What these researchers are talking about is changing the way in which we see the world – and each other. But before that can happen, we must do more than understand the biologist's suspicion about race. We must ask science, why is it that we are so intent on sorting humanity into so few groups – us and Other – in the first place.[12]

But *Newsweek*'s cover offered a representation of race – pictures of people of color of various shades in photographs cropped to emphasize shape of head, nose and lips – at odds with its text which emphasized that science was unable to provide a definitive or rather comfortable

Figure 11.1 DuBois' photographs of Negro Americans

Figure 11.2 DuBois' photographs of Negro Americans

answer about the social meaning of racial difference (see Figure 11.3). Here we see the visual display of a variety of people of color which made race seem "real," while the scientists' commentary emphasized that the reliance upon categories based on groupings of physical types had no meaning for the scientific study of race and, by implication, the socio-political debates as well. Interestingly, in *Newsweek*'s typology the persons who are raced are those who are not white. No photographs depicting differences among whites or between whites and people of color are displayed, suggesting that the differences among those classified as Black (or African American) is what is at issue.

Newsweek took a decidedly conventional approach to the "newly" defined problem of race in America. It concentrated on the divergence between biological and social meanings of race as represented by the differences among people of color. The text implied that morphological differences of skin color, for example, were no longer stable markers of race. However, unlike DuBois' use of visual markers to emphasize the link between whites and Africans that produced racially mixed African Americans, *Newsweek*'s use of the visual was employed to deny such a link. Propelled by demographic changes due to immigration and the increase in interracial marriages within the US, the major theme of the issue concerned the upcoming census of the year 2000 and the categories by which United States' citizenship will be defined. The difference between DuBois' day and our own is today racially mixed people are increasingly refusing to be relegated to a subordinate social status based on presumed biological differences.

Newsweek followed on the heels of a much more novel approach to the topic, where biology was supplanted by computer technology in the representation of racial difference – *Time* magazine's special issue in the Fall of 1993, "The New Face of America: How Immigrants Are Shaping the World's First Multicultural Society." The cover featured a slightly tanned woman, with brown straight hair, somewhat almond-shaped eyes and slightly full lips (see Figure 11.4). The side bar read, "Take a good look at this woman. She was created by a computer from a mix of several races. What you see is a remarkable preview of . . . The New Face of America."[13] The introduction to the issue by managing editor, Jim Gaines, revealed the true identity of the cover girl.

The woman on the cover of this special issue of *Time* does not exist – except metaphysically. Her beguiling if mysterious visage is the product of a computer process called morphing – as in metamorphosis, a striking alteration in structure or appearance. When the editors were looking for a way to dramatize the impact of inter ethnic marriage, which has increased dramatically in the U.S. during the last wave of immigration, they turned to morphing to create the kind of offspring that might result from seven men and seven women of various ethnic and racial backgrounds.[14]

Evelynn M.
Hammonds

WHAT COLOR IS BLACK?

And what color is white? The markers of
racial identity are every conceivable
hue—and suddenly matters of ideology
and attitude as much as pigmentation.

BY TOM MORGANTHAU

NEARLY 400 YEARS AFTER THE FIRST AFRICAN CAME ASHORE
at Jamestown—and 40 years after Rosa Parks launched the
Montgomery bus boycott—Americans are still preoccupied
with race. Race divides us, defines us and in a curious way
unites us—if only because we still think it matters. Race-
based thinking permeates our law and policy, and the sense
of racial grievance, voiced by blacks and whites alike, infects
our politics. Blacks cleave to their role as history's victims;
whites grumble about reverse discrimination. The national mood on race, as
measured by NEWSWEEK's latest poll, is bleak: 75 percent of whites—and 86
percent of blacks—say race relations are "only fair" or "poor."

But the world is changing anyway. By two other measures in the same
NEWSWEEK Poll—acceptance of interracial marriage and the willingness to
reside in mixed-race neighborhoods—tolerance has never been higher. The
nation's racial dialogue, meanwhile, is changing so rapidly that the familiar
din of black-white antagonism seems increasingly out of date. Partly because
of immigration—and partly because diversity is suddenly hip—America is
beginning to revise its two-way definition of race. Though this process will
surely take years, it is already blurring our sense that racial identity is fixed,

114

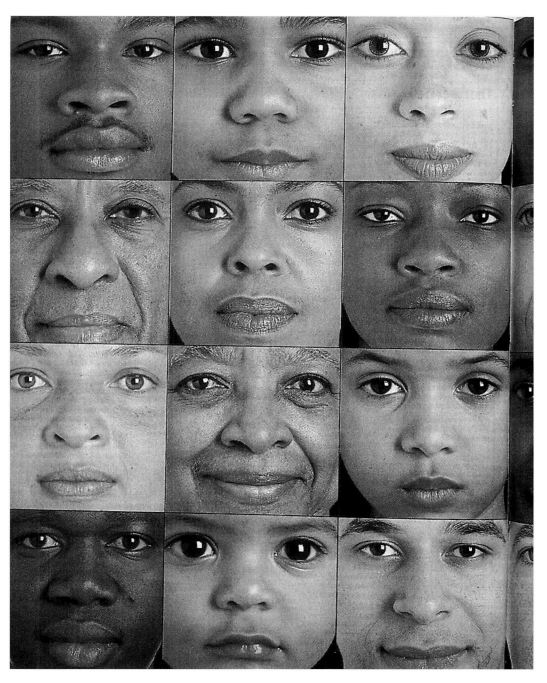

Figure 11.3 "What Color is Black?", *Newsweek*, 13 February 1995

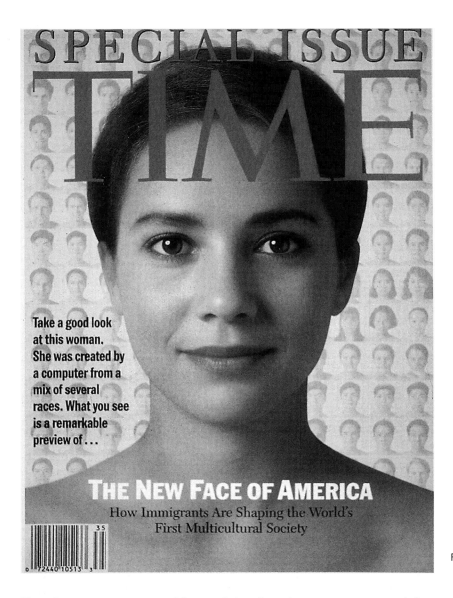

Figure 11.4 "The New Face of America", *Time* magazine, Fall 1993

The picture was generated by an Asian American computer specialist, dubbed a cybergeneticist, whose efforts are described as "in the spirit of fun and experiment." This covergirl, Eve, whom Donna Haraway has dubbed "SimEve," has an interesting lineage: she is 15 per cent Anglo-Saxon, 17.5 per cent Middle Eastern, 17.5 per cent African, 7.5 per cent Asian, 35 per cent Southern European and 7.5 per cent Hispanic. This breakdown of her racial heritage would be familiar to DuBois and any other early twentieth-century biologist or anthropologist. Eve was produced with the same software package, Morph 2.0, used in *Terminator 2* and the Michael Jackson video. *Time*'s cybergeneticist also produced a chart showing forty-nine different combinations of the

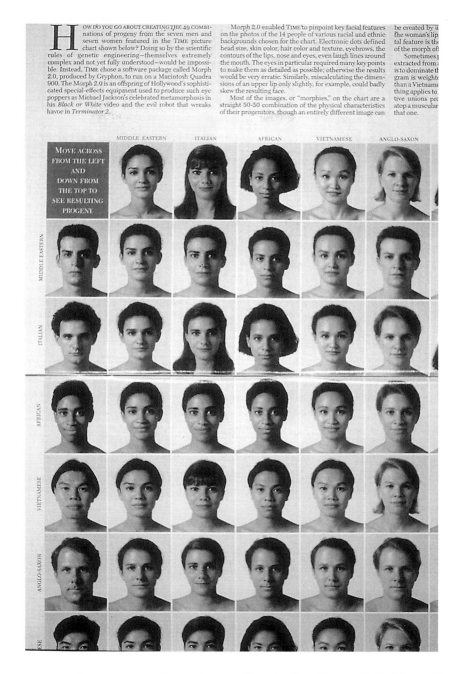

OW DO YOU GO ABOUT CREATING THE 49 COMBI-
nations of progeny from the seven men and
seven women featured in the TIME picture
chart shown below? Doing so by the scientific
rules of genetic engineering—themselves extremely
complex and not yet fully understood—would be impossi-
ble. Instead, TIME chose a software package called Morph
2.0, produced by Gryphon, to run on a Macintosh Quadra
900. The Morph 2.0 is an offspring of Hollywood's sophisti-
cated special-effects equipment used to produce such eye
poppers as Michael Jackson's celebrated metamorphosis in
his *Black or White* video and the evil robot that wreaks
havoc in *Terminator 2*.

Morph 2.0 enabled TIME to pinpoint key facial features
on the photos of the 14 people of various racial and ethnic
backgrounds chosen for the chart. Electronic dots defined
head size, skin color, hair color and texture, eyebrows, the
contours of the lips, nose and eyes, even laugh lines around
the mouth. The eyes in particular required many key points
to make them as detailed as possible; otherwise the results
would be very erratic. Similarly, miscalculating the dimen-
sions of an upper lip only slightly, for example, could badly
skew the resulting face.

Most of the images, or "morphies," on the chart are a
straight 50-50 combination of the physical characteristics
of their progenitors, though an entirely different image can

be created by u
the woman's lip
tal feature is the
of the morph of

Sometimes
extracted from a
is to dominate th
gram is weighte
than a Vietname
thing applies to
tive unions pro
atop a muscular
that one.

MOVE ACROSS
FROM THE LEFT
AND
DOWN FROM
THE TOP TO
SEE RESULTING
PROGENY

MIDDLE EASTERN | ITALIAN | AFRICAN | VIETNAMESE | ANGLO-SAXON

MIDDLE EASTERN | ITALIAN | AFRICAN | VIETNAMESE | ANGLO-SAXON

Figure 11.5 Time's
"morphies"

progeny from seven males and seven females (see Figure 11.5). Most of
the images or "morphies" on the chart are a straight 50–50 combina-
tion of the physical characteristics of their progenitors, though the
editors note that an entirely different image could be produced by
using different combinations of features. Interestingly, after eyes, the
most important parental feature is the neck, which they found often
determined the gender of the offspring. The volume of specific features

is also important. For example, if an African man has more hair than a Vietnamese woman, his hair will dominate. Of course, such manipulations of features produced some truly unexpected results as well. One of their "tentative unions" produced a distinctly feminine face – sitting atop a muscular neck and hairy chest. "Back to the mouse on that one," the editors wrote. In this case the implicit norms governing morphing appear to forbid any monstrous combinations paralleling late nineteenth-century rhetoric against the progeny of interracial unions which claimed that such hybrid persons were unnatural. With the *Time* cover we wind up not with a true composite, but a preferred or filtered composite of mixed figures with no discussion of the assumptions or implications underlying the choices.

The flippant, lighthearted tone of the essay about the "morphies" was used to deflect attention from the seriousness of the issues these images were supposed to represent. Indeed, its very title, "Rebirth of a Nation, Computer-Style," invokes yet displaces the more complicated and feared history depicted in D. W. Griffith's *Birth of A Nation* onto the field of computer games (see Figure 11.6). This special issue was, after all, about immigration – or more specifically about how citizenship will be determined in the United States in the next century. No need to trot in scientists to provide the now familiar caveats that gross morphological differences are of little use in categorizing humans and that races don't exist. *Time* showed that despite such assertions, to most Americans, race is embodied and, even with racial mixing, the existence of primary races is as obvious as the existence of primary colors in the Crayola crayon palette. There was no need to even explain the choice of categories used to produce the "morphies." We all know that "Anglo-Saxons" are different from "Italians" and so on. The computer allowed *Time* to uncritically take the three so-called basic races – white, black, Asian – and extend it to seven groups: Middle Eastern, Italian, African, Vietnamese, Anglo-Saxon, Chinese, and Hispanic. The resulting "morphies" are surprisingly similar in their physical features, yet the text makes no mention of this point. This silence on the issue of the morphological similarity of these racially mixed figures is interesting. The simultaneous recognition of greater diversity, on the one hand, and morphological similarity, on the other, suggests a strange logic of equivalence. A nose is a nose is a nose, no matter what your race is. Or is it? Is the reader to interpret this move as suggesting that morphological equivalence is an answer to the political conflict over race and citizenship that the upcoming census will surely engender? Is there a link between this logic and a political rhetoric of citizenship that assumes an interchangeability of characteristics that we all have in common but that are expressed slightly differently? *E pluribus unum*? What kind of citizenship is being imagined or configured in the logic of equivalences that morphing graphically enacts? Given the assumption

REBIRTH OF A NATION, COMPUTER-STYLE

HOW DO YOU GO ABOUT CREATING THE 49 COMBInations of progeny from the seven men and seven women featured in the TIME picture chart shown below? Doing so by the scientific rules of genetic engineering—themselves extremely complex and not yet fully understood—would be impossible. Instead, TIME chose a software package called Morph 2.0, produced by Gryphon, to run on a Macintosh Quadra 900. The Morph 2.0 is an offspring of Hollywood's sophisticated special-effects equipment used to produce such eye poppers as Michael Jackson's celebrated metamorphosis in his *Black or White* video and the evil robot that wreaks havoc in *Terminator 2*.

Morph 2.0 enabled TIME to pinpoint key facial features on the photos of the 14 people of various racial and ethnic backgrounds chosen for the chart. Electronic dots defined head size, skin color, hair color and texture, eyebrows, the contours of the lips, nose and eyes, even laugh lines around the mouth. The eyes in particular required many key points to make them as detailed as possible; otherwise the results would be very erratic. Similarly, miscalculating the dimensions of an upper lip only slightly, for example, could badly skew the resulting face.

Most of the images, or "morphies," on the chart are a straight 50-50 combination of the physical characteristics of their progenitors, though an entirely different image can

be created by using, say, 75% of the man's eyes, or 75% of the woman's lips. After the eyes, the most important parental feature is the neck, which often determines the gender of the morph offspring.

Sometimes pure volume counts. The more information extracted from a given feature, the more likely that feature is to dominate the cybernetic offspring. Even when the program is weighted 50-50, if an African man has more hair than a Vietnamese woman, his hair will dominate; the same thing applies to larger lips or a jutting jaw. One of our tentative unions produced a distinctly feminine face—sitting atop a muscular neck and hairy chest. Back to the mouse on that one. ∎

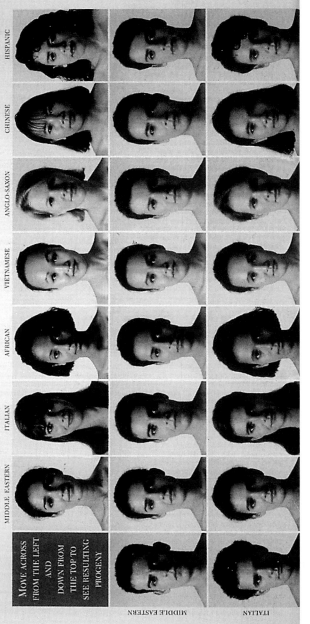

	MIDDLE EASTERN	ITALIAN	AFRICAN	VIETNAMESE	ANGLO-SAXON	CHINESE	HISPANIC

MOVE ACROSS FROM THE LEFT AND DOWN FROM THE TOP TO SEE RESULTING PROGENY

MIDDLE EASTERN

ITALIAN

Figure 11.6 "Rebirth of a Nation, Computer-Style"

of sameness with respect to power and privilege that the "morphies" inadvertently imply, will inequalities in the future be explained in terms of lack of ambition, intelligence, will, or ingenuity? Has morphological difference been supplanted by an implicit nod to behavioral and cultural differences? Or behavioral and cultural sameness? As the *Time* writers note: "Those who intermarry have perhaps the strongest sense of what it will take to return America to an unhyphenated whole. 'It's American culture that we all share.'"[15]

Despite their tone and the explicit efforts to separate the resulting morphed images from the conflicted meanings they represent, the editors of *Time* came up against their own desires:

> Little did we know what we had wrought. As onlookers watched the image of our new Eve begin to appear on the computer screen, several staff members promptly fell in love. Said one: "It really breaks my heart that she doesn't exist . . ." We sympathized with our lovelorn colleagues, but even technology has its limits. This is a love that must forever remain unrequited.[16]

This is truly the drama of miscegenation in cyberspace. The history of white men crossing racial boundaries to have sexual relations with African, Asian, Mexican and Native-American women – and then refusing to acknowledge their offspring in order to reserve the right to determine how whiteness would be defined as a characteristic of citizenship – is simultaneously implied and disavowed. Race mixing in its newest form shapes our future not the past; bits and bytes replace the flesh and blood that provoked the guilt, hatred and violence of our country's history of racial domination. Hierarchies of domination have not disappeared as female reproduction is replaced by a masculine technophilic reproduction because stereotypical racial typologies remain in place.[17] I say this because no woman of color has ever symbolized citizenship in United States history, only the denial of citizenship. Women of color were among the last groups to achieve the right to vote and all the attendant rights of citizenship that flow from it. Donna Haraway argues that SimEve forever excites a desire that cannot be fulfilled and as such is an example of the dream of technological transcendence of the body. But I think SimEve carries a different meaning in the light of the history of miscegenation – because she is a cyber – she is the representation of the desire to deny kinship and retain masculine power based on the maintenance of racial difference.

NOTES

Author's note: I want to thank Jennifer Terry for her insightful comments on this chapter.

1 Elazar Barkan, *The Retreat of Scientific Racism: Changing Concepts of Race in Britain and the United States between the World Wars* (Cambridge: Cambridge University Press, 1992), p.341.

2 Ibid., pp.341–3; and Donna Haraway. *Primate Visions: Gender, Race and Nation in the World of Modern Science* (New York: Routledge, 1989), pp.197–203.

3 Nancy Stepan, *The Idea of Race in Science* (Hamden, CT: Archon Press, 1982), p.171.

4 These pure racial types are defined in terms of morphological differences such as hair texture, skin color, shape of eyes corresponding to geographical origin e.g. white Anglo-Saxon, African, etc.

5 W.E.B. DuBois (ed.), *The Health and Physique of the Negro American* (Atlanta: Atlanta University Press, 1906), p.11.

6 Ibid., p.16.

7 Ibid., p.37.

8 Ibid., p.39.

9 "What Color is Black? What Color is White?" *Newsweek*, 13 February 1995, p.3.

10 In 1967, the US Supreme Court struck down the final existing anti-miscegenation laws in *Loving* v. *Virginia*.

11 *Newsweek*, 13 February 1995, p.64.

12 Ibid., p.69.

13 "The New Face of America," *Time* magazine, Special Issue, Fall 1993.

14 Ibid., p.2.

15 Ibid., p.65.

16 Ibid., p.2.

17 Donna Haraway, "Universal Donors in a Vampire Culture: It's All in the Family. Biological Kinship Categories in the Twentieth-Century United States," in William Cronon (ed.) *Uncommon Ground: Toward Reinventing Nature* (New York: Norton, 1995).

12

The Visible Man: the male criminal subject as biomedical norm

Lisa Cartwright

I recently overheard a conversation in which it was related that, demo- graphically speaking, American men with the highest sperm count are those incarcerated in prisons. I wasn't prepared to approach the person relating this perplexing piece of biomedical gossip to enquire about her source. Whether or not the prison population is in fact the most potent of the American male population, the claim speaks volumes about the contemporary fantasies of medical science and the US public regarding the bodies of prisoners, masculine virility, and biomedical norms. It sug- gests that the criminal body, historically associated with pathology and abnormality, may now symbolize the apex of virility and health in the national imagination.

In the late 1990s, we are witnessing a conjuncture of popular and scientific interest in the criminal body and its functions in life and in death. This fascination recalls the last century's public interest in crim- inal anatomy. As John Tagg and Allan Sekula have demonstrated, functionaries of late nineteenth-century institutions of law and social service regarded the structure and surface markings of the criminal body as a visual indicator of mental pathology.[1] This precedent sug- gests a model of criminality that doesn't quite match up with the criminal as the embodiment of potency described by my anonymous source. The anecdote I relate, along with other recent representations of the criminal body including the one discussed at length below, sug- gest that cultural critics need to reconsider the new kinds of

Figure 12.1 The Visible Human Project web page

investments being made by science and by the media public in those bodies that are regarded as charges of the state.

This image-text piece really begins with another more familiar media tale about the male criminal body as a model of health: The story of Texan Joseph Paul Jernigan, an executed murderer whose body has become one of biomedicine's prime models of normal human anatomy. Jernigan's white male body was posthumously selected from numerous cadavers circulating in the public domain to serve as the raw material for an anatomical compendium of the male body that is currently available on the World Wide Web, in CD-ROM, and on video as the Visible Man. This virtual body was joined recently (in November 1995) by a counterpart, the Visible Woman. Together, they form the nucleus of a kind of virtual family conceived by the National Library of Medicine and collaborating contractors, a digital family of anatomical models slated to be completed with the inclusion of the bodies of a younger woman and a fetus. As the first member of this family to be made available to the public, Jernigan's body has spent the past year at

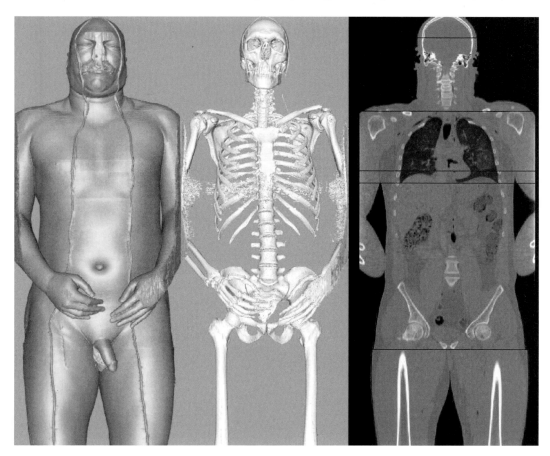

Figure 12.2 Male body

Figure 12.3 Male head

the locus of numerous private and federal projects devoted to establishing the most intricately detailed and yet universally standardized compendium of the normal male body to date. In effect, Jernigan's body has become the gold standard of human anatomy.[2]

The widespread public acceptance of Jernigan's transformation from convict to model of health is indicated in a 1996 *Chronicle of Higher Education* article wherein it is suggested that the late felon's posthumous service to the public is a form of absolution, earning him the title of "Internet angel." "In his life," author David L. Wheeler writes, "he took a life. In his death, he may end up saving a few."[3] The identity of the Visible Woman remains virtually anonymous: she is typically described as a 59-year-old resident of Maryland who died of a heart attack – a housewife who, according to her husband, was "never sick a day in her life" and hence wanted to leave her unscathed body to science.[4] The Visible Man occupies a different place in the public eye: he is imbued with a name, an identity, and a personal history – more specifically, a narrative of moral corruption in life and redemption after death. Since early 1995, Jernigan and the Visible Human Project have been the focus of a surfeit of media coverage ranging from science and medicine journal reports to World Wide Web sites to broadcasting features on venues such as National Public Radio and network news shows. Much of this coverage features not only the status of the Visible Man as a remarkable achievement of medical technology, but also the intimate details of Jernigan's criminal past.

Cultural critics would do well to consider the broader implications of the public narrative linking the Visible Human Project to Jernigan's

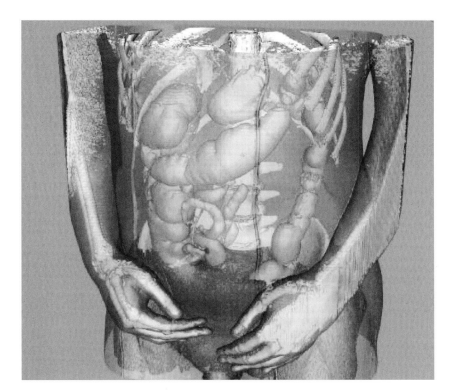

Figure 12.4 Thorax

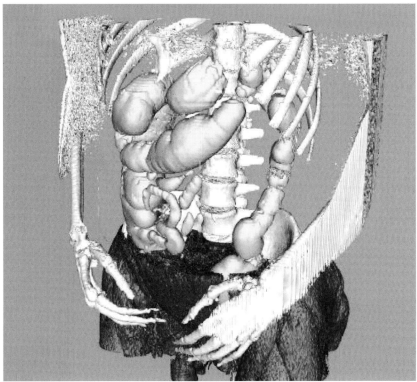

Figure 12.5 Rib cage

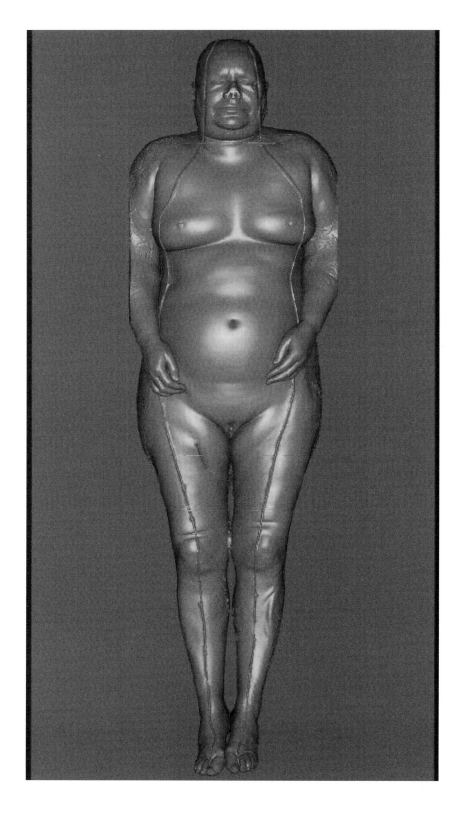

Figure 12.6 Female
body

public exoneration through his service-in-death to medical science and to public health culture. We might ask why it is that at this point in history the white male criminal charge of the state is the subject placed at the locus of a new and highly public biomedical norm. Whereas so far the Visible Woman more often has been at the center of gender-specific projects like a proposed prototype and virtual reality training program in gynecological and reproductive health care,[5] the Virtual Man more often has served as a gender-neutral model of human anatomical form and function. How did the federal government and their state university contractors justify this use of

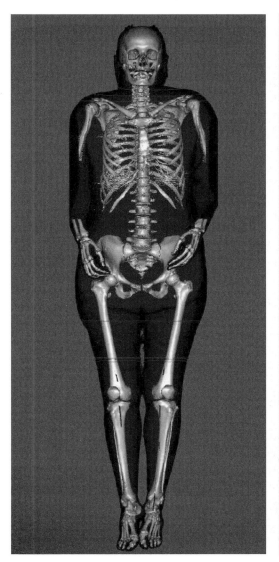

Figure 12.7 Female skeleton

Figure 12.8 Female skeleton 2

Jernigan's body? Moreover, how did the American public come to find compelling this story of the transformation of the criminal subject from public offender to public icon of physical health, embracing the media's rendering of the details of Jernigan's litigious and moral history, along with science's public rendering of his physical body? The Visible Human Project's display and dissemination of Jernigan's fragmented body is also a display of the often less overt politics of health and representation: by occupying a place in the public eye, the Project brings to the fore questions of gender, class, cultural identity, as well as questions of service to medicine "for the good of mankind" – the latter a set of questions more often negotiated behind closed doors, within medical profession settings, and not in the public media.

JERNIGAN'S INSTITUTIONAL JOURNEY

In 1981, Jernigan was caught by surprise in the midst of a home burglary. He stabbed and shot the homeowner dead. Texas courts found Jernigan guilty of murder and sentenced him to death by lethal injection. Twelve years after the crime, prison workers attached an IV catheter to Jernigan's left hand and administered a drug that effectively suppressed the brain functions which regulate breathing. As journalist David Ellison has put it, the drug made Jernigan forget how to breathe.[6]

Jernigan's story is already a tale about the conjuncture of state and medical technologies of bodily regulation and control. The IV catheter attached to his hand functioned as a kind of prosthetic disciplinary hand of the state of Texas, allowing prison officials chemically to reach into Jernigan's body and switch off the basic unconscious mechanism that regulated his breathing. But the story of state prosthetics and technological regulation doesn't end there: Jernigan's body, unlike most of the bodies that make it to the end of Death Row, was not buried and forgotten.

Jernigan may have led a life of crime, but on at least one count he was a model citizen: he had signed a donor consent authorizing medical and scientific use of his body upon death. Initially, Jernigan's generous intentions were thwarted by the fact that the cause of his death was lethal injection, a process that left his organs tainted – poisoned – and hence useless for transplant into another (living) body. However, his age (he was 39), body type, and health condition suited perfectly the needs of a rather different sort of medical team scouting the market for cadavers: a team of researchers from the University of Colorado at Boulder who had won a public competition mounted by the National Library of Medicine (NLM), a contest wherein contractors ranging from university science centers to graphic arts firms could submit plans for rendering the male and female virtual bodies which

would constitute the core of the federal Visible Human Project. This team formed the Center for Human Simulation, describing itself as "a new entity emerging from the synthesis of three-dimensional imaging and human anatomy" whose general purpose is to "develop inter-actions with computerized anatomy in virtual space" among collaborating teams of anatomists, radiologists, computer scientists, bioengineers, physicians, anthropologists, and educators.[7]

THE VISIBLE HUMAN PROJECT

In 1986, a long-range planning committee of the NLM, a division of the National Institutes of Health, had determined that electronic images would play an increasingly important role in clinical and biomedical research. They speculated about a coming era in which the NLM's widely used bibliographic and factual database services would be com-plemented by libraries of digital images, distributed over high-speed computer networks and by high-capacity physical media. The commit-tee encouraged the NLM to "thoroughly and systematically investigate the technical requirements for and feasibility of a biomedical images library." In 1989, a Planning Panel on Electronic Image Libraries was formed under the Library's Board of Regents. This panel proposed the title and basic ground plan for

a first project building a digital image library of volumetric data repre-senting a complete, normal adult male and female. This Visible Human Project will include digitized photographic images for cryosectioning, digital images derived from computerized tomography, and digital mag-netic resonance images of cadavers.[8]

Michael J. Ackerman, the head of the University of Colorado team that won the NLM contract, notes that "so much of medicine is what a doctor sees, but most of medicine in written in books."[9] Certainly there is no shortage of medical atlases and anatomical compendia – books offering images and dimensional models featuring CT scans, MR images, and PET scans as well as radiographs, photographs, drawings, and diagrams of bodily organs, systems, and sections. The NLM's data-base would break new ground not by representing the body according to the techniques of more recent biomedical imaging, but by making these images available in a highly public venue (the Internet), and by actively making it available to the medical layperson (e.g. the science teacher, the graphic artist) as well as to the specialist. Further, the Visible Human Project would make easily reproducible and highly mal-leable the relatively fixed renderings of more conventional (book-format) atlases. Those paying the fee for a license agreement to download and use the data sets that comprise the Project can optically move through the body via hypermedia links, three-dimensional

Figure 12.9 Intestine

reconstructions, and even a specialized walk-through program that allows the user to simulate spatial passage through the tissue of the body from any perspective – in Wheeler's words, as if one were "like a wall moving through a ghost."[10] Finally, whereas book atlases tend to focus on discrete bodily parts or systems, the Visible Human Project incorporates the entire body, its physical mass sliced into relatively equitable, almost arbitrary slabs, like a length of salami. Discrimination among parts thus becomes a cataloger's nightmare. As Ackerman puts it, "For a librarian, this is very unsettling. It's like having books lying all over the place not indexed or cataloged."[11]

The Colorado team aimed to work with a completely intact human body that had died while young and in good health – a tall order for the medical cadaver marketplace. They waited two-and-a-half years for the right body to materialize. According to Wheeler, Jernigan's life of crime was of no concern to the team.[12] Less than two days after Jernigan's execution, the dead felon's body was encased in a special gelatin solution and deep-frozen to minus 160 degrees Fahrenheit at the Colorado Health Sciences Center. The frozen corpse was later chopped into four segments, and each was passed through computed tomography (CT) and magnetic resonance (MR) scanners – the same equipment used in medical diagnosis – to optically render Jernigan's body into a series of planar images.

The segmentation of Jernigan's body was not limited to the realm of optics. Each frozen body-segment was passed through a cryogenic macrotome – a kind of high-tech meat-slicer that physically segmented all four blocks of the body into a total of 1,871 one-millimeter-thin slices. In the words of a project overview, this phase of the process "[revealed] slice-by-slice the beauty and detail within."[13]

Figure 12.10 Female
head

Figure 12.11 Female
head 2

133

Figure 12.12 CT head

Figure 12.13 CT head
and thorax

After each pass, color photographs were taken of the face of the remaining block. Each of these 1,878 photographs was numbered in succession, then scanned into a computer animation program that would allow its users to restack, dissemble, and volume-render discrete body parts, yielding the first digital series representing an entire human body. Users of this program can travel the entire length of vertical structures such as the spinal cord, the trachea, the esophagus, long bones, muscles, and major blood vessels. Thus segmented into a pancake-like stack of planar units, Jernigan was rendered a virtual laminated man, each black-and-white or colorized layer of which could be viewed on the NLM database individually, in succession, or in reconstructed stacks.

The idea of segmenting human tissue into planar sections for photography and projection is not new. Earlier in the century, a few scientists dabbled in this realm, slicing small body parts into ultra-thin slices and affixing these slices onto successive frames of a strip of motion picture film, then projecting these films for a cinematic tour through dense body tissue.[14] What is different about the Visible Human Project is its physical scope (an entire human body is segmented) as well as the scope of its projected use. As Wheeler notes, images from the Project have appeared in a gallery in Japan alongside body renderings by Leonardo da Vinci. The US Army is using the Project to simulate the passage of shrapnel through flesh and bone. And a State University of New York at Stony Brook team has created interactive fly-through animations of the human colon on the basis of a set of the Jernigan images.[15] Furthermore, video, CD-ROM, and interactive videodisc programs based on the Visible Man are now being marketed through Web sites and advertisements in journals ranging from *Science* to *Wired*.

I've noted that Jernigan's body was selected for the Visible Human Project on the basis of its ostensible typicality. But what constituted typicality, what constituted health for the NLM and the Colorado Health Sciences Center? Jernigan was white, weighed 199 pounds, and stood at 5'11". As recently as early in this century, his status as a criminal almost certainly would have marked his visage and his physique for close critical scrutiny. His low forehead and his close-set eyes, for example, might have been interpreted as signs of mental incompetence. However, Jernigan's form instead allows him to qualify for the role of biomedicine's model male citizen. The criminal body, ironically, becomes the prototype for the healthy male body.

The Colorado team that selected the body for the Visible Man project claims not to have learned of the identity and source of Jernigan's body until after its selection. I would argue, though, that this fact is not highly significant to my discussion. More important is the fact that Jernigan's body would never have come up for review by the team had

Jernigan not been an anonymous and marketable cadaver, a subject whose status as a live ward of the state rendered him in death a subject stripped of his rights to certain privileges of citizenry – most notably, the right of bodily privacy. What is significant is not that Jernigan's identity initially was not known, but that it did become known – moreover, become publicly renowned – at the time that the Visible Man went on-line. It is precisely because of Jernigan's status as less than a private citizen, as a subject stripped of certain rights under the auspices of the state, that he qualified as a universal biomedical subject, and as a public icon of physical health. The universal biomedical subject is thus a subject stripped of his rights to privacy and bodily integrity, even after death.

NOTES

1 See John Tagg, *The Burden of Representation: Essays on Photographies and Histories* (Minneapolis and London: University of Minnesota Press, 1993); Allan Sekula, "The Body in the Archive," *October* 39 (1986), 1–64; and David Horn, "This Norm Which is Not One: Reading the Female Body in Lombroso's Anthropology," in Jennifer Terry and Jacqueline Urla (eds) *Deviant Bodies: Critical Perspectives on Difference in Science and Popular Culture* (Bloomington, IND: Indiana University Press, 1995), pp.109–28.

2 Web page address for Visible Human Project, Mallinckrodt Institute of Radiology, Bill Lorensen "Marching Through the Visible Man" paper: http://www.nlm.nih.gov/research/visible/visible_human.html

3 David L. Wheeler, "Creating a Body of Knowledge," *Chronicle of Higher Education*, 2 February 1996, A6, A7, and A14. Quotation from page A14.

4 For information about the Visible Woman, see Jacqueline Stenson, "'Visible Woman' Makes Debut on the Internet," *Medical Tribune News Service*, 28 November 1995; "'Visible Woman' News Brief from National Library of Medicine," *Gratefully Yours* (a newsletter published by the NLM), September/October 1995; and Bill Lorensen, "Marching Through the Visible Woman," http://www.nlm.nih.gov/research/visible/visible_human.html

5 The Center for Human Simulation has proposed a collaborative joint project with the Department of Defense titled "Rapid Prototyping of Procedures and Virtual Reality Training Program in Gynecological and Reproductive Health Care." See http://www.uchsc.edu/sm/chs/

6 David Ellison, "Anatomy of a Murderer," *21–C Scanning the Future*, March 1995, pp.20–5.

7 Text from the Web home page for the Center for Human Simulation, http://www.uchsc.edu/sm/chs/

8 National Library of Medicine (US) Board of Regents, "Electronic Imaging Report of the Board of Regents," US Department of Health and Human Services, Public Health Service, National Institutes of Health, 1990. NIH Publication 90–2197.

9 Quoted in Wheeler, "Creating a Body of Knowledge," p.A6.

10 Ibid., p.A14.

11 Ibid.

12 Ibid., p.A7.

13 The Visible Human Project, Project Overview,
http://www.nlm.nih.gov/research/visible/visible_human.html

14 See the discussion of serial section films in Lisa Cartwright, *Screening the Body:
Tracing Medicine's Visual Culture* (Minneapolis and London: University of
Minnesota Press), pp.96–7.

15 Wheeler, "Creating a Body of Knowledge," p.A7. The SUNY Stony Brook project
was created jointly by the Departments of Radiology and Computer Science.

13

Inseminations

Bonita Makuch

A video installation

What the doctor did
certainly warranted a
phone call or a letter –
the possibility that my
child might have 60 or 70
brothers and sisters

a commonly used
semen extender is 3%
sodium citrite solution
with 70 parts egg
yolk

border disease virus

they stole our children
and put them into
another woman

**the temperature
reaches into the wet
and humid 90's**

No.#1 killer

these manipulations are
contrary to the personal
dignity of the human
being and his or her
integrity and identity

women are
hired to watch
the swine herd
for sows in heat

a dummy sow is
used as a mount

as operation Desert
Storm geared up, dozens
of American soldiers
stopped by their local
sperm banks to make a
deposit before heading
off to the Gulf

hog cholera virus

the child is not an
object to which one has
a right nor can he be
considered as an object
of ownership

she could have
had it delivered
by Federal
Express

AAH, MM, YEAH AAH
OUWCH! OUCH! OH YEAH... MMM UUH AAGH
MMM ow!, ouch! OHH WOW

I drove across the wrong
bridge, I developed a
splitting headache and
when I got home I went to
bed with the covers
pulled up

smells intensify

to collect a second ejaculate
immediately from the same sire
into the same artificial vagina
and into the same collection
tube, it is necessary to provoke
and to accustom him to a
conditioned reflex

she picked up the
order herself ...
it was packed in
dry-ice in a
Styrofoam box -

He must have known
that was his child, it
must have been so
peculiar. And that just
makes my skin crawl

mycoplasma

the chance of breast
cancer rises if you never
get pregnant

anaplasma marginale

procreation is deprived of
its proper perfection when
it is not desired as the fruit
of the conjugal act

AIDS put an
end to that

scrapie agent

salty skin and
aching back

right from fertilization is
begun the adventure of a
human life, and each of
its great capacities
requires time . . . to find
its place and to be in a
position to act

visiting a
sperm bank
never hurts

an assistant lifts the
back of the female and
immobilizes her in the
correct position

Suddenly I realized, "they
know, they know", and I
wished my husband wasn't
out of town. I wish he were
sitting right there beside
me

mosquito bites itch

sperm donors do so
to help create
another generation,
but some are haunted
by their thoughts

sweat rolls down
the forearm

chlamydia

even the dead exert
influence

I took my daughter to the
lab – it was summertime –
and the technician kept
calling me Mrs. Smith

It is somewhat painful, but
all of us in our lives are
faced with pain, whether it's
because of your
appearance, if you're
African American or some
other minority. Again,
that's life

human immunodeficiency virus

in case of homosexuality,
the better way to collect
semen with an artificial
vagina is to use a male
instead of a female as a
teaser

the cervix is usually pink
in colour in oestrous
females and is often
compared to a rose or
small volcano

it is through the
secure relationship to
his parents that the
child can discover his
own identity and
achieve his own
proper human
development

penetration, irritation,
assimilation

brucella ovis

14

Unnatural acts: procreation and the genealogy of artifice

David Horn

This is a preface to a planned study of the aesthetics and politics of artifice in reproductive science in France and the United States. The larger project is, among other things, an effort to take seriously and examine critically the multiple pleasures of scientific and technical work on "artificial reproduction" – including pleasures of looking, extraction, imitation, replication, and boundary transgression – and to explore how these pleasures are articulated in particular historical and cultural circumstances. (I should make it clear, however, that this chapter, which follows the genealogical stories told by reproductive sciences, is *not* particularly respectful of cultural or historical boundaries.) In what follows, I also offer a way of thinking about what is at stake in scholarship on gender and technology, where the blurring, transgression, and remapping of boundaries afford their own and varied pleasures and pose their own dangers.

Many of us have learned to be suspicious of any positions that construct "artificial reproduction" as inherently liberatory (Firestone 1970) or that reduce it to an instance of a transcultural and transhistorical domination of nature-coded-as-female (Corea 1985; Corea, *et al.* 1987; Klein 1989). The glossing of techniques and social arrangements that are as varied as mechanical insemination, *in vitro* fertilization, and surrogacy as modes of "artificial" reproduction has, of course, served a variety of historical purposes: from marking these practices as "against" or contrary to nature, and therefore deserving of moral or juridical reprobation, to highlighting their power, novelty, and promise – their ability to simulate, correct, or even replace the "natural" (Franklin 1995; Hartouni 1991). And we are by now aware that there is nothing "natural" about the least alienated practices of reproduction, that these are always culturally mediated, and in some sense *artifice* (Tabet 1985). Indeed, many forms of "artificial" insemination may involve substantially less technological mediation, and be much less invasive and violent, than "natural" insemination. At the same time, calling "artificial" any mode of reproduction that does not involve contact with a penis appears inextricably tied up with heterosexism – thus the preference some have shown for the labels "alternative" or "medically assisted" reproduction.[1]

In short, we have come to recognize that neither the boundaries nor the contents of categories like Nature and Artifice are fixed or stable. However, the designation of certain practices as "natural" or "artificial" – or as "high-tech," "revolutionary" or "new" – continues to have important social, political, and legal consequences. And, in ways that are only beginning to be explored, these and other categories may have *practical* consequences for the styles and directions of scientific research on infertility and conception, where the meanings of reproduction, the body, and technology may be varied, even contradictory, and open to continual renegotiation.

I want to take as my starting point a story of the multiple fathers of

artificial reproduction told in most histories of endocrinology and obstetrics. The story credits the eighteenth-century Italian embryologist Lazzaro Spallanzani with the first mechanical impregnation of a mammal (a poodle in 1780),[2] the English physician John Hunter with the first successful application of the procedure to a woman in 1799, using the sperm of her husband, and the Philadelphia surgeon William Pancoast with the first artificial impregnation of a woman using "donated" semen in 1884.[3]

Pancoast's achievement is recounted by one of his students, Addison Davis Hard, breaking a "vow of secrecy" some twenty-five years after the procedure in a letter to *The Medical World*. Pancoast, Hard tells us, was approached by a wealthy Philadelphia merchant, age 41, whose "home was childless." Though the man admitted to a "slight attack of gonorrhea in his youth," it was initially assumed that the merchant's wife, ten years his junior and a member of a prominent Quaker family, was unable to conceive. She was therefore examined first. Hard reports that her examination, in which he and a section of the senior class participated, was "almost as perfect as an army examination, but not the slightest abnormal condition was discovered" (1909a: 163). The "fault," it turned out, was the husband's, and two months of treatment did nothing to produce live sperm. "The only solution of this problem," joked a member of the class, "is to call in the hired man." Hard reports that:

> The woman was chloroformed, and with a hard rubber syringe some fresh semen from the best-looking member of the class was deposited in the uterus, and the cervix slightly plugged with gauze. Neither the man nor the woman knew the nature of what had been done at the time, but subsequently the Professor repented on his action, and explained the whole matter to the husband. Strange as it may seem, the man was delighted with the idea, and conspired with the Professor in keeping from the lady the actual way by which her impregnation was brought about. In due course of time the lady gave birth to a son, and he had characteristic features, not of the senior student, but of the willing but impossible father.
>
> (ibid.: 163)

By the time of Hard's writing, the son was a businessman in New York, and Hard reports having travelled there to shake his hand.

The remainder of Hard's letter is devoted to considering the possible *social* benefits of the extension of this practice to entire populations:

> From a nature point of view the idea of artificial impregnation offers valuable advantages . . . Persons of the worst possible promise of good and healthy offspring are being lawfully united in marriage every day. Marriage is a proposition which is not submitted to good judgment or even common sense, as a rule. No Burbank methods are possible, even tho they be ideal. Artificial impregnation by carefully selected seed alone will solve the problem.
>
> (ibid.: 163)

As might be expected, Hard's letter prompted loud reactions, some doubting the story's truth. One spoke of Hard's "disordered brain" (Egbert 1909: 253), while another (the only writer to liken the insemination procedure to rape) joked about Hard's "brand of drinking water" (Newth 1909: 197). But most took the story at face value, worrying (if at all) about the transgression of the boundaries set by nature, religion, and good taste. One responded that "It would have been a thousand fold better and more honorable had your professor seduced that woman while conscious; or, if you please, just as honorable had he had intercourse with her while unconscious" (Egbert 1909: 254).

But another physician, reacting in anger to invocations of religion and the authority of Nature, defended his colleagues' efforts to "modify creation and improve it by intelligence." The assault on Nature, here *explicitly* coded as rape, was in his view already commonplace: "Just think," he wrote, "how Luther Burbank has violated 'God's ways' and committed rape and promiscuousness thousands of times with his flowers, by putting pollen where it otherwise would not have fallen." "Would to God," he added, "we could, by proper selection and still other means, breed off the thorns from *our* nature" (Barton 1909: 305). Another writer, a breeder of horses who confessed to having "greatly enjoyed" the story, argued for the extension of selective castration to the human family. Instead, he lamented, "We are standing idly by and witnessing thousands of infected young men of fine families select a pure, innocent young girl, perhaps your own, to deposit the deadly seed of his 'prodigal' reaping" (Griffin 1909: 196). Hard, for his part, admitted that some parts of the story had been "embellisht purposely with radical personal assertions on the subject of generativ [sic] influences and generativ ills," and acknowledged he would "not wish to own a child that was bred with a hard-rubber syringe" (1909b: 306).

I want to call attention to several features of this origin story, in which the restoration of a "natural" function takes the form of an anesthetized, mechanical rape. Hard reports "as a matter of public interest" that, during the course of their earlier examination of the woman, the students observed the "suction function" of the uterus during orgasm (1909a: 163). In fact, the presumed relationship between sexual pleasure and impregnation was central to much of the early research on artificial insemination. Doctors talked of the need for the woman to be stimulated to the point of orgasm (though usually not at the hands of physicians or medical students) in order for impregnation to occur. Havelock Ellis, for example, attributed low rates of success in early experiments in artificial insemination to the absence of erotic stimulation (Ellis 1910, cited in Brewer 1935: 122).

This is also, of course, a story about eugenics, in which the lines between folk practices (picking "the best-looking member of the class") and emergent social technologies are blurred. From the earliest work in

animal husbandry, practices of artificial insemination and selective breeding had been inseparably linked, and we have seen that Hard was not alone in imagining the eugenic benefits of dissociating intercourse and insemination. Indeed, some eugenicists worried early on that artificial insemination of a woman using her husband's sperm might be *dysgenic*, because it risked reproducing the anatomical or physiological defects that made intercourse or normal fertilization impossible.[4]

At other times, however, concerns with paternity and the welfare of populations pushed in similar directions. One of the earliest advocates of freezing human sperm, the Italian anthropologist Paolo Mantegazza, envisioned that it would be of interest primarily to men heading off to war, who might want to ensure that their sperm survived the conflict even if they did not (Mantegazza 1866: 189).[5] But Mantegazza was also a pro-natalist, and worried about the national depopulation that might result from modern warfare (cf. Forbes 1944).[6] Almost a century later, C. P. Blacker, a British eugenicist, would propose the creation of "underground seminal banks" to protect the kingdom's sperm supply from the radiation that would be produced by a nuclear war (Blacker 1958: 51; cf. Brewer 1963).

Finally, I want to suggest that Hard's story might be read as a story of the (masculine) pleasures of transgressing boundaries, and not only those of propriety. It is also about the refashioning and mastery of the natural (imagined as deficiently managed by the social practice of marriage), and about moving beyond the limits set by bodies and sexual relations.[7] Eugenicist Herbert Brewer, writing in 1935, would advocate the displacement of intercourse ("coitus is but a means") by "telegenesis," the name he gave to "the process of reproduction from the germ cells of individuals between whom is no bodily contact" (1935: 121, 123).[8] Brewer called "eutelegenesis" practices of artificial impregnation using donor semen that were also informed by the principles of eugenics. Eutelegenesis would make it possible to overcome the "enormous margin of wastage" that Nature tolerated, and might allow one man to fertilize five million women in a single year. As a result, it would be possible to "sweep out of existence the whole inextricable tangle of latent defect in a few generations," without denying any woman (even if a carrier) the "gratification of her maternal impulses" (ibid.: 123).[9]

Here the body is constructed as an obstacle and limit, and Nature figures as unreflective and unseeing animality. In eutelegenesis, "Instead of reproduction being the blind consequence of an animal mating, it is an act of deliberate creativeness to which animal life holds no parallel" (ibid.: 124). Interestingly, male jealousy, imagined elsewhere to be an impediment to donor insemination, is constructed here as "a quality appropriate to the animal rather than the human." Brewer cites variations in male egotism uncovered by anthropology as proof that animal jealousy can, with enough cultural work, be "attenuated or

submerged" (ibid.: 125). And paternity is finally refigured here as *conception* in its original sense. Brewer suggests that

> the putative father might feel himself bound to the eutelegenic child in an even deeper sense than if the child were derived materially from himself. For, conjointly with the mother, he might feel himself to have created, *by the deliberate exercise of his will and thought*, a being in whom his ideal aspirations were embodied.
>
> (ibid.: 125, emphasis added)

The technology of cryopreservation (frozen storage of sperm) makes it possible, in short, for the human male to finally realize paternity as disembodied reason.

In 1963, Brewer would propose that a truly rational and deliberate control of procreation at the level of the couple (which he called *agapogeny*) would combine vasectomy and telegenesis: one or two samples of semen taken prior to the operation could be preserved in low-temperature storage (1963: 55). This would, in Brewer's view, have a number of advantages: eliminating unwanted or poorly timed parenthood, reducing the risk of congenital abnormalities by enabling pre-conceptional and post-conceptional prophylaxis (women would know when they were likely to conceive, and could limit their exposure to thalidomide, for example), and guarding against genetic damage to sperm caused by modern life: "the increasing use of nuclear power in industry, . . . industrial and automobile fumes, foods and food additives, tobacco, drugs, antibiotics, hormones, cosmetics, contraceptives and agents of chemical warfare" (ibid.: 56).

More recently, a theologian member of the (still active) Eugenics Society (Dunstan 1983) has taken issue with all those who might oppose artificial insemination on the grounds that it is "unnatural." Behind such claims, he argues, is the unwarranted assumption that "'Natural' human begetting is like animal begetting, alike in biological and physiological function" (ibid.: 224). And yet, argues Dunstan, blending theology and anthropology,

> In few areas of life, in fact, do we "leave it to nature," for it would be inhuman and suicidal to do so. If in everything vital we exert control over nature to serve our good, there is no reason a priori to leave fertility and infertility to natural hazard when both overpopulation and involuntary childlessness bring people to misery.
>
> (ibid.: 226)

Dunstan ends by displacing the opposition of the natural and artificial, or rather by collapsing its terms: "What is biologically 'natural' [read Nature] is to be subordinated, then, to what is humanly 'natural' [read Artifice], and this by the exercise of human reason" (ibid.: 226).

To look at the destabilization of the boundaries of the natural and

the artificial in another way, I want to turn briefly to critical studies of techno-science, and to the intersections of gender and technology mapped in and by the work of François Dagognet and Donna Haraway. In a recent article, Paul Rabinow (1992) has suggested that we read these authors in relation to each other; I would like to push this interesting comparison further and suggest a somewhat different conclusion.

Haraway's work in feminist and cultural studies of science has both followed and facilitated the undermining of "the certainty of what counts as nature" (1985: 70). For Haraway, nature is "*made*, as both fiction and fact"; even what appear to us as technological *de*-naturings are, she proposes, "a particular production of nature" (1992: 297). But though Haraway is thus wary of appeals to "the natural" figured as primordial, innocent, or whole, she remains wary too of a phallogocentric "productionism," according to which "man makes everything." For Haraway, "nature designates a kind of *relationship*, an achievement among many actors, not all of them human, not all of them organic, not all of them technological" (ibid.: 297, emphasis added).

Dagognet is a French philosopher of science and technology whose work has also gone a long way toward loosening the hold of a naturalism we inherited from the Greeks. Dagognet decries our "ancient submission" to nature (1988: 15), and our long-standing habit of denigrating the artificial – from Aristotle to Barthes' critique of plastics, from romanticism to the ecology movement. Each of these, in Dagognet's view, contributes to the "sacralization" of nature (ibid.: 40). For Dagognet, there is no longer anything natural about Nature (ibid.: 49). Nature is instead artifice: both a human construction, we might say, and a modified or indeed "conquered" environment (ibid.: 40).

Dagognet constructs nature as resource, but in a particular sense: a generator of difference, it is "polyphenomenality without limits" (ibid.: 69). Nature is not mechanism, but a plastic material that not only allows for but *calls* for transformations.[10] Nature does not ask for conservation (nor we might add, to anticipate Haraway, does it ask for conversation) – it *asks for artifice* (ibid.: 49). Rather than "denaturation," Dagognet speaks of a "supernaturalization," where "we" accomplish nature better (ibid.: 85). In the end, the choices for Dagognet (and for us) are either "veneration" or "manipulation" (ibid.: 12).

But "we" may well be led to wonder whether Dagognet's two stances – both, in a certain sense, masculinist and heterosexist – exhaust our imaginative, political, and erotic possibilities. Though both Haraway and Dagognet articulate a kind of artifactualism, and both are alive to the dangers of a romantic naturalism, the pleasures they are after seem to be decidedly different: on one hand, the pleasures of irony, conversation, and habitation; on the other, the pleasures of mastery (*maîtrise*) and manipulation. We can, I think, imagine other

pleasures as well. The point, in any case, is not to exclude the language of desire or sexuality from either techno-science or cultural studies – even technophilia, perhaps, has a bad name – but to recognize that both the pleasures and the dangers of boundary transgression will depend crucially on where "we" work to locate ourselves.

NOTES

Author's note: Research for this chapter was supported by a Seed Grant from the College of Humanities and the Office of Research at The Ohio State University. I wish to thank Laura Davis for her invaluable research assistance. An earlier version of this chapter was presented to the panel on "De-Natured Bodies: Cultural Studies, Technoscience, and the Remaking of Boundaries" at the 1993 meetings of the American Anthropological Association. I am grateful to Rayna Rapp, Jennifer Terry, and Carole Vance for their comments and suggestions for revision.

1 See Robinson and Pizer (1985: 36–7): "Alternative fertilization is as natural a means for producing a normal baby as the method employed over millions of years of human evolution – it is *different* only in that sexual intercourse is not needed." This is in contrast to the 1930s and 1940s, when it was common to highlight the unnaturalness of donor insemination by naming the offspring "test tube babies" (Rohleder 1934). *Test Tube Babies* is the title of an 1948 movie in which artificial insemination by donor is presented as a technical means to save a marriage from the dangers of alcohol and "orgies" by restoring maternity.

2 Rohleder, however, points to an Arabic source from 1322, which describes the theft of semen from an enemy tribe's stallion, and the successful fertilization of a mare (1934: 35–6).

3 Pancoast had been a Civil War surgeon-in-chief, and replaced his father as professor at the Jefferson Medical College in 1873 (Gregoire and Mayer 1965: 130). He was also the eventual owner of the bodies of the original Siamese twins (Chang and Eng) who died in 1874.

4 Marion Sims, who abandoned his research on mechanical insemination using husbands' semen in the 1860s, was reportedly "never very proud of this practical application of a physiological principle in a partially unphysiological body" (McIntosh 1909: 197).

5 Today, the vast majority of sperm that is stored in banks is for "fertility insurance" – that is, for men undergoing sterilizing medical treatments or vasectomies (Novaes 1985).

6 Mantegazza also foresaw the widespread use of frozen semen, transported over considerable distances, for the fertilization of horses and cows.

7 Stella Maria da Silva traces the pleasures of artifice, together with the compulsion to see, to extract, and to archive, to the research on insemination by Spallanzani in the eighteenth century (da Silva 1991: 123–4).

8 Marion Sims had called homologous insemination "ethereal copulation" (McIntosh 1909: 197).

9 Brewer suggested that suitable male sources for germ cells might include saints(!), philosophers, scientists, poets, artists, musicians and – if there was sufficient

demand – politicians and film idols (1935: 124). Some years later, a sperm bank containing the semen of Nobel prize winners was created in California.

10 Evelyn Fox Keller has called attention to an inversion of the terms Nature and Nurture, precipitated by the success of the vision of molecular biology: "Where the traditional view had been that 'nature' spelled destiny and 'nurture' freedom, now the roles appear to be reversed" (Keller 1992: 288).

REFERENCES

Barton, B. S. 1909. "Impregnation and Religion." *The Medical World* 27 July: 305.

Blacker, C. P. 1958. "Artificial Insemination: The Society's Position." *The Eugenics Review* 50(1): 51–4.

Brewer, H. 1935. "Eutelegenesis." *The Eugenics Review* 27(2): 121–6.

Brewer, H. 1963. "Constructive Fertility Control through Sterilization." *The Eugenics Review* 55(1): 55–6.

Corea, G. 1985. *The Mother Machine: Reproductive Technologies from Artificial Insemination to Artificial Wombs*. New York: Harper and Row.

Corea, Gena. 1987. *Man-Made Women: How New Reproductive Technologies Affect Women*. Bloomington, IND: Indiana University Press.

Dagognet, F. 1988. *La maîtrise du vivant*. Paris: Hachette.

da Silva, S. M. 1991. "L'imaginaire de la reproduction artificielle au XVIIIe siècle: Mythomania genitalis," in S. Novaes (ed.) *Biomédecine et devenir de la personne*. Paris: Seuil, pp.89–130.

Dunstan, G. R. 1983. "Social and Ethical Aspects," in C. O. Carter (ed.) *Developments in Human Reproduction and their Eugenic, Ethical Implications*. Proceedings of the Nineteenth Annual Symposium of the Eugenics Society, London 1982. New York: Academic Press, pp.213–26.

Egbert, C. L. 1909. "Regarding Artificial Impregnation." *The Medical World* 27 June: 253–4.

Firestone, S. 1970. *The Dialectic of Sex*. New York: William Morrow.

Forbes, R. 1944. "The Medico-Legal Aspects of Artificial Insemination." *The Medico-Legal and Criminological Review* 12(3): 138–52.

Franklin, S. 1995. "Postmodern Procreation: A Cultural Account of Assisted Reproduction," in *Conceiving the New World Order: The Global Politics of Reproduction*. Berkeley, CA: University of California Press, pp.323–45.

Gregoire, A. T. and Mayer, R. C. 1965. "The Impregnators." *Fertility and Sterility* 16(1): 130–4.

Griffin, J. M. 1909. "Gonorrhea – Artificial Impregnation – Offensive Perspiration." *The Medical World* 27 May: 195–6.

Hamilton, N. J. 1909. "Artificial Impregnation." *The Medical World* 27 June: 253.

Haraway, D. 1985. "A Manifesto for Cyborgs: Science, Technology, and Socialist-Feminism in the 1980s." *Socialist Review* 80: 65–108.

Haraway, D. 1992. "The Promises of Monsters: A Regenerative Politics for Inappropriate/d Others," in L. Grossberg, C. Nelson and P. Treichler (eds) *Cultural Studies*. New York: Routledge, pp.295–337.

Hard, A. D. 1909a. "Artificial Impregnation." *The Medical World* 27 April: 163–4.

Hard, A. D. 1909b. "Artificial Impregnation." *The Medical World* 27 July: 306.

Hartouni, V. 1991. "Containing Women: Reproductive Discourse in the 1980s," in C. Penley and A. Ross (eds) *Technoculture*. Minneapolis, MINN: University of Minnesota Press, pp.27–56.

Keller, E. F. 1992. "Nature, Nurture, and the Human Genome Project," in D. J. Kevles and L. Hood (eds) *The Code of Codes: Scientific and Social Issues in the Human Genome Project*. Cambridge, MA: Harvard University Press, pp.281–99.

Klein, R. 1989. *Infertility: Women Speak out about Their Experiences of Reproductive Medicine*. London: Pandora Press.

McIntosh, T. M. 1909. "Artificial Impregnation." *The Medical World* 27 May: 196–7.

Mantegazza, P. 1866. *Sullo sperma umano*. Rendiconti, Reale Istituto lombardo di scienze e lettere 3: 183–96.

Newth, C. H. 1909. "Contracted Pelves – Artificial Impregnation." *The Medical World* 27 May: 197.

Novaes, S. B. 1985. "Social Integration of Technical Innovation: Sperm Banking and AID in France and in the United States." *Social Science Information* 24(3): 569–84.

Rabinow, P. 1992. "Artificiality and Enlightenment: From Sociobiology to Biosociality," in J. Crary and S. Kwinter (eds) *Incorporations*. New York: Zone, pp.234–52.

Robinson, S. and Pizer, H. F. 1985. *Having a Baby Without a Man: The Woman's Guide to Alternative Insemination*. New York: Simon & Schuster.

Rohleder, H. 1934. *Test Tube Babies: A History of the Artificial Impregnation of Human Beings*. New York: Panurge Press.

Tabet, P. 1985. "Fertilité naturelle, reproduction forcée," in N.-C. Mathieu (ed.) *L'arraisonnement des femmes: Essais en anthropologie des sexes*. Paris: EHESS, pp.61–146.

15

23 questions

Kathy High

ATCGCAATCTGCCGA
TTGGATGGCGCGAAGC
AAGCTGGTTCTCACTT
CTTACGTTACTTCTTT
CCGACCCTAAATTTT
GTGTGTCAGGAACTGC

I imagine myself giving birth to myself . . . I have been longing to bear a child. But not just *any* child. I imagine removing a cell from my finger or my blood sample. Then cloning the cell and growing it in a petri dish to become a little embryo. Then implanting this embryo in my womb. I imagine the chance to birth myself and raise myself . . .

These narcissistic imaginings are not so very far-fetched. In this day and age of splitting eggs, imitating cells and embryo experiments, I could easily genetically alter my little replica. I could isolate and manipulate those deadly genes which have caused me so much pain and drama in my life. I could give her gifts I have always dreamed of – like a bigger brain and butt. This is the ultimate in rebirthing, my own version of being "born again," my own perfected self . . .

You know, in Italy there exist no regulations, no laws governing fertility treatments. It is the only country in the world where this condition exists, This makes it the ideal spot for "procreative tourism."[1] The Italian doctors have become famous for such procedures as: successfully impregnating post-menopausal women, developing eggs from fetuses and dead women, and even experimenting with male pregnancy (a project which, I doubt, will be terribly popular with clients

GGAGGTTCTAAACCTC
GCTCTTAAACCTGCTA
GCGGGACGTATGCTTT
ATCTGTTACTGAGAAG
GCAGAAGAGCAAGAG
AAAAGAAAGGTATTA

. . . or will it be the ultimate oedipal dream, to not just sleep with the mother, but *be* the mother/son[daughter]?). So, Italy with its over 120 private fertility clinics, is the wild frontier of biomedicine . . .

Well, I could go there for the reproduction of myself and probably make headlines. It could even be *ART* . . .
I want to see my cloned child/sister become a scientist herself . . .
I want to see her work on the recombinant possibilities of life and (in my stead) have some input on rewriting the "map." Cloning, like mirroring, seeing myself, duplicating my imagined-double-child, doubling my chances for success. I ask my self-child to seize the opportunity to critique these genetic sciences by throwing herself into research so outlandish and radical that she disturbs them all with her persistence and non-hierarchical techniques. She makes her mother proud (this is not to just make myself immortal, you understand. This is to give myself a chance to keep up with the race, so to speak – a second chance.).

In the late twentieth century there have been great advances in biotechnology. Genes have come to represent our greatest hopes for re-shaping ourselves. Reports that coddle and coo up to the mysteries of "gene-solutions" headline the papers every day: "Unraveling the Secrets of Genes",[2] "Want a Room with a View? Idea May Be in the Genes".[3] DNA tests, genetic screening and "locales" of diseases on gene maps shape our daily perceptions and dictate popular media's biases: the truth is in the genes — "They Dream of Genes"[4]

Projects of mapping uncharted frontiers and first-time discoveries are in progress: The Department of Energy's sponsored project, the Human Genome Project, is a heavily funded initiative researching the site or locale of each human gene with the specific purpose of constructing a map. (*With a map, you can find your way.*) One proposed program branching out of the Human Genome Project is the Human Genome Diversity Project (HGDP). The goals of the HGDP are to record the genetic differences among aboriginal peoples of the world, to map migratory patterns of various groups. By collecting blood and tissue samples from "dwindling" indigenous groups around the globe, the project will create a large database and permanent storage of indigenous genetic materials (indigenous groups "in place" before 1492 are being considered for inclusion). Noted geneticist Walter Bodmer says that the Diversity Project is "one of the most important components of the Human Genome Project [and] will therefore involve the setting up of a type of rescue genetic archaeology, . . . a molecular Noah's Ark".[5]

But the HGDP has been called the "vampire project" by many indigenous groups who were asked to participate. Requests have been made to "cease and desist immediately all activities regarding the DNA structures (genetic fingerprints) of the people of the Onondaga and Cayuga Nations and other indigenous nations and peoples" (letter from Chief Leon Shenandoah and the Onondaga Council of Chiefs to the head of the HGDP, Mr Friedlaender). Debra Harry, from the Northern Paiute Nation, Nevada, has written "The Project puts Indigenous peoples' most fundamental property - their own genes - in the hands of anyone who wants to experiment with them. In doing so, the Project opens the door to widespread commercialization and potential misuse of the samples and data."[6] The very notion of an "endangered" people implies extinction and the termination of a specific group. Indigenous nations are fighting off a new kind of colonization, a kind of "biopiracy," which allows

science (quite conveniently and profitably) to see nation people (once again) as statistics and data.

But who can argue with SCIENCE?

As a Caucasian American, a member of the potential "colonizing group," I feel it is important to question technological autocracy from this perspective. I want to reach *deep* into the throat of our culture to extract reasons for our fascination with *and* fear of gene therapies, cloning, and our conflicted desire for an ideal set of genes. The mixed implications of the HGDP on the one hand, and the potential for (possibly curative?) genetic manipulations on the other — and that place where such areas intersect — are some of the issues underlying the narrative and the investigation of my project *The 23 Songs of The Chromosomes* — a futuristic musical coming soon . . .

I desire with my cloned offspring to produce not simply a critique of rapid technological innovation but rather, and in keeping with my previous work, to express an acute examination of scientific methodology and scientific vision. I want her to interrogate whether it is merely adequate to predict the future and I want her to address some of the new ethical problems that are arising. At this crucial point in the evolution of genetic technology, when rapid progress and history are being made, I want her to be not simply "reactive," but "active" in her(my) response to an understanding of science practices.

And we will then question everything . . .

1-800-Give-Egg

So, finally I would like to ask you some questions, or rather I would like to play 20 questions – no 23 questions to be exact – for our 23 pairs of chromosomes.

Twenty-three questions

Why are these discoveries important – important for whom? And who says so?

Do these new technologies replicate us in ways that disassociate us from our bodies, our communities, or do they bring us together in new ways?

Are we colonizing (cloning) our (one) image to the exclusion of others? (And you can be certain that not all of us will make the grade...)

What are the global considerations in (en)visioning these technologies?

Are we determined by our biologies? By our genes? (If in doubt, please check the map...)

Not wanting to be either a Luddite or a "techno groupie," how do I consider and situate myself alongside new technologies such as surrogate arrangements, embryo sales, fetus implants, gene collections and sex determination?

Who has access to genetic engineering technologies? (A commonly asked question. And for the most part it seems to depend on access to money.)

Are the new superhighways of cyberspace like the new super-connections on the great human genome map? Will these act as literal coordinates? Does it matter where the computer for America On Line resides? Does it matter where @ is at?

Can we pinpoint the locale for

160

the gay gene? (does this include lesbians?)

If I am a cyborg, can I buy and sell any body part? Does it matter what country it is from?

If genetic engineering and biotechnology are being hyped and sold as ferociously as the new electronic superhighway or cyberspace, which one should I buy stocks in?

If we are created in a test tube or petri dish, and all communications are changing to digital bits and factoids, what will our art work look like? How will it be distributed, via genes or fiberoptics?

Who will control our DNA data? Our insurance companies? The military? Our employers? Our mothers?

When will we be informed of our destinies?

What about selling embryos or eggs or ova? I would make a lot of money, right? (More if I were younger and a natural blond.) But do I get to know who buys them? Does it even matter?

Can I rent someone to have my embryo now? I'm running a little late because I have to speak at this conference and then fly across the country and deliver a paper. Can she do it now? I have a break in my schedule in nine months. I hope it will be cheap, you know, I'm not very well paid for all this. What happens if the baby is defective? Oh, I don't know...

If I drink, or smoke, or am HIV positive, and I get pregnant, what do you think I should do?

If all abortion clinics operated in facilities where IVF research was being conducted, would we then buy the embryos? Would the women having abortions pay for the abortions

or should they get paid for having them?

In a surrogacy arrangement can anyone change their mind?

How much should surrogacy cost? It's been at the same base rate of about $10,000 for the past fifteen years. Shouldn't inflation affect this area, too?

Shouldn't there be a surrogate's union?

Okay, I like the idea of genetic manipulation. Does that mean that I can wipe out alcoholism from my family forever? But isn't that what makes us so crazy and stubborn and Scottish? Maybe that isn't a good question. Maybe I should consider the "shopping gene."

And finally how many people here would have made it through prenatal genetic screening at a company like "Sunshine Genetics"?

NOTES

Author's note: Special thanks to Shani Mootoo and Diane Bertolo, Nora Fisch, Tom Damrauer, Rick Prelinger, David Kalal, Melodie Calvert and Jenny Terry for all their help and support. This talk was also given at IMAGES Film/Video Festival, *Rituals of Future Bodies*, panel curated by Laura McGough, Toronto, Canada, 1995.

1 Celestien Bohlen, "Almost Anything Goes in Birth Science in Italy," *New York Times*, 3 April 1995.

2 Thomas H. Maugh, "Unraveling the Secrets of Genes," *Los Angeles Times*, 31 October 1993, p.A1.

3 William K. Stevens, "Want a Room With a View? Idea May Be in The Genes," *New York Times*, 3 November 1993, p.B5.

4 Daniel Callahan, "They Dream of Genes," *New York Times Book Review* 7, 12 September 1993, p.26.

5 *The Book of Man: The Human Genome Project and The Quest to Discover Our Genetic Heritage*, by Walter Bodmer and Robin McKie, NYC: Scribner (1995), p.174.

6 Information About Intellectual Property Rights No. 6, January 1995, *The Human Genome Diversity Project and Its Implications For Indigenous Peoples*, by Debra Harry, Northern Paiute Nation, Nevada.

16

Biotechnology and the taming of women's bodies

Soheir Morsy

INTRODUCTION

Science and technology have come to symbolize the "progress" and "development" of Western societies. As such, these social productions constitute powerful foreign policy instruments for developed nations to the north of the global divide. By the admission of the National Science Board of the (US) National Science Foundation, scientific co-operation with so-called developing countries provides "economic, diplomatic, and other policy benefits going beyond the immediate needs of science *per se*" (cited in Dickson 1984: 164–5). Science-based technology, ranging from micro-electronics to biotechnology, provides immense political leverage and economic profits to Northern centers of superior scientific expertise.

Among others, Henry Kissinger and Henry Nau have been prominent champions of the utilization of science and technology as conduits of foreign policy. As a member of President Reagan's National Security Council, the latter argued that superior science and technical expertise allow the US to impose "a more subtle and total form of imperialism than was possible in any previous period of history" (quoted in Dickson 1984: 166). Demographic management through biotechnology which tames the bodies of women/"breeders" of the global South illustrates this kind of imperialism.

On the home front in the US the new long-acting, provider-dependent contraceptive technology also has great potential as an instrument of social control. In this society, where minority racial status and social disempowerment often coincide, and where racism/classism are effectively disguised as a fight against "the epidemic of adolescent pregnancies," and purposeful political interpretations of "ending welfare as we know it" (Hadjor 1995; Ward 1995; Williams 1994), Norplant contraception threatens the civil liberties of impoverished women (ACLU 1995: 4).

THE OTHER IN THE SERVICE OF SCIENCE AND TECHNOLOGY

Although science and technology-assisted control of the legendary female Other are now better served by medicalization, and the construction of an illusionary global feminist consensus (Hartmann 1994), their utility as a mechanism of domination is far from novel. Ideas about science and technology have been central to Western ideologies of dominance for a number of centuries (Adas 1989). For example, during the colonial era Bacon's engendered view of science–nature, which had served patriarchy well in its rationalization of the domination of European women by their men, was extended to the relations between Europeans and non-Europeans. Every aspect of the colonized Other's existence, from "tropical"

166

*Biotechnology
and the Taming
of Women's
Bodies*

diseases to culture, became the object of scientific inquiry (Hess 1994: 82–6).

The political utility of Other-focused science extends to feminist discourse. Reflecting on "the use and abuse of anthropology," Michelle Rosaldo remarked,

> Women elsewhere are, it seems, the image of ourselves undressed . . . Their strengths prove that we can be strong . . . We want to claim our sisters' triumph as a proof of our worth, but at the same time their oppression can be artfully dissociated from our own, because we live with choice, while they are victims of biology.
>
> (Rosaldo 1980: 392)

The type of "undressing" and perceived "victimization" described by Rosaldo is certainly benign compared to other forms which have targeted the physical body of the female Other in the past, and at present.

For the colonial era there is ample documentation of a variety of fantasies of seduction in which Europe's constructed "primitives" are symbolized by the female body (e.g. Graham-Brown 1988, *passim*; Michalak 1984; Spurr 1993, *passim*). Of these, the case of Sarah Bartmann (Saartjie Baartman, aka the Hottentot Venus) is one of the more tragic examples of the practice of dehumanization under the guise of Science.

As described by Jordan and Weedon (1995), Bartmann was a woman from Southern Africa who, in the early 1800s became an indentured servant in Europe where African women were widely believed to have a fierce, "primitive sexual appetite." Sarah Bartmann had two physical attributes which were believed to epitomize sexual "primitiveness": hypertrophy of the labia and hugely protruding buttocks (steatopygia). Before her death in 1815, at the age of 25, she was exhibited over a five-year period in Paris and London. After her death, her body was dissected and her genitalia and buttocks were put on display at the Musée de L'Homme in Paris, where they remain to this day (ibid.: 276).[1]

While the body of the female Other has long served to provide Europeans with pleasure in the form of sexual fantasies, and even promote their science in the process, it was, and still is considered a source of danger when viewed as a breeding machine. Today, in the land of the Musée de L'Homme, as in the US, the influx of immigrants of color has become central to the agenda of the political Right.

The US government, in its efforts to control population in the so-called developing world has long served as a leading promoter of international "contraceptive inundation." In this endeavor women of the south have again served science well, as consumers/testers of contraceptives which are not legalized, or which have been banned in their countries of origin, and as "volunteers" for experimental trials of new

contraceptive technologies (Ehrenreich *et al.* 1979; Hartmann 1995; Morsy 1993).

THE INTERNATIONAL DISCOURSE ON "POPULATION"

While the international discourse on "Population" has been cleansed of the overtly racist language of the past, it still betrays a concerted effort to impose control over women's bodies at home and abroad. This is manifest in a pro-natalist position for women of the north, exemplified in its most extreme form by abortion clinic terrorism in this country, and by what Renate Klein (1989) has described as "the exploitation of [the] desire" of infertile women who are subjected to the physical and mental pain of technology-assisted conception. For all the rhetoric of freedom of choice, which one would assume to include the choice of remaining childless, the anguish endured by women of the north in pursuit of conception suggests that motherhood remains central to the cultural construction of womanhood.

Among women of the global south the promotion of new forms of contraceptive technology, such as the five-year, surgically implantable device marketed under the commercial name of Norplant, proceeds within the framework of demographically informed "family planning" programs which target "breeders," be they in Indonesia, Thailand, Brazil, Egypt, or inner city Baltimore. Before Norplant, other forms of contraceptive technology, such as IUDs, including the infamous Dalkon Shield, had been shamelessly promoted as the epitome of progress, and as Science's contribution to women's liberation no less. For example,

> French experts, indignant about the subjection of women among Muslims, declared that women in Africa had suffered greatly from "millenary inequality." The IUD was presented as the only means that could free women from their husbands and from society in general . . . [N]ot surprisingly, nothing was said about the means of their economic independence.
>
> In the meantime, within France itself, population experts were earnestly striving to keep Frenchwomen from having the right to take the pill.
>
> (Moreau-Bisseret 1986: 75)

As purposeful instruments of population control, the new professional provider-dependent contraceptive technologies are a far cry from the safe and woman-controllable means of fertility regulation which feminists have long struggled for. Beyond the rhetoric appropriated from feminists by the international population establishment, the recent exposure of the potential for racist social engineering inherent in the "magical" Norplant technology underscores the dark side of international "family planning" (Hartmann 1995), and the practice

of "choice" among poor women of the US (ACLU 1990, 1991, 1992, 1995) who are "sentenced to Norplant" (Baker 1991).

For the US the belated discovery that the "Norplant Miracle" has been nothing less than a "Norplant Nightmare"[2] is hardly surprising for those familiar with the experience of women of the south who served as "bodies of choice" for Norplant experimental trials (Hartmann 1995; Morsy 1993; UBINIG 1988). Surprise is also muted by recalling that Norplant technology originated as the brainchild of William Shockley, the infamous eugenicist and advocate of scientific racism. Shockley's vision of controlling the population of allegedly low-IQ blacks and working-class whites who tended to have large families is no secret (Rose and Hamner 1976).

ANTI-FERTILITY "VACCINES": ANOTHER "MIRACLE" OF BIOTECHNOLOGY

While Norplant has been approved for use in a number of countries, including the US, ignoring reasoned objections from feminists, including medical professionals in this country and elsewhere, the anti-fertility vaccines are still in the phase of clinical trials but already discredited within the framework of an international campaign. Launched by the Amsterdam-based Women's Global Network for Reproductive Rights in November of 1993, the International Campaign for a Stop of Research on Antifertility "Vaccines," mushroomed into a worldwide effort. By May of 1994 some 369 groups and organizations in thirty-five countries had joined the Campaign.[3] For opponents of the "vaccines" a central issue is the potential for their abuse. In this regard Judith Richter (a feminist health activist who has been in the forefront of the international opposition to the anti-fertility "vaccines") considers abuse potential in terms of inherent features of the technology (prolonged duration of effectiveness, difficulty of voluntary reversibility by the user, and ease of administration – "vaccination" on a mass scale) which increase the likelihood of uninformed, misinformed and coercive administration of the contraceptive (Richter 1994).

As described in the literature of the Campaign, and elaborated in the work of Judith Richter (1993), the stated aim of the immunological contraceptive technology is to bring on temporary infertility by turning the immune system against bodily elements which are essential for biological reproduction. Of the variety of anti-fertility "vaccines," which are mainly for women, the one on which research is most advanced is that which aims to neutralize the human pregnancy hormone HCG (human chorionic gonadotrophin). This is a hormone which is produced in the body of a woman shortly after conception (fertilization).

A biological trigger mechanism is central to making HCG work as a contraceptive device. The hormone is altered and attached to a bacterial or viral carrier (such as a diphtheria or tetanus toxoid). With this

biological ploy the immune system is tricked into mistaking the natural pregnancy hormone for an infectious germ and reacting against it accordingly. As a result, the body's secretion of pregnancy-related substances is impeded and the fertilized egg is expelled. Variations on this scheme of immunological tampering include interference with the production of sperms, the maturation of egg cells, the fertilization process itself, and the implantation and development of the early embryo.

Within the framework of the Campaign, the Women's Global Network for Reproductive Rights has compiled contrasting evaluations of the "vaccines," which document women's criticism, researchers' promises, and promoters' arguments:

- Women observe that we have no control over this new technology while researchers flaunt it as long-acting.
- Women express concern that the action of this new technology cannot be stopped upon a woman's request. To promoters, on the other hand, the technology is valued as a new antigenic weapon against reproductive process.
- Women fear life-long sterility; researchers pride themselves on the technology's effectiveness as an instrument for fertility control.
- Women see no advantage over existing contraceptive methods; researchers emphasize "no user failure."
- Whereas women foresee adverse effects of tampering with a delicate immunological system, promoters focus on the ease of administration on a mass scale, pointing to the established familiarity with anti-disease vaccines among targeted populations.
- Women's questioning of immunological risks are countered by assertions of safety: no adverse effects on hormones and metabolism is the assertion offered in response.
- Women reject the false comparison with vaccines against diseases, promoters argue in favor of contraceptive choice.
- Feminist activists raise questions about the impact on HIV of immunological tampering; promoters are content with the technology's usefulness for women in Third World countries.
- Women say we don't need a bad choice contraceptive . . . besides, pregnancy is not a disease, and the contraceptive effect of this technology is unreliable . . . Promoters say the anti-fertility vaccines do not interrupt sexual intercourse.

The non-interruption of sexual intercourse is regarded as an improvement over Norplant from which prolonged bleeding may cause such disruption. This has been noted as an impediment to Norplant acceptability among Muslim women, for whom menstrual bleeding is considered polluting, and therefore a barrier to sexual intercourse.

Needless to say, the issue is not a matter of correctable elemental limitations but involves radical interventions in the social context of the production, promotion, and utilization of the new reproductive technologies.

CONCLUSION

Feminist assessment of the new forms of biotechnology (e.g. Klein 1989; Rose and Hamner 1976; Yanoshik and Norsigian 1989) has gone a long way toward deconstructing the notions of "progress" and "development" which often accompany the promotion of this type of technology. In the process due emphasis has been placed on the power structures of which biotechnology is born, within the framework of which it is promoted internationally, and to the reproduction of which it contributes.

Analytical orientations which transcend those of the individualistic, single issue "choice" posture have facilitated the linking of the development and propagation of woman-centered biotechnology to a multitude of power asymmetries, including those between classes, ethnic groups, physicians and patients, as well as males and females. Adopting such an orientation, which attends to the global political economy, Yanoshik and Norsigian (1989: 62) observe that

[B]ecause western medicine, the population control establishment, and the pharmaceutical industry are more interested controlling population and making money than in ensuring users' safety or creating woman-centered options, the effects of many of the contraceptive technologies have proven catastrophic. Millions of women's lives have been adversely affected by following advice or order to use such "miracle" technologies, oral contraceptives, Depo-Provera, or hormonal implants.

Informed by such an explicitly political analytical orientation, other researchers have also revealed the technological management of biological reproduction as simultaneously a mechanism of *social* reproduction. Biotechnology is thus recognized as harboring the potential for reinforcement of dominant values ranging from "appropriate" definitions of healthy offspring, and "professional" judgement, to the mystification of state power.

As technological fixes increasingly become integrated within a framework of medicalization, this confuses the international politics of women's reproductive rights. In attending to the serious political challenge represented by this development, and related technology-assisted mystification, it is crucial not to lose sight of the importance of shared, popularized scientific knowledge as an instrument of resistance. More generally, there is a continued need for informed international feminist solidarity based on mutual respect and appreciation of local priorities of struggle.

NOTES

1 The case of Saartjie Baartman was but one among many Khoikhoi and San people whose remains, including "trophy heads," formed part of the collections of European museums and institutions of scientific research. According to the 7 February 1996 edition of the *Washington Post*, Nelson Mandela's post-apartheid government has called for the recovery of Baartman's remains (among others of her people's desecrated bodies), including her brain and genitalia. As reported in the *Post* "the decision on Baartman's fate will be made by French scientists . . ."

2 *Norplant Nightmare* is the title of a documentary aired on 26 February 1996 by the Washington, DC based ABC affiliate WJAL. Contradicting the notion of "Norplant Miracle," the program highlighted the plight of women who have suffered from Norplant's adverse side effects, and the difficulties surrounding its removal. The documentary also brought attention to the law suits which have been filed against the manufacturer on behalf of adversely affected users of this new contraceptive technology.

3 Additional information on the Campaign, and a list of signatories, may be obtained from the Coordinating Office of the Women's Global Network for Reproductive Rights, NZ Voorburgwal 32, 1012 RZ Amsterdam, The Netherlands.

REFERENCES

ACLU. 1990. *Annual Report*. New York: Reproductive Freedom Project.

ACLU. 1991. *Testimony of Ann Brick on Behalf of the American Civil Liberties Union of Northern California Before the Women's Caucus of the California State Legislature and the Senate Health and Human Services Committee*, October 16.

ACLU. 1992. "Two More States Contemplate Punitive Welfare 'Reforms.'" *Reproductive Rights Update* IV(7): 6.

ACLU. 1995. *Background Briefing: The Civil Liberties Issues of Welfare Reform*. New York: Reproductive Freedom Project.

Adas, M. 1989. *Machines as the Measure of Men: Science, Technology, and Ideologies of Western Dominance*. Ithaca, NY: Cornell University Press.

Baker, B. 1991. "Sentenced to Norplant." *The Network News* (of the National Women's Health Network, Washington, DC) January/February.

Dickson, D. 1984. *The New Politics of Science*. New York: Pantheon Books.

Ehrenreich, B., Dowie, M. and Minkin, S. 1979. "The Charge Genocide; The Accused: The U.S. Government." *Mother Jones* 4(9): 26–37.

Graham-Brown, S. 1988. *Images of Women: The Portrayal of Women in Photography of the Middle East 1860–1950*. London: Quarter Books.

Hadjor, K. B. 1995. *Another America: The Politics of Race and Blame*. Boston, MASS: South End Press.

Hartmann, B. 1994. "Consensus and Contradiction on the Road to Cairo," in C. H. Ruge and M. K. Linlokken (eds) *Successes and Failures in Population Policies and Programmes*. Oslo: The Norwegian Forum for Development and Environment, pp.8–12.

Hartmann, B. 1995. *Reproductive Rights and Wrongs: The Global Politics of Population Control.* Revised edition. Boston, MASS: South End Press.

Hess, D. J. 1994. *Science and Technology in a Multicultural World: The Cultural Politics of Facts and Artifacts.* New York: Columbia University Press.

Jordan, G. and Weedon, C. 1995. *Cultural Politics: Class, Gender, Race and the Postmodern World.* New Brunswick, NJ: Rutgers University Press.

Klein, R. 1989. *The Exploitation of a Desire: Women's Experiences with In Vitro Fertilization.* Deakin University, Australia: Women's Studies Summer Institute.

Michalak, L. O. 1984. "Popular French Perspectives on the Maghreb: Orientalist Painting of the Late 19th and Early 20th Centuries," in J.-C. Vatin (ed.) *Connaissances du Maghreb: Sciences Sociales et Colonisation.* Paris: Editions du Centre National de la Recherche Scientifique, pp.47–63.

Moreau-Bisseret, N. 1986. "A Scientific Warranty for Sexual Politics: Demographic Discourse on 'Reproduction' (France)." *Feminist Issues* 6(1): 67–85.

Morsy, S. A. 1993. "Bodies of Choice: Norplant Experimental Trials on Egyptian Women," in B. Mintzes, A. Hardon and J. Hanhart (eds) *Norplant Under Her Skin.* Amsterdam: Wemos; Women's Health Action Foundation, pp.89–114.

Richter, J. 1993. *Vaccination Against Pregnancy: Miracle or Menace?* Amsterdam: HAI (Health Action International)/Bielefeld, Germany: BUKO Pharma-Kampagne.

Richter, J. 1994. "Beyond Control: About Antifertility 'Vaccines,' Pregnancy Epidemics and Abuse," in R. Snow and G. Sen (eds) *Power and Decision Making: The Social Control of Reproduction.* Cambridge, MA: Harvard University Press.

Rosaldo, M. Z. 1980. "The Use and Abuse of Anthropology." *Signs* 5(3): 389–417.

Rose, H. and Hamner, J. 1976. "Women's Liberation: Reproduction and the Technological Fix," in H. Rose and S. Rose (eds) *The Political Economy of Science: Ideology of/in the Natural Sciences.* London: Macmillan Press.

Spurr, D. 1993. *The Rhetoric of Empire: Colonial Discourse in Journalism, Travel Writing, and Imperial Administration.* Durham, TENN: Duke University Press.

UBINIG. 1988. *Norplant: The Five-Year Needle.* Dakkar, Bangladesh: UBINIG.

Ward, M. 1995. "Early Childbearing: What Is the Problem and Who Owns It?" in F. D. Ginsburg and R. Rapp (eds) *Conceiving the New World Order: The Global Politics of Reproduction.* Berkeley, CA: University of California Press, pp.140–58.

Williams, B. 1994. "The 'Reproductive Underclass' and the Raced, Gendered Masking of Debt," in S. Gregory and R. Sanjek (eds) *Race.* New Brunswick, NJ: Rutgers University Press, pp.348–65.

Yanoshik, K. and Norsigian, J. 1989. "Contraception, Control, and Choice," in K. S. Ratcliff (ed.) *Healing Technology: Feminist Perspectives.* Ann Arbor, MICH: University of Michigan Press, pp.61–92.

17

Brains on toast: the inexact science of gender

Joyan Saunders and Liss Platt

This experimental videotape presents a humorous examination of scientific theories about gender and sexuality. The cast of eight characters (a professor and her students) grapples with past and present research data on brains, hormones, reproduction and private parts. They discover a legacy of tainted evidence revealing several generations of scientists on a hell-bent mission to create and exaggerate differences between male and female anatomy and cognitive function. The tape digs up a storehouse of suppressed evidence which demonstrates that these biological distinctions are highly ambiguous and frequently non-existent. Throughout the narrative, man-on-the-street interviews are intercut with other scenes, including a bullfight, a dinner party with brains as the main course, and a nightmare sequence which finds the professor in bed with her entire class.

In the 1850s craniologists

were weighing brains and they discovered that women's brains are generally smaller than men's . . . bigger was better, even then, and the researchers concluded that this made men intellectually superior to women . . .

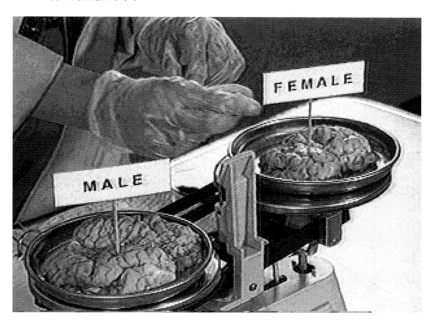

But what about elephants and whales?

They eventually figured out that elephants do have bigger brains than men, and this became known as the

Elephant problem

It was replaced by another formula that calculated brain weight in relation to overall body weight. With this new-fangled method it could be shown that a man was indeed smarter than an elephant after all . . . Unfortunately this formula had to be jettisoned when it became apparent that

Relative to their body weight, women have bigger brains than elephants

and men.

During the Victorian era scientists believed that a woman's reproductive system had a debilitating effect on her brain. It was said that menstruation, childbearing, and breastfeeding literally drained the brain of blood and other vital juices. If a woman chose to defy nature and exercise her brain, she would reverse this natural flow . . .

Blood would travel upstream
from her uterus to her head . . .

Her mind could only be nurtured at the expense of her fertility. OK, that was then and this is now. Now we know better than that, but still we're haunted by the specter of infertility, and now it's called an epidemic. Surely this isn't just a replay of tired old Victorian notions . . . Well, let's try to visualize the contemporary problem lady. I, I think it's me, an ambitious well-educated woman whose

ovaries and eggs

have been atrophied by the physical and mental demands of her high stress career. Gee, I guess you do have to break a few eggs to make an omelet. But wait a minute, we've been down this road before, and now it is time to ask, what's wrong with this picture . . .

Low sperm count

is a principal cause of infertility – the average man's count has fallen from 200 million sperm per millimeter in the 1940s to between

40 and 70 million in the 1980s.

There are persistent rumors

that Kim Novak is a biological male who was raised as a female because he/she was born without the . . .

standard male equipment.

This guy, John Money, is a psychologist who did studies in the 1960s on girls who were born with masculinized genitals because they were exposed to

high levels of androgens while they were still in the womb . . . They had enlarged clitorises, fused labia, things like that. Some of them were mistaken for boys. After their

condition was diagnosed

they were operated on, and this is usually described in really euphemistic terms, like the genital tissue was rearranged into a female appearance . . .

In most cases the operation is more like surgical castration and nothing is left of the clitoris that looked

too much like a penis.

I want to tell you a true story about
a perfectly normal baby boy who
lost his penis at seven months old.
The baby boy and his identical twin
brother were taken to the doctor
for circumcision. The doctor

over-juiced the current

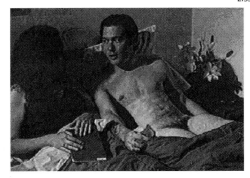

on the electric cauterizing tool and cooked the penis of the first baby boy.
Shortly thereafter it sloughed off like an umbilical cord. The parents
consulted a plastic surgeon who recommended that the boy be

reassigned as a girl.

That's when he was taken to Dr John Money. When the boy was 17 months
old he was given a change of name, clothing, and hairstyle. At 21 months
old his testicles were removed and the genital area was reworked into a
female appearance. Money periodically consulted the mother to check on
the child's progress . . . The
boy became a

perfect

little girl . . .

"You want me to tell you how
we made the change-over
from her being a boy to being
a girl. OK, well, at the outset
I started dressing her not in
dresses, but, you know, in

little pink slacks and frilly lacy blouses,

things like that. And I let her hair grow, and later on I made all her night-
wear into granny gowns. Now she wears bracelets, and she likes for me to
wipe her face. She can't stand to be dirty, and her twin brother is so
different. I can't wash his face for anything. She seems to be daintier,
maybe it's because I encourage it. One thing that really amazes me is that

she's so feminine . . ."

part three

Home

18

Techno–homo: on bathrooms, butches, and sex with furniture

Judith Halberstam

BATHROOMS

Recently, on my way to give a talk in Minneapolis, I was making a connection at Chicago's O'Hare Airport. I felt the need to use the facilities, to freshen up, to relieve myself and other euphemisms, and I strode purposefully into the women's bathroom. No sooner had I entered the stall than someone was knocking at the door: "Open up, security here!" I understood immediately what had happened. I had, once again, been mistaken for a man or a boy and some woman (fearing what exactly?) had called security. As soon as I spoke, the two guards at the bathroom stall realized their error, mumbled apologies and took off. On the way home from the same trip, in Denver's new airport, the same sequence of events was repeated. Needless to say, the policing of gender within bathrooms is intensified in the space of an airport where people are literally moving through space and time in ways that cause them to want to stabilize some boundaries (gender) even as they traverse others (national). However, having one's gender challenged in the women's rest room is a frequent occurrence in the lives of many androgynous or masculine women, indeed, it is so frequent that one wonders whether the category "woman" when used to designate public functions is completely outmoded.[1]

It is no accident then that travel hubs become zones of intense scrutiny and observation. But gender policing within airport bathrooms is merely an intensified version of a larger "bathroom problem." The bathroom problem makes all of its participants aware of otherwise invisible gender standards and their violation and brings us all into proximity with the laws which bind women to femininity. The accusation, "You're in the wrong bathroom," really says two different things. First, it announces that your gender seems at odds with your sex (your apparent masculinity or androgyny is at odds with your supposed femaleness); second, it suggests that single-gender bathrooms are only for those who fit clearly into one category (male) or the other (female). Either we need open access bathrooms, multi-gendered bathrooms or we need wider parameters for gender identification. The bathroom, as we know it, actually represents the crumbling edifice of gender in the twentieth century. The frequency with which I and others I know are mistaken for men in public bathrooms suggests that a large number of feminine women spend a large amount of time and energy policing masculine women. Something very different happens of course in the men's public toilet where the space effectively becomes a sexual free-zone. So, while men's rest rooms tend to operate as a highly charged sexual space in which sexual interactions can take place, women's rest rooms tend to operate as an arena for the enforcement of gender conformity. In fact, the reason we maintain sex-segregated rest rooms, one might argue, has little to do with a sexual modesty and everything to

do with preserving male-only sexual space. Sex-segregated bathrooms, moreover, continue to be necessary to protect women from male predations but they also produce and extend a rather outdated notion of a public/private split between male and female society.[2]

The bathroom is a domestic space beyond the home which comes to represent domestic order, or a parody of it, out in the world. The women's bathroom accordingly becomes a sanctuary of enhanced femininity, a "little girl's room" to which one retreats to powder one's nose or fix one's hair. The men's bathroom signifies the extension of the public nature of masculinity – it is precisely not domestic even though the names given to the sexual function of the bathroom – such as cottage or tea room – suggest it is a parody of the domestic. The codes which dominate within the women's bathroom are primarily gender codes; in the men's room they are sexual codes. Public sex versus private gender, openly sexual versus discretely repressive, bathrooms beyond the home take on the proportions of a gender factory. What gender are the hundreds of female-born people who are consistently not read as female in the women's room? And since so many women clearly fail the women's room test, why have we not begun to count and name the genders which are clearly emerging at this time? One could answer this question in two ways: on the one hand, we do not name and notice new genders because as a society we are committed to maintaining a binary gender system. On the other hand, we could also say that the failure of "male" and "female" to exhaust the field of gender variation actually ensures the continued dominance of these terms. Precisely because virtually nobody fits the definitions of male and female, the categories gain power and currency from their impossibility.

It is remarkably easy in this society to not look like a woman. It is relatively difficult, by comparison, to not look like a man: the threats faced by men who do not gender-conform are somewhat different than for women. Unless they are consciously trying to look like women, men are less likely than women to fail to pass in the rest room. So one question posed by the bathroom problem asks, What makes femininity so approximate and masculinity so precise? Or to pose the question with a different spin, Why is femininity easily impersonated or performed while masculinity seems resilient to imitation? Of course, this formulation does not easily hold and, indeed, it quickly collapses into the exact opposite: Why is it, in the case of the masculine woman in the bathroom, for example, that one finds the limits of femininity so quickly while the limits of masculinity in the men's room seem fairly expansive?

We might tackle these questions by thinking about the effects, social and cultural, of reversing gender typing. In other words, what are the implications of male femininity and female masculinity? In "Reading the Male Body," Susan Bordo laments that "when masculinity gets symbolically 'undone' in this culture, the deconstruction nearly always

lands us in the territory of the degraded, while when femininity gets symbolically undone, the result is an immense elevation in status" (Bordo 1993: 721). This changes the terms of gender irreversibility slightly; here Bordo seems to suggest that even a hint of the feminine sullies male masculinity while all masculinizations of femaleness are elevating. I think my bathroom example proves that this is not so. Her examples of elevated masculine females include Susan Sarandon and Geena Davis in *Thelma and Louise* and Linda Hamilton in *Terminator* (1984) and Sigourney Weaver in *Aliens* (1986). It is not difficult to see that what renders these performances of female masculinity quite tame is their resolute heterosexuality. When and where female masculinity conjoins with possibly queer identities, it is far less likely to meet with approval.

BUTCHES

Gender non-conformity is suppressed in the bathroom and we could almost call the public rest room a technology of gender enforcement. Many theorists, including most notably Teresa De Lauretis and Donna Haraway (De Lauretis 1987; Haraway 1990), have observed that gender is a technology and one which works to obscure the mechanisms by which gender is rendered natural. In other words, the apparent "givenness" of gender is its technology and while femininity often manifests as technical effect or simply as artificial, masculinity draws its power from its seeming stability and organic qualities. But it is actually relatively simple to expose the mechanisms of dominant male masculinity; indeed, the most masculinist of film genres, the action–adventure film, does so all the time. For example, we could look to the most recent James Bond film, *GoldenEye* (1995), for a representation of the technology of masculinity.

In *GoldenEye*, Bond battles the usual array of bad guys: commies, Nazis, mercenaries and a super-aggressive violent femme type. He puts on his usual performance of debonair action-adventure hero and he has his usual supply of gadgetry to aid him – a retractable belt, a bomb disguised as a pen, a laser weapon watch, and so on. But there's something curiously lacking in this latest Bond flick, namely, credible masculine power. Bond's boss, M, is a noticeably butch older woman who calls Bond a dinosaur and chastises him for being a misogynist and a sexist. His secretary, Miss Moneypenny, accuses him of sexual harassment, his male buddy betrays him and calls him a dupe and, ultimately, women seem not to go for his charms – bad suits and lots of sexual innuendo – which seem as old and as ineffective as his gadgets.

Masculinity, in this rather action-less film, is primarily prosthetic and in this and countless other action films, has little if anything to do with biological maleness, signifying more often as a technical special effect.

In *GoldenEye* it is M who most convincingly performs masculinity and she does so partly by exposing the sham of Bond's own performance. It is M who convinces us that sexism and misogyny are not necessarily part and parcel of masculinity even though historically it has become difficult, if not impossible, to untangle masculinity from the oppression of women. The action-adventure hero should embody an extreme version of normative masculinity but instead we find that excessive masculinity turns into a parody or exposure of the norm. Since masculinity tends to manifest as natural gender itself, the action flick with its emphases on prosthetic extension actually undermines the heterosexuality of the hero even as it extends his masculinity. So, in *GoldenEye*, for example, Bond's masculinity is linked not only to a profoundly unnatural form of masculine embodiment but also to gay masculinities. In the scene in which Bond goes to pick up his newest set of gadgets, a campy and almost queeny science nerd gives Bond his brand new accessories and demonstrates each one with great enthusiasm. It is no accident that the science nerd is called Agent Q. We might read Agent Q as a perfect model of the interpenetration of queer and dominant regimes – Q is precisely an agent, a queer subject who exposes the workings of dominant heterosexual masculinity. The gay masculinity of Agent Q and the female masculinity of M provide a remarkable representation of the absolute dependence of dominant masculinities upon minority masculinities.

Minority masculinities and femininities destabilize binary gender systems in many different locations. As many feminist and anti-racist critics have commented, femininity and masculinity signify as normative within and through white, middle-class, heterosexual bodies. Richard Fung, for example, writing about gay male porn suggests that pornographic narrative structures assume a white male viewer who embodies a normative standard of male beauty and male desirability. Within this scopic field, porn characterizes black men as excessively sexual and as wholly phallic and Asian men as passive and asexual (Fung 1991). Films by artists of color which disrupt this representational code – like *Looking for Langston* (1988) by Isaac Julien and *Tongues Untied* (1989) by Marlon Riggs for example – can undo the hierarchized relations between dominant and minority sexualities but they also have the power to reorganize masculinity itself.

Other assaults upon dominant gender regimes come from queer butch performances which might include drag king shows, butch stand-up comedy routines or butch theatrical roles. For example, in terms of drag king performances, stars like Elvis Herselvis or Tony Las Vegas (performed by Julie Wheeler) turn dominant masculinity around by parodying male superstardom and working conventional modes of performed sexism and misogyny into successful comedy routines. As Tony Las Vegas, for example, Julie Wheeler manages to parody

masculinity by performing its most unnatural and obviously staged aspect: sexism. Exhorting the audiences in dyke clubs to "show us yer tits" and standing far too close to other women on stage with him, Tony reeks of the tricks of misogyny. Tony's manipulations of a stagy and theatrical masculinity draw attention to not simply the performative aspect of masculinity but also the places where non-performativity has ideological implications. In other words, by exposing smarmy male attentions to femaleness as staged, the drag king refuses any construction of misogyny as the natural order of things.

In one of the very few articles in print on the topic of drag kings, Sarah Murray asks provocatively: "Why hasn't drag developed into a distinct theatrical genre among lesbians in the United States?" (Murray 1994: 344). She answers her own question by drawing upon conventional notions of lesbian invisibility and by remarking upon the "naturalization of the masculine." She states correctly, "a woman has less to grab on to when doing individual drag" (ibid.: 356). Obviously, my argument about the apparent stability of male masculinity concurs with Murray's analysis. I also agree with Murray that the forms of masculinity that are available for parody tend to be either working-class masculinities (the construction worker, for example) or explicitly performative middle-class masculinities like the lounge lizard. However, where we diverge is on the topic of lesbian masculinities themselves. Murray finds butch iconicity to be less about redefining masculinity and more about appropriating male power. She reduces butchness to an historical marker of lesbian visibility which belongs to 1950s' lesbian communities but not to contemporary queer dyke culture and she suggests that lesbians, ultimately, "don't feel free to play with the masculine the way gay men play with the feminine" (ibid.: 360).

I would respond to these arguments by saying that first, it is crucial to recognize that masculinity does not belong to men, has not only been produced by men and does not properly express patriarchy. Second, butch identity has a complicated relation to notions of lesbian community and lesbian visibility and, particularly, to lesbian drag. Since so little has been written on lesbian masculinity that does not reduce it to a stereotype of the lesbian or a pathetic parody of maleness, we have yet to determine what its relations might be to either lesbian or transgender definition. Furthermore, butches may not be the most appropriate women to do male drag. Murray avoids any substantive discussion of transgenderism in her article because she can't account for what happens when the drag is no costume but represents part of an identity effect. When she does mention transgender figures like Billy Tipton, she incorrectly and imprecisely characterizes them as "female" and uses feminine pronouns to talk about their performed identities. Butches, and transgender butches in particular, to be perfectly clear, do not wear male clothing as drag; they embody masculinity. For this

reason, some of the best drag king performances may actually come from fem drag kings like Shelley Mars, performers who maintain a disjuncture between gender and performed gender.

In a slightly different kind of butch theater, a queer performance art piece called "You're Just Like My Father" by Peggy Shaw (1995) represents female masculinity as a pugnacious and gritty staging of the reorganization of family dynamics via the butch daughter. There is no question here that Shaw's masculinity is part and parcel of her lesbianism rather than a drag identity. Shaw becomes her mother's substitute husband, her lovers' substitute fathers and brothers and she constructs her own masculinity by reworking and improving the masculinities she observes all around her.

As Shaw's piece clearly illustrates, the home and the family within the hetero-binary sex/gender system signify as the location and the foundation of stable genders. The home and family function most often as myths of the naturalness of heterosexuality, but these myths, as Shaw shows, are remarkably vulnerable and fragile. The notion of the home is, simply, an ideological space which mimics order, comfort, privacy and personal space but which in fact balances upon the precipice of sexual chaos, produces restricted genders and functions as an extension of the public policing of gender.[3] Domesticity in general tends toward chaos and as we turn the corner on gender technologies moving into the twenty-first century, the home increasingly figures within popular representation and queer representation as a site for the collapse of heteronormativity and the development of techno-homos or queer genders.[4]

SEX WITH FURNITURE

One last queer example of a text in which gender, domestic space and alternate sexualities are put into disarray is an independent queer dyke film called *Flaming Ears* (1992). This film presents us with a vision of queer genders within a highly charged dangerous domesticity. *Flaming Ears* by Austrian co-directors Angela Hans Scheirl, Dietmar Schipek and Ursula Pürrer creates a new visual language for queer sex, romance and violence. Shot on Super 8 and blown up to 16mm, this film manages to create a wild and glittering visual landscape. Model towns, converted cars, futuristic fashions, odd domestic interiors and comic-book style backdrops combine to form an expressionist cartoon aesthetic which juxtaposes odd shadows and angles with saturated and vivid colors.

This extraordinary film is set in the year 2700 in the town of Asche where a peculiar band of lesbian characters – Volley, Nun and Spy – live out a strange subcultural existence. The plot is elaborate and extravagant but can be summarized as an anti-romantic horror movie. The *Women Make Movies* press packet describes it as follows:

The film follows the tangled lives of three women – Volley, Nun and Spy. Spy is a comic book artist whose printing presses are burned down by Volley, a sexed-up pyromaniac. Seeking revenge, Spy goes to the lesbian club where Volley performs every night. Before she can enter, Spy gets into a fight and is left wounded and lying in the street. She is found by Nun, an amoral alien in a red plastic suit with a predilection for reptiles, and who also happens to be Volley's lover. Nun takes her home and subsequently must hide her from Volley.

On the frame of this strange and rather intricate narrative trajectory hangs an exquisite visual adventure. Alternating between a kind of Alice in Wonderland effect of slanted over-sized rooms and a *Blade Runner* atmosphere of dilapidated urban sprawl, this film shows how easy it is to make the world look excessively different. Domestic scenes make everyday utensils like woks and ovens into space age tech-art and city scapes make the urban night into a place of danger and visual tension. The general effect of intense recastings of the "real" are heightened by the poetic screenplay. Characters say things like "We burn our hands fighting for the sun" and "the revolution of love is bloody."

Flaming Ears really attempts to capture a queer rewriting of domesticity and gender simultaneously. The domestic is thoroughly sexualized in *Flaming Ears* and whether we are watching a scene of a latex-clad

Figure 18.1 Flaming Ears filmmakers: Angela Hans Scheirl, Ursula Pürrer and Dietmar Schipek

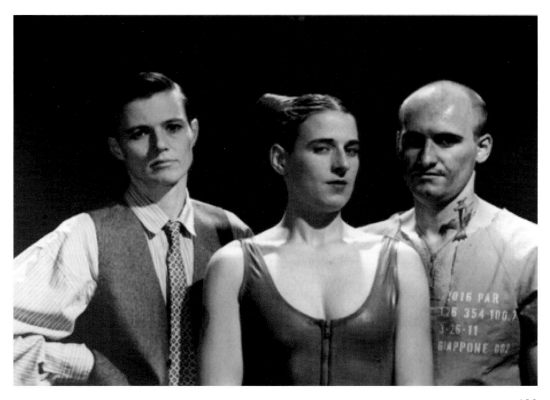

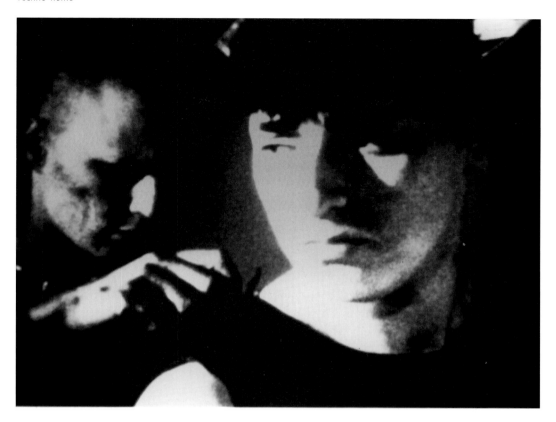

Figure 18.2 Nun and Volley in *Flaming Ears*

gender transitive character frying a mini-crocodile in a blood-splattered kitchen, or a sex worker arranging flowers in her living room wearing a wooden cock and balls around her waist, queer desires and genders saturate the domestic scene. Featuring bizarre and almost unfamiliar sex scenes, the film is spliced with ritualistic violence like vampirism and sex with furniture. In one extraordinary scene we watch a particularly hot and tender encounter between Volley and a cabinet at the beginning of the film: as she rubs her crotch on the cabinet, Volley whispers to it "Don't move dear little furniture." This encounter between woman and cabinet is perhaps the most romantic scene in the film; physical encounters elsewhere occur between Nun and a dead body or between anonymous groups of women. Only in the cabinet scene is anything like sentimental exchange approximated. Furthermore, the scene extends sex to seemingly inanimate objects, not by turning them into sex devices but by imbuing them with sexuality *per se*. The cabinet scene is romantic because Volley and the cabinet seem to exchange pleasure and desire and precisely because Volley does not treat the cabinet as simply furniture.[5] In *Flaming Ears* gender is literally a body technology, a relation between people and things, a group endeavor and a visual special effect. The casual rendering of diverse

embodiments in this film demonstrates the elegant simplicity of gender construction within a visual technology.

The technology of gender exercised within the public space of the bathroom and the private space of the home cannot withstand the onslaught of queer genders: which is not to say that *Flaming Ears* is simply a utopian vision of gender breakdown; rather, *Flaming Ears* allows us to imagine the disintegration of dominant genders as they occur incrementally across flesh and textiles, through houses and rooms, within families and homes. As we move toward a postmodern *fin de siècle*, the foundations of what we have called gender lie in ruins about us. But the ruin of the sex/gender system also promises renewal and reconstruction and new and different sexualities and genders, transgenders.

QUEER FUTURES

In this chapter, I have tried to chart the implications of gender policing and gender performances within public spaces and map them onto a utopic vision of radically different bodies and sexualities. By making such a move, I do not wish to suggest that we can magically wish into being a new set of properly descriptive genders which would bear down upon the outmoded categories of male and female. Nor do I mean to suggest that simply by creating the desegregation of public toilets we will change the function of dominant genders within heteropatriarchal cultures. However, it seems to me that there are some very obvious spaces in which gender difference simply does not work right now and the breakdown of gender as a signifying system in these arenas can be exploited to hasten the proliferation of alternate gender regimes in other locations. From drag kings to spies with gadgets, from futuristic queers to those who desire sex with furniture, gender and sexuality and their technologies are already excessively strange. It is simply a matter of keeping them that way.

NOTES

1 The continued viability of the category "woman" has been challenged in a variety of academic locations already; Monique Wittig, most notably, argued that "lesbians are not women" in her essay "The Straight Mind" (Wittig 1992: 121). Wittig claims that since lesbians are refusing primary relations with men, they cannot occupy the position "woman." In another philosophical challenge to the category "woman" made by a transgender philosopher Jacob Hale, Hale uses Monique Wittig's radical claim to theorize the possibility of gendered embodiments that exceed male and female (Hale 1996). Cheshire Calhoun suggests that the category "woman" may actually "operate as a lesbian closet" (Calhoun 1995: 9).

2 Some people are currently writing about the social construction of gender within the operation of sex-segregated bathrooms. Barbara Cruikshank, for example, is presently working on a project called "Flushing Gender: Public Toilets and Public Life" which tries to expand upon gender-based exclusion within public toilets to think about other exclusionary public spaces.

3 In other contexts, mostly notably postcolonial, home may function as a myth of a lost origin or as a symbolic space within which to measure or account for the effects of colonialism (George 1994).

4 Think of films like *The Hand that Rocks the Cradle* and numerous horror films which turn the home into a mausoleum; think also of films like *Disclosure* which can barely sustain the fiction of home comforts.

5 The sex with furniture scene fulfills Elizabeth Grosz's definition of carnality in "Animal Sex." She writes: "There must be some coming together of disparate surfaces; the point of conjunction of two or more surfaces produces an intensification of both" (Grosz 1996: 288).

REFERENCES

Bordo, S. 1993. "Reading the Male Body." *Michigan Quarterly Review* (32)4, Fall: 696–737.

Calhoun, C. 1995. "The Gender Closet: Lesbian Disappearance under the Sign 'Women.'" *Feminist Studies* 21(1), Spring: 7–34.

De Lauretis, T. 1987. *Technologies of Gender: Essays on Theory, Film and Fiction.* Bloomington: Indiana University Press.

Fung, R. 1991. "Looking for My Penis: The Eroticized Asian in Gay Video Porn," in Bad Object Choices (ed.) *How Do I Look? Queer Film and Video.* Seattle, WA: Bay Press, pp.145–68.

George, R. M. 1994. "Homes in the Empire, Empires in the Home: The Impact of Imperialism on English Women." *Cultural Critique* 26, Winter: 95–127.

Grosz, E. 1996. "Animal Sex: Libido as Desire and Death," in E. Grosz and E. Probyn (eds) *Sexy Bodies: The Strange Carnalities of Feminism.* New York and London: Routledge, pp.278–99.

Hale, J. 1996. "Are Lesbians Women?" *Hypatia* 11, Spring: 2.

Haraway, D. 1990. "A Manifesto for Cyborgs: Science, Technology and Socialist Feminism in the 1980's," in L. J. Nicholson (ed.) *Feminism and Postmodernism.* New York and London: Routledge.

Murray, S. 1994. "Dragon Ladies, Draggin' Men: Some Reflections on Gender, Drag and Homosexual Communities." *Public Culture* (6)2, Winter: 343–63.

Wittig, M. 1992. *The Straight Mind and Other Essays.* Boston: Beacon Press.

19

Home surgery instructions

Barbie Liberation Organization

———————————————————

Barbie / G.I.☆JOE HOME SURGERY INSTRUCTIONS

OFFICIAL Barbie Liberation Organization

1. To open Barbie, insert a screwdriver firmly into the joint at the base of the spine. With a quick jerk, snap the screwdriver down towards the buttocks. Pry the backplate off, working up from the waist. Once the back is loosened, grab it with your fingers and snap it straight off with a firm yank. Do not twist. Remove head, arms, and legs. Gently loosen circuit board. Break off tab holding speaker in place. Remove speaker/circuit board.

2. Using saw, sever battery contacts from rest of circuit board as shown. Battery contacts go back into doll.

Cut at dotted line

3. To open G.I. Joe, remove batteries and pop off head. Using saw, make incision across abdomen from seam to seam. **Be careful not to cut wires underneath.**

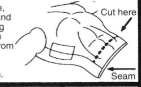

Cut here

Seam

4. Start prying front/back plates apart at neck and work down towards shoulders. **Careful – neck is fragile**. Once shoulders are split, insert screwdrivers into joints where arms meet torso. Pry torso apart from both arms simultaneously.

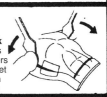

5. Cut bracket holding Joe's circuit board in place and loosen board, speaker, and switch.

6. Locate power wires (red & black) running from Joe to contacts on circuit board. Heat contacts with soldering iron. Remove wires from board but leave them attached to Joe. Solder two similar replacement wires onto circuit board.

Power wires

7. Locate the switch on Barbie's circuit board. Heat the four solder points and remove. A solder-removing bulb may help.

Switch

8. When removing Joe's switch, make a note of where the switch wires meet the circuit board. Heat contacts and remove switch.

9. Wire Joe's power and switch to Barbie's circuit board as shown. Install board, speaker, and switch back into Joe. Hot glue works well to anchor everything in place. Speaker should be firmly glued to breastplate for maximum volume.

top view

Solder wires from Joe's switch to these points.

Solder red power wire here

Solder black power wire here

bottom view

10. **IMPORTANT**: When running the Barbie circuit board in Joe, use only three batteries. You may want to re-wire the battery contacts, or substitute something to take up the extra space. A filed-down conductive nail wrapped in tape works well as a pseudo-battery.

11. There are two options for re-installing Barbie's switch. The first (and more difficult) is to use a small, stiff, non-conductive scrap of circuit board, plastic or similar material. Mount the switch on the board, and sandwich it between the board and the button on Barbie's back. Glue the board to the posts on Barbie's back. If done carefully, Barbie need never know she's been under the knife.

12. The second option is to use a small momentary contact switch (Radio Shack Cat. No. 275-1571B). Mount it in place of the button in Barbie's back. It's easier and more permanent, although Barbie no longer looks like everyone else.

13. Unfortunately, Joe's circuit board will not fit properly into Barbie without modification. First, de-solder and remove this capacitor.

14. Next, cut down board by removing shaded areas shown below. *(bottom view)*

Remove

15. Cut two 2" pieces of wire. Solder them from the contacts on Barbie's switch to these points.

16. Re-solder capacitor as shown. (Note: capacitor shares a contact with switch)

Black stripe on this side Solder here

17. Cut any additional unused space off the board. Solder the two wires from step 6 to Barbie's battery contacts.

18. Fitting the board into Barbie is tricky. You may need to bend the capacitors or shave the posts in her chestplate. Before re-sealing Barbie or Joe, first make sure body parts fit together properly. Apply epoxy around rim of front and back plate. Quick-drying epoxy is not recommended, as it leaves little room for error. First insert both neck sections into the head, insert the arms and legs, then clamp the doll together. To touch up any scars or mistakes, use plumber's epoxy putty and model paint.

Figure 19.1 Home surgery instructions

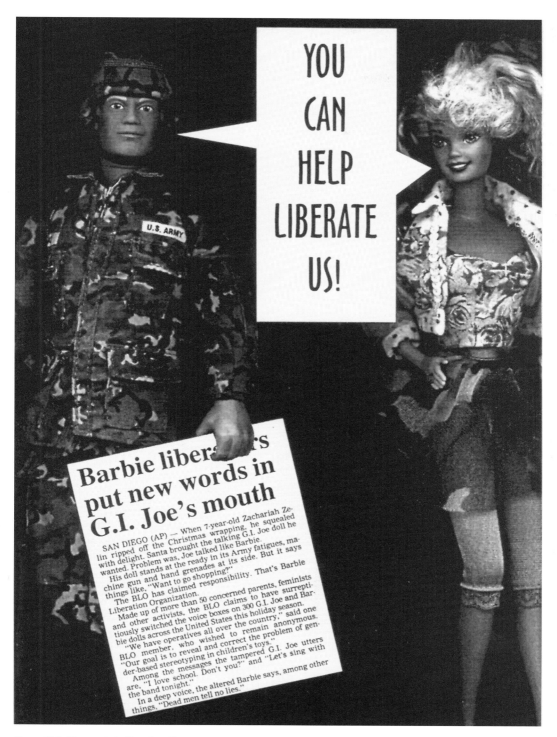

Figure 19.2 "You can help liberate us!"

20

Is it tomorrow or just the end of time?

Connie Samaras

Figure 20.1 Identifiable Flying Object, LAPD helicopter in pursuit, Hollywood/Silverlake border

Figure 20.2 Alien head – first mass produced and distributed in the US 1987

ABDUCTION EXPERIENCE: IMPRESSIONS OF ABDUCTION NARRATIVES READ BY THE CORRECTOR, RECORDED 17–19 MAY 1994, L.A., CA, USA

(1)

> "On the world stage the white man is just a microscopic minority."
> (Malcolm X, 1964)

(2)

Since 1990, the corrector has read numerous accounts of abduction experiences. She has also watched all recent US films on the subject and has attended various conferences and forums devoted to ufology as well as abductions. What follows are a few initial observations.

(3)

In 1992 the Intruders Foundation funded a Roper Poll to determine what percentage of the US population has been abducted by aliens. In looking over the test questions, the corrector noted that she had a yes response to the majority of the questions targeted to identify abductees. Sample questions included:

- Have you ever seen a ghost?
- Have you ever had an out of body experience?
- Have you ever experienced missing time?
- Have you ever woken up paralyzed sensing a stranger in the room?
- Have you ever seen balls of light illuminating your bedroom at night?
- Have you ever seen a UFO?
- Have you ever had unexplained scars or wounds?
- Have you ever felt like you can fly?

(4)

The highest percentage of people responding yes to such questions turned out to be, according to Budd Hopkins (abductee therapist and visual artist), "trend setters, intellectual leaders, and liberals" because "these people tell the truth."

(5)

The majority of reported abductions take place in industrialized countries located in the Northern Hemisphere of the planet. The overwhelming majority of these abductees are taken from the United States.

(6)

The vast majority of abductees tend to be white (a category of ethnicity/race that is, at present, inadequately defined) and middle class (a class strata in the US which is diminishing in size). However, the accuracy of this figure, as well as any other mentioned here, is dependent on an analysis of the methods used by recorders to gather abductee stories.

(7)

Although most abductees are assumed to be predominantly white, the first legitimate case of an alien abduction was that of an interracial couple, Barney and Betty Hill – an African American male and a white American female. They were abducted late at night on 19 September 1961 from their car on a country road near Lincoln, New Hampshire.

(8)

At first it was assumed the Hills had suffered a joint delusion (a *folie à deux*). But because they were an upstanding couple in their community (Barney Hill was president of the New Hampshire National Association for the Advancement of Colored People, the NAACP) and because their narratives were too closely matched in bizarre detail, the country's leading ufologists decided that this was not a shared delusion.

(9)

Betty Hill is the first woman abductee on record to have reported an examination by aliens involving female anatomy and human reproduction. She stated that alien examiners inserted a long needle into her abdomen with the explanation that they were performing a "pregnancy test."

(10)

The majority of abductees are women. Except for a 1970s' film about the Hills starring James Earl Jones, to date, the majority of Hollywood motion pictures dealing with abduction experiences are about men. Only a recent made-for-TV movie about abductees (made in consultation with the Intruders Foundation) is primarily about women.

(11)

In the last few years there have been numerous reports from female abductees about forced pregnancies. Initially the aliens will often harvest a given human female's eggs and, on a subsequent abduction, will re-implant a fertilized egg back into her uterus. After about 1–2 months, the woman is abducted again and the fetus is harvested and raised *in vitro* on the spacecraft. Sometimes the aliens will also harvest a human fetus from a female abductee, genetically alter it, and raise it *in vitro* on the ship.

(12)

Sometimes these women report being introduced to their offspring. The corrector has only ever read descriptions of these alien/human hybrids as being grey and ugly with patches of blond hair.

(13)

Two types of aliens are typically described by abductees. Those that fetch the abductees from earth are described as under five feet tall and grey with big heads and sometimes, as Betty Hill first reported, with big noses. Once in the examination area, the abductee meets what seems to be the head alien, or head examiner. This alien is taller with almond-shaped eyes, a little mouth and almost no nose.

(14)

The description of the "head" alien is the image most typically reproduced in the United States. The corrector has noted that this image is similar to that of a human light-skinned aborted fetus and/or the head of her cat Leo when she pulls back his ears.

(15)

The examiner alien is said to communicate with the abductees telepathically. Unlike the greys, the examiner seems a bit more compassionate in its attempt to help the abductee overcome her or his terror. Both types of aliens, however, are far less emotional than human beings. Many abductees report that the aliens are both intrigued and repelled by our inability to background our emotionality.

(16)

The majority of material on abductions examined by the corrector often leaves the impression that the greatest horror is the alien probing of human orifices and the sometimes subsequent implantation into the body of various alien devices often resembling double-coiled IUDs in their description.

(17)

The corrector has noticed that the probing of male orifices is given particular attention over the probing of female orifices in abduction literature. The violation of the male body is discussed in language developed on earth in the late twentieth century used first to discuss the sexual abuse of women. In *Communion*, the 1987 autobiographical account of abductee, heterosexual family man, and horror story writer Whitley Strieber, careful attention is paid both in the book and film to the anal probe performed on Strieber by the aliens and his feelings of violation.

(18)

At the 1992 UFO ExpoWest in Los Angeles, held next to LAX, Budd Hopkins, in discussing his 1993 made-for-TV-movie *Intruders* (made in collaboration with a TV network and the Intruder Foundation) mentioned Strieber's *Communion*. Hopkins proclaimed, "Strieber's an abductee but confused" and followed up with this joke: "If you run into an alien who gives you a high five don't bend over."

(19)

In 1993 Hollywood made a film, *Fire in the Sky*, about the abduction of a regular guy. Macho, virile, white and working class, the lead character's unwavering masculinity was presented as proof that the abduction phenomenon is real. During the alien probe scene, all orifices were penetrated except for the anus. This scene was one of the most horrific and brutal ever witnessed by the corrector on film. In fact, the corrector's movie companion, a horror movie buff and niece of a B-horror film actress, was so repelled that she left the theater during this scene.

(20)

In addition to directing the probing and reproductive manipulation, the examiner alien is also the one who sometimes seduces the abductees. Both male and female humans have reported a sexual attraction that they cannot resist. There are descriptions of men ejaculating in response to the alien (often interpreted as means of harvesting sperm). The corrector, however, has yet to read any serious account of a given human female's arousal.

(21)

In all accounts read by the corrector of sexual attraction to the alien examiner, the men are described as perceiving the examiner as female. Similarly, when discussing female abductees' desire, these women are said to perceive the examiner as male. The corrector therefore concludes that no lesbian, gay male, transsexual or bisexual has been abducted to date and are, thus, representative of segments of the human population safe from alien abductions. However, the corrector also recognizes that this, again, may reflect an error in the methodology being used to gather and record abductee narratives.

(22)

Abductees who have not yet accessed their memories suffer an incredible level of anxiety and are said to suffer from post-traumatic syndrome. They have terrible nightmares, nagging fears, panic disorders, the feeling that something is not right, and a deep sense of shame.

(23)

In his 1994 book *Abduction*, Harvard psychiatrist John Mack states that he believes abduction memories are not masks for early sexual abuse, incest and/or other traumatic abuse. He insists these narratives are authentically about alien abduction. He has found, however, that "sexual abuse appears to be one of the forms of human woundedness that, at least from the experiencer's standpoint, has led the aliens to intervene in a protective or healing manner."

(24)

Dr Mack has also discovered that his clients, although terrified by their initial abduction experiences (recent research claims that abductees are taken repeatedly throughout their lifetime – additionally, abduction experiences are often found to run in the family) eventually make their peace with their trauma through the realization that they have been chosen by aliens to communicate to humans that the earth is in grave danger of a complete eco and/or political collapse.

(25)

This collapse is imminent and, once it happens, aliens will intervene with the help of enlightened abductees in assisting with a global re-organization.

(26)

The corrector is frequently asked whether or not she believes in aliens. This she cannot yet answer conclusively. She does feel, however, that grass roots organizing and radical politics have become increasingly difficult endeavors for a number of reasons. She sometimes wonders if the inability to imagine social change as something other than the result of a total apocalypse is a constant source of deep anxiety.

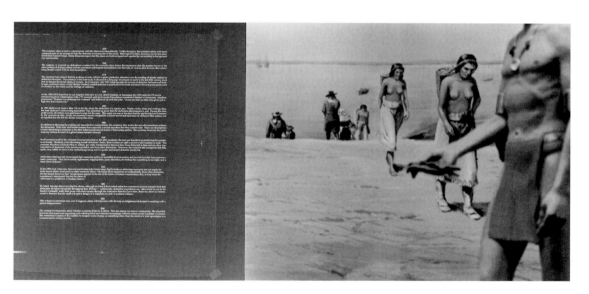

Figure 20.3 New category-abduction experience: impressions of abduction experiences read by the corrector, recorded 17–19 May 1994, L.A., CA.
Source: The Natural History Museum, NYC.

MISSING TIME[1]

The text above and the images surrounding it are from a recent body of work I'm doing correcting the representations of earth culture sent out to extraterrestrials by the US in 1977 on the Voyager interstellar space probes. These two spacecraft, containing copper-etched images, writings and audio recordings as a salutary overview to "possible extraterrestrial civilizations," have currently reached our solar system's end and continue to purposefully travel on. Predictably erased are any vestiges of that era's social change movements e.g. civil rights, women's liberation, anti-war, lesbian/gay liberation, nuclear disarmament. The result is a privileging of elite white male American/ Eurocentric culture where women's bodies are depicted as reproductive vessels, non-Western communities are timelessly portrayed as outside of technology and where whiteness and heterosexuality are naturalized because, once again, they are not commented upon. However, the Voyager selection team, headed by astronomer Carl Sagan, saw themselves as having made every attempt to be as rational and inclusive as possible. In contrast, my archive acknowledges its limitations, partiality and irrationality as a means, in part, of addressing the sorts of cultural anxieties produced by the fear and inevitability of psychological and social change.

This is a wide-ranging work. As corrector, I found I had to add several new categories as well as amplify in more complicated and confusing ways, those designed by Sagan and his team. The passage above draws from Harvard psychiatrist John Mack's 1994 publication *Abduction: Human Encounters with Aliens*.[2] As a means of both addressing and asking the question – Why is it that white middle-class US women are being abducted from their homes, in the middle of the night by a technology so advanced that it's beyond our perceptions but, whenever described, is metaphorically steeped in the technologically mundane like kitchen appliances and car parts? – I'd like to discuss both Mack's work and that of his colleague David Jacobs, a history professor at Temple University who published, in 1992, *Secret Life: Firsthand Encounters of UFO Abductions*.[3]

In a truly surreal *fin-de-siècle* illustration of Foucaultian theory, these two experts have come forth with sympathetic medical and academic definitions of these abduction tales i.e. what the abductees say is what it is. I remember when I first heard about Jacobs and Mack. I was at a UFO convention near the LA airport. It was packed with several hundred people. As you entered the lobby, a convention sign guiding you upstairs perkily sat next to a baby grand piano belting out, completely on its own, "I'm Just Mad About You." Inside, Budd Hopkins, hypnotist and legitimizer of abduction narratives, but who doesn't really count because he was trained as an artist, was rhapsodizing

about how these books, coupled with the 1993 production of the TV movie *Intruders*, were about to revolutionize the perception of abduction lore and ufology from the domain of crackpots and ex-CIA agents to institutional and professional credibility. I, too, awaited these books with bated breath (but not for the same reasons). Predictably, as with Sagan, cultural critique, historical circumstance, political realities and semiotics are out the door here (or, in abductee-speak, out the window).

These narratives and descriptions of events may seem quite humorous. But, having been to so many conventions and forums on the subject as well as having consumed so many of these narratives, I'm hesitant to have a good laugh over them since the overriding sense one comes away with is that there is a great deal of pain being expressed here. It's true, as some therapist friends of mine have remarked, that these UFO groups serve as a kind of containment field for schizophrenia and other mental disorders. But the main drive of people like Mack, Jacobs and Hopkins is to assure us that these are not the delusions of psychotic people, primarily women, but, rather, the true experiences of normal, everyday people suffering great anguish, silence, and stress about having absolutely no control over repeated violations of their psyches and bodies. They must be believed in order that they can bear witness.

I agree with these new experts that the mass administration of pyschotropic drugs is not the solution. However, I depart from their attempts to aculturalize, ahistoricize and apoliticize these narratives as the road to recovery since I don't believe that what we are bearing witness to is a bipedal alien race, so technologically advanced they leave no material residue whatsoever but so scientifically retarded that their primary preoccupation is with endless ethnographic probes of the "mysteries" of human reproduction and procreative sex. Instead, we are seeing vast and complex metaphors of, and real psychic anguish and confusion over, massive social change and upheaval. As evidenced by science fiction, perceptions of outer space and alien life embody both a reactionary nostalgia for the seamless hegemony of traditional power relations as well as the heterogeneous imaginings of different social spaces crafted by the articulations and longings of oppositional cultures and historically marginalized peoples.

Embedded in these narratives are complex and overlapping amalgamations of desire for both reactionary and progressive social order. Obviously, from my corrector's piece alone one can detect racism, homophobia, heterosexual angst for the kinds of kinship structures and means of sexual contact created, invented, and imagined by queer culture, a fear over the loss of white dominance, a desire by white people to be dominated and taken, an essentialist conviction that gender is based on biology, a dysphoria with the rigidity of a two-sexed gender

system, an anxiety over the double-bind of how one who feels marginalized can speak of their rights without speaking of biology, a crisis of national identity and the fear of a corporate global reorganization, a fear of miscegenation, an anxiety about rapid, unregulated developments in new technologies such as computers and genetic engineering, sexual shame and repression, a terror over the escalating erosion of rights to privacy by a state which subordinates human welfare to corporate welfare, a hatred of feminism and women, and an anxiety over the assault on reproductive rights for women.

But why is it that the feminist language of sexual abuse has been appropriated by these new experts to legitimize these accounts of victimization? Also, why is it that the female body, specifically the white body, is the tableau on which these anxieties are written?

In answering these questions, I'd like to begin with three observations. First, Jacobs states that "no investigator has ever been abducted as a result of his [sic] research." In other words, not unlike my joke that we queers are safe from abductions because these aliens seem only to be interested in procreative sex, these researchers are made safe by their power to define. Second, in all the reading I've done, there has not been any way to stop these repeated abductions until I read Jacobs. It seems that if you train a running video camera on an abductee while she is sleeping, nothing happens. But alas, the tape runs out and the human gets napped or else, mysteriously, the subject will get up and go to sleep on the couch out of the camera's eye and, poof, they're gone. My third point follows this last. For all the sorts of sci-fi, high-tech imaginings this subject would seemingly lend itself to, there is no real technology here just like there's no photographic evidence no matter how many TV shows they air on the subject. Technology, in fact, is stripped away and what we are left with are the naked machinations of human power relations and struggles. It is no coincidence that, when the middle-aged men who dominate UFO conferences are not busy at the podium with abduction horror tales, they are hard at work on government conspiracy theories.

What interests me here is the fear being expressed by these new experts. The fears of the abductees are quite evident. For example, descriptions of these women being taken through windows (while the aliens, like the electronic impulses of TVs, computers, and surveillance systems magically enter and exit through the walls) speak volumes about the disintegration of rights to privacy and the undeniable collapse of public and private. Gone are the days of simplistic separations of public and private spheres. But why is it that the definers appropriate feminist language on sexual abuse? It is because they see themselves as victims but without a hope in sight of change, because, on their planet, to politicize, to put aside biological determinism throws a spaceship-sized wrench into the workings of an imagined manifest

destiny which, in reality, is no longer vertically shaped and erect with an American flag planted on top?

But Mack and Jacobs are not the cartoon constructions of militaristic, spook masculinity one normally encounters among male ufologists. They literally weep for their subjects because they are literally weeping at their own paralysis, a product of the predicament of disorientation which inevitably emerges when one no longer occupies the center position. On the one hand, there's the terror of losing political power by investing it in the "other," a necessary condition for the survival of humanity. On the other, being liberal, they weep for the fact that, despite their investment in the familiar order of things, it is arranging itself daily into the hands of fewer and fewer with a rapidly shrinking winner's circle.[4] Just as I like to imagine more than two sexes, here I imagine more than two hands: one which gestures in lament to disappearing public access to political dialogue and exchange; one always busily at work trying to dismantle gains made by people of color, women, sexual minorities, and labor; one which beckons in the distance to a fascist breeding ground.

The female body is a perfect projection screen for these reaction formations, the perfect fetishistic foil. First of all, something's terribly wrong, it doesn't really make sense, but we must believe it. However, it's really crazy sounding and, after all, who could really believe a woman? But then again, these are *white* women, not women of color because, if they were, who would possibly believe them? But, ultimately, who even believes white women, especially middle- and upper-class women? It brings to mind a quote from Alice Echol's insightful essay, "White Feminists and the Jackie O. Problem."[5] In the early days of women's liberation, white male leftists' contempt for feminism and denial of the politics of gender were "encapsulated in that taunt-posed-disingenuously-as-a-question, 'You mean, you think Jackie O. is oppressed?'"

But it's not just the abductees that are gendered female. So too are the aliens despite Jacobs' feeble attempts to determine their gender in light of the irritating handicap that they have no identifiable genitalia. The aliens are short, thin, light, hairless with no discernible muscle structure and opaque, unreadable eyes which seem to transfix – sounds like the Twiggy look. Comfortingly, though, they seem to have no teeth. They are super technological but descriptions of examination equipment read like an inventory of Julia Child's kitchen. Additionally, they are highly racialized, mostly constructed in the form of Asian stereotypes. They are short, inscrutable, unfeeling, industrious, task-oriented, organized by mass consciousness not individualism, able to invade us with their technology against our inability to invade them. Their leaders are colored yellow/tan with slanted eyes. Add to this, as many theorists such as Rey Chow[6] have pointed out, that a hallmark of Orientalizing is the Western feminizing of all Asian bodies because, in

the hierarchy of gender, woman is lesser, and we are back to the human-snatching alien as a female construction.

Some of Mack's colleagues have surmised that he has gone over the deep end because of a broken heart. As someone who has been over that cliff myself, I can empathize. I am not a believer in a hierarchy of pain and abuse, it's all relevant, it's all important. For example, is physical abuse any less traumatic than sexual abuse? Is law professor and anti-porn feminist Catharine MacKinnon correct in assuming that "genocidal rape" in Bosnia is a greater trauma than date rape in the US? But even though there is a sensitivity to the experts Mack and Jacobs (thank you feminism), it is cut short (thank you gender, race, and class asymmetry) by the protectionist rhetoric of a colonizer who can't get to his colony because it's in another dimension. A colonizer terrified of yet mesmerized by the realization that more than one dimension has always existed, that time and space are forever in flux, that social order is forever multidimensional.

I'd like to close with a remark by one of the aliens. Jacobs points out that abductees rarely overcome their trance-like states to ask any questions they may have. In this particular instance, a woman was able to ask an alien "Do you sleep?" The answer: "We are always sleeping."

NOTES

1 All illustrations are from the series "Partial Correction to the Representations of Earth Culture Sent Out to Extraterrestrials on the 1977 U.S. Voyager Interstellar Space Probes," Connie Samaras, 1994–6.

2 John Mack, MD, *Abduction: Human Encounters with Aliens* (New York: Scribners, 1994).

3 David Jacobs, PhD, *Secret Life: Firsthand Accounts of UFO Abductions* (New York: Simon & Schuster, 1992).

4 It is interesting to note here an article which appeared in the *New York Times* shortly after I gave this talk at the Wexner Center: "Professor Writing of Aliens Is Under Inquiry at Harvard," William H. Honan, 4 May 1995. Honan states that a peer review committee was formed by the Dean of the Harvard Medical School, Daniel Tosteson, to investigate whether Mack's work was in accordance "with Harvard's standards of scholarly investigation." Headed by an emeritus professor of the medical school and a former editor of *The New England Journal of Medicine*, Dr Arnold Reiman, the committee included two lawyers from the Harvard counsel's office. Honan states: "A faculty member who has seen the committee's draft report said it vigorously defended Dr Mack's right to pursue any subject he finds of interest but deplored his scholarship methods. Dean Tosteson has several options once he receives the report. They range from intiating procedures to cancel Dr Mack's tenure and remove him from the faculty to congratulating him for his bravery in following his inclinations in a line of exploration sure to invite ridicule." The article goes on to say that "Dr Mack has retained a Boston lawyer, Roderick MacLeish Jr, who says the review is far from benign. 'It's an issue of academic freedom . . . History has not been kind to individuals and entities that tried to

suppress controversial or unorthodox viewpoints, and this is that kind of case.'" Honan also notes that Mack's non-profit research organization, the Center for Psychology and Social Change, has received $250,000 a year for the past three years "about two-thirds of its annual budget from Laurance S. Rockefeller." (Thanks to Douglas Crimp, Paula Allen, and Carole Vance who each individually brought this article to my attention – New Yorkers who know my California-based loyalty to the *LA Times*.)

5 Alice Echols, "White Feminism and the Jackie O. Problem," forthcoming in Alice Echols, *Shaky Ground: Sexual Politics and Cultural Transformation in Postwar America* (Columbia University Press).

6 Rey Chow, *Woman and Chinese Modernity: The Politics of Reading Between West and East* (Minneapolis, MINN: University of Minnesota Press, 1991).

21

Vulnerabilities

Andrea Slane

Based on the video *Irresistible Impulse*

Vulnerabilities based on the video
Irresistible Impulse by Andrea Slane

A STRONG lock is a good INVESTMENT. Those requiring KEYS on BOTH SIDES are the most SECURE.

Kim has a penchant for strangers, the hapless individual who knocks at her door. She likes the randomness of these approaches, the surprise of their good fortune. She is attracted to the crises she engenders.

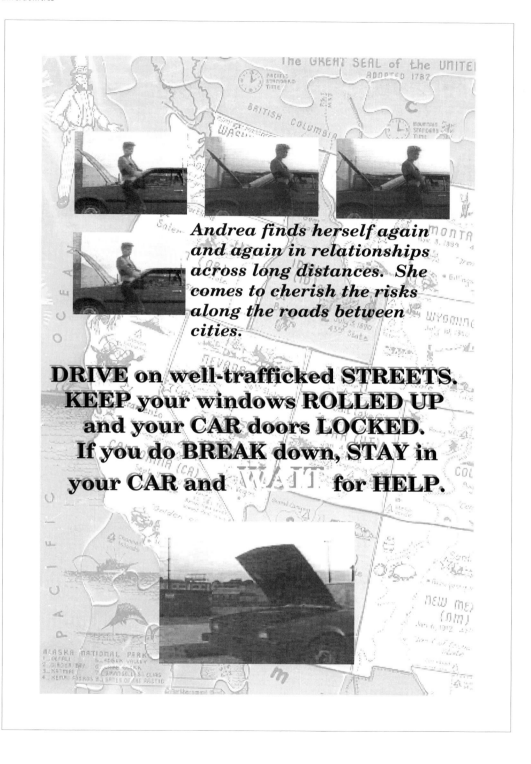

Andrea finds herself again and again in relationships across long distances. She comes to cherish the risks along the roads between cities.

DRIVE on well-trafficked STREETS. KEEP your windows ROLLED UP and your CAR doors LOCKED. If you do BREAK down, STAY in your CAR and WAIT for HELP.

give out information about YOURSELF to a STRANGER over the TELEPHONE.

MCI

ANDREA E S
Acct 804

Long Distance continued
Calls from 804-640-8658

Amount	Place		Date	Time	Rate	Min
$ 11.39	FF	SAN DIE CA	Sep 11	12:10A	*N	117
.39		SWARTHMO PA	11	12:46P	*D	2
.19		BROOKLYN NY	11	12:46P	*D	1
.60		ROCHESTE NY	11	12:49P	*D	3
.26	FF	COLUMBU OH	12	7:52A	*N	3
1.65		BRONX NY	14	10:34P	*E	13
.74	FF	COLUMBU OH	14	10:59P	*M	8
5.99	FF	COLUMBU OH	14	11:07P	*N	66
1.25		LINDAVIS CA	15	12:23P	*D	6
.21	FF	COLUMBU OH	15	5:26P	*E	2
.08	FF	COLUMBU OH	16	11:49P	*N	1
2.26	FF	COLUMBU OH	17	11:54A	*N	25
6.13	FF	SAN DIE CA	17	1:56P	*N	63
.44		CHARLOTS VA	18	11:53A	*D	2

Page 10

Natascha thrills to her own resourcefulness. She guards her whereabouts and company from lovers, and earns a reputation for evasion. She protects herself with dreams of heroism, the rescue of a distressed girl who gives herself completely.

ALMOST anything you HAVE in your PURSE can be used as a WEAPON -- a TEASING brush or a RAT TAIL comb for example. Hold firmly and MOVE forward with an UPWARD jabbing THRUST.

Their insecurities are permanent.

2 2

The party line: gender and technology in the home

B. Ruby Rich

At the time of initially delivering this talk, I had just come from burying my father; at the time of finishing this text, I've just lit the yahrzeit candle for the first anniversary of his death. My father has been on my mind throughout my process of conceptualizing and finalizing my thoughts and has certainly been present whenever I've sat down, laptop and modem at hand, to work on it. My father and my memory of him are central to the theme of the original conference panel at the Wexner Center: technology, gender, the home. My only memory of overt physical conflict with my father (for violence was not a staple of interaction in our fairly repressed Bostonian family life) involved a disagreement about the telephone. Well, a fight actually. The memory is extraordinarily vivid, though not precise in its details. I remember my father's act of brutally ripping the telephone out of the wall – or perhaps he just ripped the line out of a jack? I'm not really sure, but either way, it left a lasting impression.

Today I have a different impression of the incident, which retrospectively strikes me as emblematic. The problem? I'd been talking on the phone too long. I wouldn't hang up i.e. cede the phone to my father. The telephone was clearly contested territory: my father, as family patriarch, rightly felt that he held undisputed ownership; but I, as a teenager in the early years of the concept, felt that I had unquestioned priority as the household's designated social consumer. My father was an organization man: a lifelong Masonic member and officer, an active synagogue member, and assiduous family man, he depended on the telephone to maintain his network of social ties. I was a girl coping with a difficult change in communities; at age 15, I'd had to change high schools and was wrestling with an upscaled setting, school cliques and snobberies, the discovery of class, and the inevitable growing pains of adolescence. I desperately needed the telephone as part of my meager arsenal. My father and I were on an obvious collision course as our respective claims to telephonic primacy clashed repeatedly. The solution of a second line was unthinkable, not least for economic reasons; anyway, our family values of thrift and sharing, however imperfectly practiced, ruled out such a solution.

Despite having only one line, we did have a lot of phones in our house. My father was a mechanical engineer who prided himself on small feats of magic-making such as customized stereo speakers hidden in various rooms and multiple telephones, or extensions as they were termed. In those days, it was considered quite a feat to "trick" the telephone company by installing illicit extension phones; back then, phones were supposed to be duly registered, with monthly bills calibrated according to the number of instruments. In order to keep people honest, there was an operative myth (or paranoia or fact) that the phone company had a device for measuring rings that could detect these extra telephones by the multiple decibels they generated. My

father would doctor the extra phones accordingly: silent extensions, their ringers removed, told no tales. There was a complicated pride attached to this arrangement, as the family could congratulate itself simultaneously on its enhanced status of technological richesse and the purloined bargain that made it possible.

In the postwar period of 1948–63 – from the time of my birth straight through to the Beatles and the JFK assassination – my childhood and adolescence were conducted in an atmosphere of fairly modest techno-logical innovation, compared, that is, both to the eras that precede/follow and to the massive innovations and dislocations in the spheres of culture and politics of the time. Cars were already around, but transistor radios were new. Music was already around, but rock&troll was new. The telephone had been around for more than half a century, but its uses in the 1950s and 1960s merely consolidated the shifts already begun in earlier decades.

As elucidated by Michèle Martin in her essay "'Rulers of the Wires?': Women's Contribution to the Structure of Means of Communication," the telephone was, for the first twenty-five years of its history, designed purely as an instrument of business to be used exclusively by men. Women's use of the telephone for gossip, secrets, recipe ex-changes, and other such domestic functions was initially a subversive one, discouraged and even stigmatized by the telephone company until the profit motive took hold. Then ideology obediently followed. The chat was legitimized; indeed, ads began to advance the telephone as helpmate, companion, and housewifely necessity.

Martin's chronology tracks the first half of the twentieth century. In my time, teenagers pursued a new adaptation of the technology, using it for friendships, dating, and the crucial function of cultural transmis-sion ("Did you hear?"). For our mothers' generation, World War II made the telegram the fetishized form of communication: women dreaded its arrival, sat at home hoping it wouldn't arrive, for it inevitably made them widows. For my generation, a new ritual evolved: girls still sat at home waiting, but this time it was waiting by the phone – for Him to call.

Still, change was relatively minor, more a matter of increment than anything else. Telephones were a more simple matter than they are today. Regular lines and party lines, that was the choice. And the term "party line" implied not ideological fidelity but the absence of privacy – and presence of community. Poor or rural people shared party lines: one had to wait for the other to get off the phone in order to make a call, an ethic of sharing enforced by community. Party lines were also invitations to eavesdropping, so that secrets could be harvested "on line" and shared with neighbors. The party line was a double-edged sword that cut in both directions, toward benefit on the one hand,

burden on the other. Whatever its drawbacks, it did enhance community, particularly in rural areas and for the homebound. Households with individual lines were isolated in luxury, telephonically speaking.

Telephone's technological progress in those days was relatively modest, even if reaction to any change at all could make it seem otherwise, like the mini-uproar that greeted the telephone company's edict to replace the old-fashioned exchanges with numbers. I remember when our Boston phone number changed from LOngwood-6 to 566. Song lyrics and movie titles changed forever, and people complained about the sacrifice of tradition to a horrible depersonalized technocracy of numbers, but everyone adapted.

It was a more innocent time, to be sure. I remember folktales about telephones, too: my favorite was one that cast the phone as killer. I heard the story during the summer I spent in Appalachia in 1971. One afternoon, during a particularly fierce thunderstorm, I was warned not to do any talking on the phone and then regaled with the tale of an unlucky resident of a nearby holler, some years back, who chanced to answer the telephone during an electrical storm and was instantly killed by the lightning charge that had actually been the cause of the line's frenzied ringing. I loved the story and retold it endlessly. In my version, the lightning is an impatient assassin which is waiting for its prey to leave the house, but finally fed up, just calls on the phone instead and thus accomplishes its killing more elegantly (and technologically). Telephonic murder, I said.

It was in Chicago in the 1970s that I first encountered the world of people without telephones and realized that the phone had quietly become a demarcation of status. Most middle-class users of the telephone took the appliance for granted and were oblivious to its selective utilization. Meanwhile, invisible in the rosy national picture, people without telephone service developed an identity not unlike those of the illiterate or, today, the homeless. They suffered from telliteracy, phonelessness, and the social disdain that such states invoke: it was harder for them to get jobs, to get credit, to stay in touch with kin outside their immediate physical environs. Today, voice mail arrangements are beginning to address these discrepancies but for the past twenty or thirty years, no such solutions were in place. To be without a telephone amounted nearly to a revocation of citizenship, so thoroughly did it curtail multiple forms of social participation.

In his 1995 article, "Beyond Universal Service: Characteristics of Americans Without Telephones, 1980–1993," Jorge Reina Schement powerfully proves the case that I only suspected from anecdotal evidence back then. He traces the domino effect of deprivation and impoverishment occasioned by the lack of a telephone, measuring impact on everything from job options to social isolation to the weakening or severing of family ties. Schement found, not surprisingly, that

telephone access corresponded exactly to income level and race, and additionally that single mothers with small children were particularly at risk for being telephone-deprived. So stark was the data that Schement questions the viability of democracy without more equitable access.

Today, of course, our national economy and communications systems have become totally centered on the telephone as delivery apparatus. This transformation may have been produced by the telephone itself, but it was never planned that way, a distinction that reminds me always to keep in mind the gap between invention and application. Such a gap became brutally clear, for example, to the atomic scientists who stood as stunned witnesses at Trinity over fifty years ago, reflecting too late on the atomic bomb's explosion and the implications of what they'd just wrought. Such moments are rare, though; more commonly, the recognition is a more slowly evolving response to a progression of technological change that gradually acquires a life of its own – that is to say, when it acquires a nature that is ascribed to the technology itself, rather than to the social functions or political mandates that gave rise to its invention in the first place. Just as the Model T never implied freeways or traffic jams, just as Nickleodeons never implied multiplexes or Hollywood production or VCRs, so Alexander Graham Bell's invention could never have prescribed or even anticipated its own evolution.

"Cambia, todo cambia" ("It changes, everything changes"), so goes the famous song by Mercedes Sosa. A prophecy of history triumphant and dictatorship finite in the Argentine context of its original performance, Sosa's song could equally apply today to technology and its status in a world in which technology and economics have effectively replaced old-fashioned politics as the rulers of people's lives. The effervescence of technology allows a peculiar contradiction to survive certain extinction: each time that the utopian claims made for a particular technology (said to revolutionize society or democratize access or ensure interactivity to one and all) can be clearly identified as false, a new technology is already emerging from development and is already magnetizing these same claims, all over again, to charge its own mission and promise. What cable television failed to do, home video would now do; what home video didn't accomplish, the camcorder revolution would; what camcorders missed doing, now the Internet would do. And on and on it goes, technological breakthrough upon technological breakthrough, *ad infinitum*, with promises held aloft forever, never dampened, never diminished.

The telephone, of course, became fruitful and multiplied, reproducing itself and its net profits throughout the 1980s and 1990s: telephone services (call waiting, call forwarding, voice mail), fax machines, computer modems, multi-line households, children with beepers, yuppies with cellulars – and don't forget to factor in whatever

new wireless wonder is undoubtedly being readied for purchase at this very moment. As the media greets each new product line with the breathless enthusiasm formerly reserved for medical breakthroughs or fashion shows, I find myself experiencing an uneasiness as powerful as the pleasure that I also, to be honest, do feel.

First, the pleasure. My life of the past decade would not have been possible without the telephonically based developments that have taken place, starting with the fax machine in the 1980s that allowed me to file stories without a budget for messengers or express delivery services. Using Canadian friends as intermediaries, I could fax Cuba with something like immediacy despite the mail and telephone embargos within the US. When my 80-year-old neighbor lost so much of her hearing that she could no longer hear over the phone, I learned to dial the relay operator to get put through to the TTD that she'd persuaded the local Elks Club to donate to her, and we found we could still "talk" together. When printing out articles on deadline became too slow for down-to-the-wire deadlines, I got a fax modem and filed copy straight out of the computer. I became one of the first people in my crowd to have email so that I could stay in touch with my good friend in Mexico over PeaceNet. When I decided to move to San Francisco from New York and realized I'd be spending a lot of time on airplanes, I bought the PowerBook 100, the first generation of Macintosh laptops, the minute they came onto the market. Soon I began using it as a personal teleprompter, delivering lectures from it in darkened halls to great blue-light effect.

When my mother and father both became terminally ill in Boston, and I really did spend my life on airplanes, my sanity and professional life were saved by the little machine as I wrote articles in the air, faxed them to editors late at night from my parents' kitchen, then logged on to read reassuring messages bearing strength and support from friends at an hour when I couldn't risk disturbing my parents' sleep with conversation. I became a technogirl through and through, eventually catching up with the Internet and following film festival gossip through the Web. Now I research my stories through Web pages and could even do research for my lover this fall, reading the Mexican newspapers every day on the Web and culling articles about the ever-unfolding political scandals. I cannot imagine life without multiple telephone lines, portable computers, on-line services, or fax machines, and no, I don't want to go back to a simpler unwired life. I've mutated enough to be comfortable. I await the next generation of technology as eagerly as the next generation of humans.

But now for the dis-ease part. It seems obvious to me that these changes have totally redefined notions of the public and private and may very well have collapsed the public/private distinction entirely. Our ability as individuals to access "the world" and vice versa from multiple

locations in private and public space has shifted the boundaries of epidermal differentiation. Already the increase in home offices has occasioned fights over zoning, as municipalities and suburbs struggle to distinguish between home and office given the new structures of white-collar labor. Industrialization in its earlier forms gave rise to cities; as work shifted from factories to white-collar enterprises, suburbs flourished. The new techno-industry has no such location, it's everywhere and nowhere, a continuation of the atomization process begun by television, then cable and home video. This decentering may be fashionably postmodern, but its linkage to traditional forms of government and political structure seems increasingly unclear: in this local version of transnational governance, old categories of precinct or parish make little sense.

And there's another aspect of neighborhoods worth notice: when my sisters and I had to camp out at the family home after my father's death, we knew we couldn't co-exist there with only one telephone. So we called NYNEX and placed an emergency order for additional lines to get us through the period of mourning, planning, and arrangements. The supervisor approved the emergency order (death is good for something) and the lineman came out the next day, spent hours wiring the house but then suddenly walked out on us. It seems that the telephone lines were already maxxed out with modems and fax machines and extra chat lines. There were literally no lines available for him to connect us. And there wouldn't be for weeks or months. If that's the situation in a stable middle-class neighborhood, what's the likelihood of getting the inner city wired into the information age?

Additionally, with electronic communication, even the concept of location has changed. Witness the shift in signifiers of wealth. Once upon a time, status was conferred by the conspicuous accumulation of objects (e.g. the Rockefellers). But now it's an accumulation of presences (on the Internet with a Web page, on the street with a pager, on the road with a car-phone) that signifies wealth. It's this dispersed series of ephemeral locations that has come to denote a contemporary form of power no longer adequately representable by a concentration of possessions (not that anyone's giving those away, though; technologies and customs still overlap).

The single location, by contrast, has been eviscerated by the entrance of technology into its very guts: the office is no longer a finite or self-contained entity, much less so the home. Is it real, or is it Memorex? In the office, this penetration has given rise to electronic espionage, database theft, hacker pranks, and in-house surveillance. In the home, the effects are just as pronounced even if they are less discussed and lacking in protective devices. Most important, the introduction of new computer/telephone technologies into the home raises urgent questions of gender and class.

Is technology gendered? It's a most basic question, and there's an easy choice of obvious answers: yes it is , and it's male; no it's not, computers are the great gender equalizer, look at all the women at work in the sector; yes, it's male, just log onto the Internet if you want a dose of frat-house culture.

If technology is indeed gendered male, then what does my enjoyment of it signify? Am I really female when I use my computer or do I engage in some sort of techno sex-change, cross-dressing my RAMs to blast off into cyberspace? Or is logging on itself a sign of queerness, a proof of my lesbian identity, a sign that I'm butcher than I appear to be? Am I one of the boys or one of the girls? Is it the computer that confers gender mobility, or does my pleasure in gender mobility make me computer-friendly? Should someone do a study of Luddites and their correlation with gender fixity? Or is something else really at stake here? There has been lots of discussion of people shape-shifting when they enter cyberspace, trading their identities for screen names that transform gender or age or sexuality in order to enter a free-play zone of virtual sexual interaction. But there's been very little discussion of how the apparatus itself splices gender into the mix, how the very act of booting up and logging on may contain profound gender enactments in the real world and real mind–body of the gendered user.

As difficult as it may be to argue technogendering with any authority, it's clear that the entrance of these technologies into the home has rendered domestic space less "female." Indeed, women seem increasingly disenfranchised within the sphere of the home, the sphere that was supposed to represent the most sacred female sphere and the refuge of last resort. (Obviously, women who are conversant with computer technologies occupy a different position in such an argument: for them, it's probably the home itself that's the greater subject of dislocation.) I would argue that women are becoming marginalized in the very space to which they used to be central. As technologies transform the household, those women who still occupy the traditional position of stay-at-home wife/mother are in danger of becoming a species of retired railroad car, dumped on a siding while the new locomotives speed by. Unable to program the VCR, they are reduced to whining as hubbie channel-surfs, hogging the remote. Fearful of their children's futures, they contemplate the purchase of computers which they don't know how to use and feel too intimidated to try. Computers may be the new encyclopedias, something procured by our mothers or grandmothers to uplift their children, but never read themselves. Their role was to dust them.

How can this situation be changed? World War II propaganda taught us that women could be mobilized out of the home into the factories and then back again. Rosie The Riveter ads compared factory machines to home appliances to encourage women to transfer their skills. That's the kind of campaign that's needed again. For too long, technology for

the home has meant food processors, microwave ovens, or at best, the home shopping network and Volvos. That's what's aimed at women. But what if life were different? What if home technology could mean more than listening to the baby over a wireless monitor or baking bread in the same machine that kneads it? What if truly female uses could be devised and implemented and marketed? Imagine a truly interactive computer/telephone system that seeks to break women's isolation, replace the extended family with virtual communities, and enhance women's empowerment through strategic linkages.

There could be, for example, an on-line bulletin board (BBS) for input to libraries (that's input, not catalog access), so that women who can't get out to attend meetings could counter the ban-the-book efforts of women with greater leisure time or mobility. Imagine museum access on-line, allowing women to explore shows of interest to them and read commentaries by other women like themselves. Imagine an on-line network for elderly care and communication that could alleviate isolation and upgrade quality of life for its members, as well as mobilizing support or advocacy. Single mothers, too, would benefit immensely from a connectivity able to open avenues for shared resources and information. Such inroads have begun. Self-help groups have started on the Web: a letter to Ann Landers indicated that there are currently over 1,000 such networks dealing with grief, eating disorders, etc. The trick, of course, is to move from individual contact to organizational structure, societal intervention, systemic change.

Interactivity needs to be extended into the legal sphere. Imagine a system of BBS and Web sites for tracking deadbeat dads from state to state, so that women could have their own privatized version of "America's Most Wanted." One recent article reported that women living alone were now installing separate telephone lines without extensions in their bedrooms and putting dead-bolt locks on the bedroom doors. The reason? To be able to run there and call for help when somebody breaks into the house to rape or rob or murder them. Imagine designing an alternate approach to home safety and surveillance that depended not on instilling terror in women but rather on alleviating it.

Imagine, for instance, what existing computer/telephone technology could do to alleviate domestic abuse and save women's lives. All the required parts are already out there; they just need to be connected. Just adapt the medical-alert system further into a community-rescue system, in combination with a Guardian Angel-style system of volunteers with beepers and an adaptation of the mapping systems like the Global Positioning System now being installed in luxury automobiles or tested in Atlanta to relieve Olympic gridlock. Forget the bracelet that locates the woman for the police; it's not working, and a bracelet isn't the right model anyway.

Instead, any woman in jeopardy would be hooked into her neighborhood alert system: a cry for help would be routed to her local rescue volunteers through a system of "broadcasting" that could be adapted from current faxing systems to notify beepers, while her mapped location could go out simultaneously by email and fax. Like a volunteer fire department, there could be brigades in every city and town that would respond to an alarm with the very same commitment to saving human life that fires call upon. A network could encompass college groups, unions, off-duty service personnel of various kinds, sports teams, daycare phone trees, etc. And I bet it would do the job better than the cops and empower women all the more. Enough of self-defense as the only option! Rescue is a more powerful concept. And rescue with the help of an adapted technological system (the Dick Tracy watch as a Save The Women icon) is possible today, if only individualism can be transformed into community action plans. If only technology can be used, not just to fragment communities, but to build up communities again via electronic functioning – as, indeed, some social-service agencies and entrepreneurial inner-city advocates are beginning to explore (if only they receive the necessary equipment donations, comprising a less attractive target consumer base, presumably, than the Christian Coalition lobbyists on the floor of the Republican Convention in August 1996, who were proudly testing new hand-held data-management devices networked into a brand new frequency just approved and unlikely yet to be jammed by cellular overuse.)

Will technology ever be used in the service of women's goals and needs, though? At the moment, its uses are closely following the ordained paths, predictably fulfilling only the most commercial interests or the most narrowly defined versions of individual leisure pursuits. Will technology ever be equitably dispersed across society, so that individuals regardless of class position can log onto their relevant Web sites (or whatever comes next) and participate in the virtual communities of their peers? Will interactivity ever be activated so as to empower the user as something more than a consumer of offered products and services?

Given this chapter's focus upon the home and the intersection of gender and technology therein, it is useful to keep in mind the traditional functions of the home and the implications for appropriate technological participation: safety, nurture, comfort, recognition, edification, cultural retention and reproduction. None are intrinsically threatened by the arrival of technology nor are any exempt from its purview; the problem, of course, lies in how to commandeer the tele-computer apparatus in the service of our real needs and not our manufactured desires. In the summation of his article, Jorge Reina Schement calls for a technological policy that could rectify the effects of class, elucidating the need for a "technology bill of rights" to

prevent the further stratification of society into electronic hierarchies. I believe that such a call is utopian: we are living in a time of harsh economic and political maneuvers, in an era that I believe is no longer characterized by democratic capitalism but instead by the early stages of neo-feudalism in which traditional rights are being deliberately and systematically eroded and redefined.

I don't believe that any benevolent government is prepared to deliver computers to underclass doorsteps. But I do believe in resistance. As neo-feudal society becomes increasingly fragmented and chaotic, electronic technologies have the potential to become a means of resistance, gathering individuals into diverse, dissident communities capable of modelling and enacting alternate plans, values, and methods. The question, ultimately, is not whether the technology is capable of any of this, but whether we are.

REFERENCES

Martin, M. 1988. "'Rulers of the Wires?' Women's Contribution to the Structure of Means of Communication." *The Journal of Communication Inquiry* 12, Summer: 89–103.

Schement, J. R. 1995. "Beyond Universal Service: Characteristics of Americans Without Telephones, 1980–1993." *Telecommunications Policy* 19(6): 477–85.

23

Information America

Julia Scher

INFORMATION AMERICA

WE PROVIDE NATIONWIDE INFORMATION
FREE-FOR-ALL DIRECTORIES
For information cultivation and
extraction we use the brightest,
newest, and fastest:

master and slave voice readers
conspiratorial electricians and room
debuggers
Intra-gender non-traceable bank cards
counterspy transmission interrupters
fake family services providers
heavy food intake and output meters
body bag, morgue and hospital
information gatekeepers
pirates and leakers
warrior companies and guidance
counselors
exhausted military market sales envoys
injectables
airport harassment vehicles
urine vapor detector whips
cleavage and buttocks analysis tongs
searchers and sifters
symbolic and real law enforcement
fabricated evidence
sex beds
live intimacy - real and feigned
daytime seduction and finger analysis
surveillance
machines of dominance and delight
Biometrics
military genetic records
government data sellers
fax files
beige computer input terminals
welfare files
blood and oral swabs
fingerprints
dental records
children's escort services

MISSION STATEMENT:
We utilize freshly gathered judgments,
identifications and verifications to make
our bright, shiny and vitamin-rich
database state-of-the-art. We heighten
the symbolic and communicative aspects
of filing INFORMATION AMERICA by using
gentle, pleasing and inviting computer
commands on new subjects. Our goal is
not to manage individuals, only space.

contrib utors

The Barbie Liberation Organization (BLO) is an international group dedicated to the humanization of children's toys. Since 1993, the Organization's diverse membership has switched the voice boxes on thousands of talking GI Joe and Barbie Dolls across the USA and Canada, resulting in GI Joes that reveal "I wanna go shopping!" and Barbies that order, "Dead men tell no lies!" Under the approving gaze of Santa Claus, the BLO has executed shop-giving campaigns each Christmas, placing the altered dolls back on store shelves to the gleeful surprise of unsuspecting customers. By executing a carefully layered strategy of mainstream media collaboration, the BLO has seen their subversive protest of gender stereotyping reported worldwide. For more information, contact the BLO at 3841 Fourth Ave #207, San Diego, CA 92103.

Ericka Beckman is a filmmaker living and working in New York City. Her work has been exhibited at the Museum of Modern Art in New York, Galerie Nationale du Jeu de Paume, Paris and the ICA in London among others. She is currently working on a project entitled *Hiatus* which merges notions of high tech interactive computer games with fantasy and fiction.

Gregg Bordowitz is a video and filmmaker living in New York City. His autobiographical experimental documentary about living with AIDS,

Fast Trip, Long Drop (1994), premiered at the Sundance Film Festival. It was featured in the Whitney Museum Biennial and was broadcast on WNET and WNYC in New York. In 1995, he made *A Cloud in Trousers*, a film based on a poem by Vladimir Mayakovsky. His recent film, *The Suicide*, completed in 1996, is based on the play by Nikolai Erdman, written in 1928. Currently he is working on a screenplay adaptation of Tony Kushner's play, *A Bright Room Called Day*.

Melodie Calvert is the Associate Curator of Media at the Wexner Center for the Arts and runs the Wexner Center's Art and Technology program. She is also a video artist and producer. Her works have been exhibited internationally and are in the collection of the National Gallery of Canada.

Lisa Cartwright is an Associate Professor of English and Visual and Cultural Studies at the University of Rochester. She is author of *Screening the Body: Tracing Medicine's Visual Culture* (Minneapolis: University of Minnesota Press, 1995) and co-editor with Constance Penley and Paula A. Treichler of *The Visible Woman: Imaging Technologies, Science, and Gender* (forthcoming). She produces educational multimedia on health issues and has co-curated an exhibition on technology and art for the New Museum of Contemporary Art in New York. Her writings on technology and visual culture have appeared in *Zone, Representations, Visual Display* (Bay Press, 1995), and elsewhere.

Sara Diamond is currently the Artistic Director of Media and Visual Arts at the Banff Centre, where she is executive producer of all new media and television projects. As well as her work as a curator, writer and teacher, she has exhibited extensively as a video and installation artist and has researched and created television and video works about women and work in Canada.

Judith Halberstam teaches literature and queer theory at the University of California, San Diego. She is the author of *Skin Shows: Gothic Horror and The Technology of Monsters* (Durham, NC: Duke University Press, 1995). Her articles have appeared in *Feminist Studies, Social Text* and *Women and Performance*. Her essay in this collection emerges out of her book in progress on "Female Masculinity."

Evelynn M. Hammonds is Assistant Professor of the History of Science in the Program in Science, Technology, and Society at Massachusetts Institute of Technology. Her research is in the history of medicine and public health in the US. She is currently working on a project on the changing conceptions of race and gender in medicine and biology from the turn of the century to the present.

238

Kathy High is a media artist living and working in New York City. She makes video tapes, teaches and is the Editor of the critical journal *Helix: A Journal of Media Arts and Communication*, which encourages dialogue among alternative media makers. Much of her video work combines documentary and narrative elements and investigates the gendered implications of scientific technologies such as issues of women and medicine. Video works include *I Need Your Full Cooperation* and *Underexposed: The Temple of the Fetus*. Her most recent piece is a musical about gene mapping called *The 23 Songs of the Chromosomes*.

David Horn is Associate Professor of Comparative Studies at The Ohio State University, and is a member of the faculty in Art Critical Practices. He is the author of *Social Bodies: Science, Reproduction, and Italian Modernity* (Princeton, NJ: Princeton University Press, 1994) and is completing a genealogical study of the criminal body as a site of legal and scientific evidence.

Bill Horrigan has been Curator, Media Arts, at the Wexner Center since 1989. Prior to that, he worked at the American Film Institute in Los Angeles and Walker Art Center in Minneapolis.

Ira Livingston is Assistant Professor of English at the State University of New York at Stony Brook. His publications include *Arrow of Chaos: Romanticism and Postmodernity* (Minneapolis: University of Minnesota Press, 1997) and *Posthuman Bodies* (edited with Judith Halberstam) (Bloomington, IN: Indiana University Press, 1995).

Bonita Makuch is a multi-disciplinary artist and teacher. Her artwork deals with issues of desire, illness, memory and growing up on a dairy farm. Her drawings and installations have been exhibited internationally and she is currently working on a CD-ROM based on her installation *Inseminations*.

Margaret Morse teaches film and video theory and criticism at the University of California, Santa Cruz. She has written on art and technology, electronic culture, and cultural constructions of women's bodies. She is completing a book entitled *Electronic Culture: Fictions of the Present Tense in Television, Media Art and Everyday Life*.

Soheir Morsy has held academic positions in the US and Egypt and now teaches anthropology at Tufts University where she is Director of Women's Studies. Her work with specialized agencies of the United Nations has addressed issues of gender, agrarian development, and health. Her current research concerns include gender and technology, the social production of knowledge, and the global politics of science.

Liss Platt is a videomaker, photographer, and installation artist who lives and works in New York. She is currently the Program Coordinator at Media Alliance, a state-wide media arts organization, and an Instructor at the School of Visual Arts. Her works have been exhibited internationally and she also curates, writes and plays ice hockey. Most recently she received a 1995 Media Production Grant from the New York State Council on the Arts and co-edited, with Kathy High, the Landscape(s) issue of *Felix: A Journal of Media Arts and Communication.*

B. Ruby Rich is a cultural critic who writes on issues of film, sexuality, and cultural politics for the *Village Voice, Sight and Sound, Elle, Mirabella,* and *OUT* magazines, as well as the daily and weekly press, scholarly journals, and anthologies. Her film commentary can be heard on public radio via *The World* in the US and *The Arts Tonight* in Canada. She is an adjunct Associate Professor at the University of California, Berkeley, and editor of the film/video reviews for *GLQ: A Journal of Lesbian and Gay Studies.*

Connie Samaras is an artist and writer based in Los Angeles. She is also an Associate Professor in the Department of Studio Art at the University of California, Irvine. Most recently, she's come to a deep appreciation of the antiquity and function of conscious, collective rituals used to perform partial, temporary possession as a means of helping one to distinguish the rigidity of personality from the vast and less visible capacities of the self.

Joyan Saunders is an intermedia artist who works in video, installation, and photographic tableaux. Her work has been exhibited internationally at venues including the Berlin Film Festival, LACE and the American Film Institute in Los Angeles, and the New Museum and Museum of Modern Art in New York. She has received numerous grants from the Canada Council on the Arts and her work is in the permanent collections of Canada's National Gallery, the National Film Board, and the Art Bank. She is currently an Associate Professor in the Art Department at the University of Arizona, Tucson, where she directs the New Genre Program.

Julia Scher is a New York based media artist and currently Visiting Assistant Professor of Media and Performing Arts at the Massachusetts College of Art. Her art work has been exhibited internationally and reviewed widely in the art and popular presses.

Andrea Slane is a mediamaker and film scholar who teaches film studies in the English Department of Old Dominion University. Her

mixed-media film and video projects include *Irresistible Impulse* and *The Alleged*, which have been shown internationally. She is working on a manuscript tentatively entitled *Family Values and Nazi Perversions: Anti Fascist Rhetoric on Sexuality in American Theory, Film and Commentary (1930–1995)* and is currently working on a new video entitled *Paper Trails and Kinks in the System: Multimedia Vignettes.*

Mary Ellen Strom works as an independent videomaker, performer and teacher. Strom's single channel video work has been exhibited at the Museum of Modern Art in NYC, Artists Space, the ICA in Boston, the Art Institute of Chicago, the Kansas City Art Institute, the Videonale in Germany and the Madrid Festival among others. Since June 1993 Strom has been directing School's OUT: The Naming Project, a video and performance workshop for lesbian and gay youth who live in New York City. She is currently working on *Pink*, a television program for girls that is a feminist alternative to traditional children's programming. Strom is also creating an installation based on ideas of rodeo that will premiere at the Museum of Contemporary Art in Los Angeles in March 1997.

Christine Tamblyn is an Assistant Professor at The University of California, Irvine. She has published over one hundred articles and reviews in magazines, catalogs and books. Her two CD-ROMs (*She Loves It, She Loves It Not: Women and Technology*, and *Mistaken Identities*) have been exhibited internationally in Great Britain, Spain, Australia, Finland, Canada, The Netherlands, Austria and Germany, as well as extensively in the United States.

Jennifer Terry is an Assistant Professor of Comparative Studies at The Ohio State University, concentrating on cultural studies of science, medicine, technology, feminist theory, and the history of sexuality. She is co-editor with Jacqueline Urla of *Deviant Bodies* (Bloomington, IN: Indiana University Press, 1995), and is currently completing a book entitled *Mapping An American Obsession: Science, Homosexuality, and Defining Norms of Citizenship.*

Nina Wakeford teaches feminist theory and cultural studies in the Department of Sociological Studies at Sheffield University, and is a creator of the Octavia Project Web Site (http://www.shef.ac.uk/uni/projects/wivc) on gender and technology. Her recent articles include "Sexualized Bodies in Cyberspace," in *Beyond the Book: Theory, Text and the Politics of Cyberspace*, edited by Warren Chernaik and Marilyn Deegan (London: University of London, 1996).

index